Art Therapy and Social Action

Art Therapy and Social Action

Edited by Frances F. Kaplan

Jessica Kingsley Publishers
London and Philadelphia

First published in 2007
by Jessica Kingsley Publishers
116 Pentonville Road
London N1 9JB, UK
and
400 Market Street, Suite 400
Philadelphia, PA 19106, USA

www.jkp.com

Library of Congress Cataloging in Publication Data
Art therapy and social action / edited by Frances F. Kaplan.
 p. ; cm.
Includes bibliographical references and index.
ISBN-13: 978-1-84310-798-9 (pbk. : alk. paper)
ISBN-10: 1-84310-798-8 (pbk. : alk. paper)
 1. Art therapy. 2. Social action. 3. Art therapy--Social aspects.
I. Kaplan, Frances.
[DNLM: 1. Art Therapy--methods. 2. Social Change.
WM 450.5.A8 A783875 2007]
RC489.A7A782 2007
616.89'1656--dc22

 2006014164

British Library Cataloguing in Publication Data
A CIP catalogue record for this book is available from the British Library

ISBN 978 1 84310 798 9

To Ani,

who improves my world just by being in it

Acknowledgements

Book acknowledgements present something of a quandary. How many people should be mentioned? – there are such a lot who contribute in one way or another to a book's completion. Should the friend who spurred me on by saying, "Do it and do it now!" get a mention? I say, "Yes," and I say, "Thank you, Audrey." Should the contributor who read several of the chapters (in addition to her own) and found some errors be singled out? Absolutely! "Many thanks, Lani." Should all the other friends and acquaintances who listened patiently while I explained and complained about the work involved also be mentioned? That would be too long a list, I'm afraid, but they are certainly owned a collective "Thank you!" Now what about family – those people to whom I am closest and who gave encouragement, took on some of my responsibilities to allow me time to work, and who only occasionally interfered? Definitely! Many thanks and a heap of gratitude go to Martin, Ruth, Jason, and Summer. Without them (and grandbaby Anika), my life would be without luster.

In other cases, no questions arise. Publisher Jessica Kingsley and her staff certainly deserve mention for their assistance, attention to detail, and overall humanity. And hardly least on this list are all those who contributed to this book. Their dedication to expanding the ways in which art can help others is exemplary. I am humbled by all that they have done and do.

Contents

Introduction **11**
Frances F. Kaplan, Marylhurst University, Marylhurst, OR

Part I Expanding the Therapeutic Role

1. **Art Therapy as a Tool for Social Change:
 A Conceptual Model** **21**
 Dan Hocoy, Pacifica Graduate Institute, Carpinteria, CA

2. **The Art Therapist as Social Activist: Reflections
 on a Life** **40**
 Maxine Borowsky Junge, Loyola Marymount University, Los Angeles, CA

Part II Acting and Reflecting on the Action

3. **Facing Homelessness: A Community Mask
 Making Project** **59**
 Pat B. Allen, School of the Art Institute of Chicago, Chicago, IL

4. **Wielding the Shield: The Art Therapist as Conscious
 Witness in the Realm of Social Action** **72**
 Pat B. Allen

Part III Resolving Conflict

5. **Art and Conflict Resolution** **89**
 Frances F. Kaplan

6. **Drawing Out Conflict** **103**
 *Anndy Wiselogle, East Metro Meditation of the City of Gresham,
 Gresham, OR*

Part IV Confronting Anger and Aggression

7. Anger Management Group Art Therapy for Clients
 in the Mental Health System 125
 Marian Liebmann, Inner City Mental Health Service, Bristol, UK

8. Symbolic Interactionism, Aggression, and Art Therapy 142
 David E. Gussak, Florida State University, Tallahassee, FL

9. The Paper People Project on Gun Violence 157
 Rachel Citron O'Rourke, Portland, OR

Part V Healing Trauma

10. Some Personal and Clinical Thoughts About Trauma,
 Art, and World Events 175
 Annette Shore, Marylhurst University, Marylhurst, OR

11. Art Making as a Response to Terrorism 191
 Rachel Lev-Wiesel, Haifa University, Haifa, Israel and Nancy Slater,
 Adler School for Professional Psychology, Chicago, IL

Part VI Building Community

12. Unity in Diversity: Communal Pluralism in the Art
 Studio and the Classroom 213
 Michael Franklin, Naropa University, Boulder, CO, Merryl E. Rothaus,
 Naropa University, Boulder, CA and Kendra Schpok, Mount Saint
 Vincent Home, Denver, CO

13. Art and Community Building from the Puppet
 and Mask Maker's Perspective 231
 Lani Gerity, Prospect, Nova Scotia, Canada and Edward "Ned"
 Albert Bear, Fredericton, New Brunswick, Canada

14. Art Therapy for this Multicultural World 244
 Susan Berkowitz, Founder, All People's Day®, Lake Hiawatha, NJ

THE CONTRIBUTORS 263

SUBJECT INDEX 267

AUTHOR INDEX 271

Tables

Table 11.1: Incidence of specific art elements across groups 204
Table 11.2: Examples of narrative themes across groups 205
Table 11.3: Incidence of narrative responses across groups 206

Figures

Figure 1.1: Arcs of influence 31
Figure 1.2: Desired state 35
Figure 3.1: Masks on exhibit at Oak Park Village Hall 60
Figure 3.2: Mask making in the park 63
Figure 3.3: Mask titled "Local Warrior" by John, Township Youth
 Services Director 65
Figure 4.1: Still life 78
Figure 4.2: House and fool 84
Figure 6.1: Allen's conflict situation (photograph by Richard Fung) 106
Figure 6.2: Teresa's tools for working with conflict (photograph by
 Richard Fung) 107
Figure 6.3: Gina's perspectives drawing (photograph by Richard Fung) 115
Figure 6.4: Interests versus positions: the iceberg (photograph by
 Richard Fung) 116
Figure 7.1: "Bad Day – Good Day" 131
Figure 7.2: Peaceful place/cemetery 132
Figure 7.3: "ANGER = VIOLENCE" 133
Figure 7.4: "ANGER = CRIME" 134
Figure 7.5: Positive and negative images 135
Figure 7.6: "Peace/Harmony/Happiness" 136
Figure 7.7: Anger and peace 137
Figure 8.1: Jason's inside-outside origami box 150
Figure 8.2: Prison project mural (detail of Jason's section) 151
Figure 8.3: Jason's mandala drawing 152
Figure 8.4: Eric's torture chamber made of Styrofoam blocks
 and popsicle sticks 153
Figure 8.5: Eric's "Scorpion anger Beast" made from Model Magic 154
Figure 9.1: Paper Person showing heart 167
Figure 9.2: Paper Person as superhero by eight-year-old boy 168
Figure 9.3: Paper Person as memorial 169
Figure 9.4: Die-in, Portland, Oregon 171
Figure 10.1: Pencil drawing of a brutal scene 183
Figure 10.2: Restorative pencil drawing 184
Figure 10.3: Oil painting of two owls in the darkness 184
Figure 10.4: "The World," colored pencil drawing 186
Figure 10.5: Two warriors, colored pencil drawing 187

Figure 11.1: G's drawing: "Total Destruction" 199
Figure 11.2: Z's drawing: "Them and Us" 199
Figure 11.3: Y's drawing: "The Crash" 200
Figure 11.4: R's drawing: "Hurt" 201
Figure 11.5: L's drawing: "Indifference: Why or Until When?" 202
Figure 11.6: C's drawing: "Helplessness" 203
Figure 12.1: Rabbi Zalman Schacter-Shalomi visits the NCAS 215
Figure 12.2: Members of the aphasia group working on a mural 219
Figure 12.3: A beloved member of the Naropa University community
 visits the NCAS 222
Figure 12.4: Kendra Schpok working on a large painting 226
Figure 12.5: NCAS member with partial paralysis enthusiastically working
 on a large drawing 228
Figure 13.1: A group of puppets in the Bread and Puppet collection 234
Figure 13.2: "A Warrior Knows," mask by Ned Bear 237
Figure 13.3: A K'chi Kuhkiyik Arts Camp participant with puppet 240
Figure 14.1: The Craft-Dough People by participants ages 11 to adult
 (photograph by Angelo Quaglia) 248
Figure 14.2: Teenagers portray the race of their Craft-Dough Person while
 performing skits that disprove prejudice-lies (photograph by
 Susan Berkowitz) 249
Figure 14.3: A young student experiences the beauty of different cultures
 by drawing one of the four family groups (photograph by
 Angelo Quaglia) 255
Figure 14.4: Life-size figures created by students serve as a backdrop for
 their original skits about the possible misunderstandings
 between people of different cultures (photograph by
 Angelo Quaglia) 256
Figure 14.5: Susan helps a student learn to fold a Peace Crane, which is a
 universal symbol of peace (photograph by Angelo Quaglia) 258

Introduction

Frances F. Kaplan

Why this book?

Some people are still waiting to be convinced that *art* and *therapy* go together. Certainly for them – and possibly for you who are reading this and who most likely accept art therapy as a viable modality – *social action art therapy* is something of a contradiction in terms. After all, art therapy endeavors to facilitate inner, individual change, and social action strives to make outer, collective change. But, before addressing what social action art therapy is or might be, the reasons for attempting to combine the two approaches should be addressed. In an attempt to present a holistic view, I'll start with some underlying personal motivations and build from there.

Throughout much of my life, I've felt the urge to bring together seemingly disparate entities. This probably began in childhood with my attempt to be the glue for a family that didn't quite fit together – with, as one can imagine, only limited success. As an adult, I've responded to this urge in ways both trivial and significant. When I took up cooking, I searched for recipes for dishes that combined unusual ingredients such as the "soup to nuts" cake that uses condensed tomato soup as a major component. When I sought my life's work, I looked for ways to combine my two loves: art and science. In the process of this last, I more or less "invented" the concept of art therapy and then discovered that others had gotten there before me (Kaplan 2000). Finally, in midlife, I became interested in promoting change – not just on an individual level but also on a societal one – and spent many years involved with the peace movement.

Thus began my efforts to apply art therapy to larger issues. And, as it happened, I found that others had preceded me there as well (e.g. Junge *et al.* 1993). Knowing that I was not alone in seeing the potential for art therapy to widen its scope encouraged me to take on this book project – a project that

represents more than my own predilections and presents some of the remarkable work that others have been doing. In this way, art therapists and other members of the helping professions could be offered models for expansion of their fields and could, in the process, quite possibly increase the effectiveness of what they do.

What is social action art therapy?

During the first half of the 20th century when art therapy had its beginnings, psychoanalysis was the therapy of choice. Consequently, art therapy started out as a form of psychoanalysis that used visual imagery. Indeed, it has been said that Margaret Naumburg, considered to be the original "mother" of art therapy in the US, simply substituted the easel for the couch (Ulman 1987). Her focus was on exploring the individual's unconscious, and the painting or drawing by the client was the object of free association in a manner similar to the Freudian approach to dreams.

By the 1960s when I was undergoing my personal therapy, psychoanalysis was beginning to widen its scope. Although many psychoanalysts were against seeing clients in groups, the psychoanalyst I went to had an interpersonal bent and used group therapy in combination with individual therapy. Art therapists, initially more out of necessity than theory (seeing a number of people at a time was cost efficient), were conducting groups as well. However, under the influence of Edith Kramer (our "second mother" of art therapy), the group approach was by and large an art studio approach with little emphasis on interpersonal interactions. By the time I started my art therapy training in 1974, however, change was evident. Interactional group art therapy based on neo-Freudian psychodynamic theory was being advocated and practiced.

The latter part of the 20th century and the first part of the 21st century have seen additional changes. Art therapy has embraced many psychotherapeutic approaches in addition to psychoanalysis, and it has begun to be sensitive to the diverse cultural backgrounds from which clients originate. In addition to becoming more culturally competent, this means that some art therapists try to assist clients with culture-related problems as well as intra- and interpersonal problems. It also means that a few art therapists have approached certain problematic aspects of society as though these were the "clients" they wished to help.

But we are not yet at a point where the question – What is social action art therapy? – can be adequately answered. When I began soliciting authors

for the various chapters in this collection, I had only a vague idea of how social action art therapy could be defined. When a potential contributor to this collection expressed confusion about what was wanted, I responded with a succinct yet simplistic definition. I said in effect that social action art therapy operates outside the usual box of individual illness (mental or physical) and addresses societal problems by providing services to perpetrators, victims (potential or actual), or people who work with members of these groups. However, in the process of editing this book, the contributors have educated me by expanding my perspective: *social action art therapy is this and more.*

In the interests of clarification, let's return to the problem of creating an amalgam of seemingly incompatible elements (art, social action, therapy). Recall that many artists have used their art to address social issues (for some relatively recent examples, see O'Brien and Little 1990). Also recognize that therapists, too, have a certain history of working for the betterment of society, as the organizations Psychologists for Social Responsibility and Counselors for Social Justice attest (for information about these groups, see www.psysr.org and www.counselorsforsocialjustice.org).

These realizations could lead us to conclude that it is primarily individual artist-therapists who undertake social action to address certain social problems, either inside or outside the traditional therapy setting. And, indeed, this is part of what social action art therapy is about (see chapters in Parts III and IV of this book). Or we might decide that it means using art activities to help people deal with environmental or cultural calamities (see Part V); or that it means practicing art therapy or therapeutic art outside traditional therapy settings – taking art therapy into the streets, as it were (see Part VI). And, again, we only have partial answers.

But, in different ways, the chapters in Parts I and II invite us to look at this brand of art therapy from another angle. What the authors of these chapters have to say suggests that social action and art therapy cannot – or at least should not – be separated. Now, how do we wrap our minds around this? The solution is both complicated and simple – that is, it is complicated in practice yet ultimately simple in concept: we cannot separate the people we treat from the cultural settings in which they live and by which they have been influenced. None of us exists in a social vacuum: each of us comprises a unique amalgam of genetic endowment, family upbringing, environmental influences, and collective history.

We have been inclined to think about personality and psychopathology in terms of nature or nurture – often attempting to assign etiology to one or

the other. Lately, we have begun to understand that the origins of both are an interaction of the two. At the same time, largely due to the multicultural movement, we have come to understand that we cannot ignore the contributions of culture, which have sources well beyond the family unit and even beyond ethnicity and race (Lee 1999). This means that, when we treat people, we must take into account the culture (or variety of cultures) they come from and to which they will return. It also means that we must honor their backgrounds and yet assist them in dealing with aspects of society that have contributed to their suffering. And, given the uniqueness of each one of us, it means that whenever we attempt to help someone we must be aware that we are essentially working cross-culturally and therefore must proceed with all the sensitivity and self-knowledge we can muster. To do otherwise runs the risk of imposing on our clients some of the same injustices they have experienced in the larger social order.

Where does this leave us? The inescapable conclusion is that whether we take art therapy into the streets or we remain secluded in our treatment settings, we would do well to "think" social action. Just as some family therapists have stated that family therapy is a way of conceptualizing treatment as well as a set of treatment techniques, so, too, is social action art therapy a state of mind as well as a method of action. One does not necessarily need to have the whole family in the room to treat family problems (Goldenberg and Goldenberg 1985), and one does not necessarily need to be demonstrating in public places to effect social action.

Summing up

Trends in treatment have ranged from seeing mental problems as largely the result of internal processes, be they of a psychological or a biological nature (Freud 1949; Shuchter, Downs and Zisook 1996), to locating the cause in early family relationships (Kernberg 1976; Kohut 1971), to placing it within the larger social realm (Laing 1967), and to initial attempts to give credence to all these sources (Erikson 1963). Social action art therapy puts the emphasis on societal factors because they have been neglected too often. It is conceived in the various chapters of this book as working to create social change, elevate awareness of social problems, provide community service, understand origins of socially unacceptable behavior, provide instruction in socially oriented interventions, and increase sensitivity to the social context of troubled individuals. However, none of this means that, in the general

practice of therapy, personal and relationship factors should be neglected. Rather, it means that a third component should be added to these two.

As the foregoing implies, the chapters in this book are quite different in style and content. Some are mostly practical, providing techniques that others can adopt or adapt; some are highly personal, offering insight into the type of person the artist-therapist-activist tends to be; and some are conceptual in whole or in part, supplying the groundwork for a theoretical approach to the book's topic. Nevertheless, there is a common thread that runs through all. Looked at from a broad perspective, this text examines the degree to which art therapists and other members of the helping professions bear a responsibility to the larger community from which their clients originate. It also provides a variety of creative answers – and raises some significant questions – as to how artist-therapists might proceed in shouldering a rather overwhelming but highly important obligation.

Lunching with an art therapist friend awhile back, I was struck by a comment she made when the conversation inevitably turned to art. "I don't think art can save the world these days," she said with a sad shake of her head. I nodded in dejected agreement. Thinking about this exchange later, I came to a more nuanced conclusion: perhaps art can't save the world, but combined with therapy it can have a significant part to play in rescuing some of its citizens. And this, it seems logical to advocate, can be done most successfully by considering these citizens *in their full context.*

Some concluding words

Now, before I step behind the editor's protective curtain of relative anonymity, I'll let you in on something else. I almost abandoned this project in its very early stages. The reason had a great deal to do with what happened on September 11, 2001. I had barely begun to work on the initial version of this book when the terrorists struck, badly damaging the Pentagon and destroying the World Trade Center in New York. Suddenly, my project seemed trivial – frivolous even – and extremely futile. These judgments were reinforced by the US government declaring a "war on terrorism," which some media pundits also referred to as "the *first* [emphasis added] war of the 21st century." I went through a period during which I vacillated between rebuking myself for being grandiose (who was I to think I had anything to contribute?!) and berating humanity for being such a lost cause.

Shortly after the devastating events of 9/11, however, I read an article by John Rockwell, in *The New York Times* (2001), whose message eventually

worked its way to the depths of my consciousness and helped to bring me around (along with the reminder to myself that whatever small bit we can do is better than doing nothing at all). Rockwell asked, "What is the role of the arts in the present crisis, and how will the arts change in response to the new circumstances in which we live?" (p.1). He also conjectured that, on the basis of responses to the crisis from nine artists from different fields, artists in general felt helpless and judged their work "irrelevant, even offensive" (p.1). He concluded his piece, however, with these memorable words:

> In any crisis there is a risk that the arts will be scorned or dismissed as an irrelevant distraction. Now that the real news, of terror and death and war, has arrived, attention to art with a different agenda might seem out of place.
>
> But art has its own importance; it stakes its own claim. We are told that in times of crisis, we need to rely on faith. Art can be a faith, too, from which some of us draw the deepest solace. A terrible consequence of this new climate of fear and revenge would be for our enemies, blind and intolerant, to turn us into them. We must retain our values, and those values very much embrace the sometimes messy creativity of the arts.
>
> Art is life itself. If we can sustain our arts in a diversity as rich as our social and political and religious diversity, then our artists can indeed play a most valuable role. They can sustain and inspire us, but they can also lead us – directly or, more likely, indirectly – from darkness to light. (Rockwell 2001, p.3, Copyright © 2001 by The New York Times Co. Reprinted with permission.)

To add to this would be superfluous.

I'll leave the stage now and open the curtain on the main event. In what follows, the focus is on visual art therapy, but it should be kept in mind that much of what is said can also be applied to other creative approaches used by helping professions.

References

Erikson, E.H. (1963) *Childhood and Society* (2nd edn). New York: W.W. Norton.

Freud, S. (1949) *An Outline of Psycho-Analysis* (rev. edn, J. Strachey, trans.). New York: W.W. Norton.

Goldenberg, I. and Goldenberg, H. (1985) *Family Therapy: An Overview* (2nd edn). Monterey, CA: Brooks/Cole.

Junge, M.B., Alvarez, J.F., Kellogg, A. and Volker, C. (1993) "The art therapist as social activist: Reflections and visions." *Art therapy: Journal of the American Art Therapy Association 10*, 3, 148–155.

Kaplan, K.K. (2000) *Art, Science and Art Therapy: Repainting the Picture.* London: Jessica Kingsley Publishers.

Kernberg, O. (1976) *Object Relations Theory and Clinical Psychoanalysis.* New York: Jason Aronson.

Kohut, H. (1971) *The Analysis of the Self: A Systematic Approach to the Psychoanalytic Treatment of Narcissistic Personality Disorders.* New York: International Universities Press.

Laing, R.D. (1967) *The Politics of Experience.* New York: Pantheon Books.

Lee, W.M.L. (1999) *Introduction to Multicultural Counselling.* Philadelphia, PA: Accelerated Development.

O'Brien, M. and Little, C. (eds) (1990) *Reimaging America: The Arts of Social Change.* Santa Cruz, CA: New Society.

Rockwell, J. (2001) "Peering into the abyss of the future" (Electronic version). *The New York Times,* 23 September, 1–3.

Shuchter, S.R., Downs, N. and Zisook, S. (1996) *Biologically Informed Psychotherapy for Depression.* New York: Guilford Press.

Ulman, E. (1987) "Variations on a Freudian Theme: Three Art Therapy Theorists." In J.A. Rubin (ed.) *Approaches to Art Therapy: Theory and Technique.* New York: Brunner/Mazel.

PART I

Expanding the Therapeutic Role

Art Therapy as a Tool for Social Change

A Conceptual Model

Dan Hocoy

Introduction: How the twain meet

The relationship between art therapy and social action is not entirely self-evident. Although conceived from feminist origins and nurtured by progressive political leanings (Junge 1994), art therapy in contemporary practice (Elkins and Stovall 2000) still diverges significantly from political activism and direct interventions for social justice. Conversely, social action does not specifically address the psychological and intrapsychic wounds of individuals. So, how exactly does the healing profession of art therapy intersect with the political praxis of social action? Is there a theoretical framework that might undergird a coherent relationship between these enterprises? As art therapy has struggled to find an adequate theory just to reconcile art and therapy (Rubin 1987), it is not surprising that there exists no conceptual model that integrates the work of social action with the practice of art therapy in a comprehensive fashion. Yet, an overarching framework that recognizes this inherent relationship and articulates its concepts, principles, and orientation would be of value.

Hocoy *et al.* (2003), psychotherapists who have worked in art therapy in one capacity or another, have struggled with this very issue and developed a general framework for how Western therapeutic practices might be reconciled with social action; the application of this framework to art therapy is presented here.

The image and social action

One way in which social action and art therapy are linked is through the versatility and power of the image. Social action is ultimately predicated on the relationship between personal and collective suffering, and the image has the unique ability to bring to consciousness the reality of a current *collective* predicament, as well as the *universality* and *timelessness* of an individual's suffering. Moreover, images can concurrently heal personal-collective wounds while demanding a response to injustice.

The image is regarded as having the potential to mediate between the individual and the collective. Cassirer (1955) believed that consciousness is mediated and transformed through symbolic forms, and the image "is one means through which the 'I' comes to grips with the world" (p.204). For Carl Jung, the archetypal image, an expression of a universally recurring theme that transcends time and culture (Schaverien 1992), allows connection to the collective unconscious. An awakening to a shared predicament can be transformative in itself, as well as serve as a basis for social action. For instance, the images of the Mexican muralist movement of the early 1900s, which embody Kuhns' (1983) "enactments in a culture" (p.53), brought awareness of a collective plight and served as a language of solidarity, empowerment, and revolution for a largely illiterate population.

According to Jung, the image can be transformative in two basic ways: (a) through the healing derived from conscious awareness of a previously denied aspect, and (b) by tapping into the healing potential of the psyche – specifically, the central archetype of the Self (Wallace 1987). Evidently, these capacities of the image apply on the collective as well as the individual level. With regard to the first transformative process, Schaverien (1992) explains:

> [The image] is the means through which the subjective and objective nature of the patient's experience is mediated. The [image] is no mere handmaiden in the service of psychotherapy, instead it is a formative element in the establishment of a conscious attitude to the contents of the unconscious mind (p. 11)... Through the seeing of the image...the patient's relationship to unconscious material begins to change. (p.21)

In terms of the second transformative process, Wallace (1987) describes the Self as a vast, unbounded healing factor that is accessed through the image and that "compensat[es] for any imbalance that might arise" (p.114). These healing functions may be manifest in Augusto Boal's (2000) *Theatre of the*

Oppressed, in which the frozen gestural images of participants (resulting from exercises to address oppression) bring forth creative improvisation from the unconscious and, conceivably, from the Self in addition to *conscienticization* (i.e. collective consciousness).

Jung (1961) also alludes to a third way that the image can heal:

> The images of the unconscious place a great responsibility upon a man. Failure to understand them, or a shirking of ethical responsibility, deprives him of his wholeness and imposes a painful fragmentariness on his life. (p.193)

Jung suggests here that an image may be a representation of an alienated aspect of the psyche and asserts there is a "moral obligation" (p.187) to understand such messages from the unconscious and to effect reparation. Clearly, then, the image can serve as a call for individual and collective action to address marginalized aspects of human potential. Examples of this may be seen in the photographic images of Sebastiao Salgado (1997, 2000, 2004), which document human plights including struggles for land rights, poverty, displacement, and genocide and implicitly charge the viewer with an obligation to address these instances of injustice. Interestingly, there exists empirical research supporting these dynamics; Kaplan (1994) found evidence of a relationship between the nature of the images one spontaneously produces and the likelihood one will engage in social action.

Art therapy: Whom does it serve?

As with any social institution, art therapy "derives from a specific set of cultural assumptions, values, and constructions" (Hocoy 2002a, p.141) and contains within it the biases of the society of which it is a product. Although art therapy may be less culture-bound (e.g. Kalish-Weiss 1989) than other societal enterprises and often acts in countercultural fashion, it is still inescapably shaped by the viewpoint and socioecopolitical arrangements of the culture from which it originates. The structures that undergird contemporary society developed from a particular set of power relations and tend to privilege some individuals at the expense of others; these structures are usually taken for granted because they have been the consistent ground of our existence and are as invisible as the air we breathe (Greenfield 1997). Yet these invisible societal arrangements perpetuate a social order that contributes to disparities in status and resources, ruptures in relationship and experience, and disdain for difference and diversity, as well as a host of other inequities.

These shadow elements of society manifest in its institutions and citizens, and inescapably reside in the endeavors of art therapy and the psyches of art therapists (Hillman 1975, 1992). Without examining how the worldview and social order of the dominant culture are embedded in its practices and philosophy, art therapy can unknowingly reinforce structures of domination and contribute to continuing injustices. Even the "healing" traditions can be in service to dominant culture interests, complicit in neocolonial power arrangements, and tools of assimilation and social control (Szasz 1984). Junge *et al.* (1993) ask:

> As art therapists are we too often helping people adjust to a destructive society? Are we ourselves co-opted by the status quo and, understandably, yearning to be inside, adapt, make do, and continue to cope with a fatally injured mental health system? (p.150)

For art therapy to be a force of individual and societal liberation rather than an unwitting vehicle of social compliance, the therapy itself must be liberated from the invisible structures and biases inherent in it. Yet:

> A part of our history as art therapists that may impede us is that...[t]ypically, we are not trained as...social and cultural analysts or critics, but as those who through the art therapy process help people cope and adapt [to unjust systems]. (p.150)

Difficult questions need to be asked: whom or what in society does art therapy privilege or serve? In what ways might a profession, in which 87 per cent of its practitioners identify as "Caucasian" (Elkins and Stovall 2000), be blind to established hierarchies of power, especially ones predicated on race? In what ways might art therapy participate in oppressive perspectives and dynamics of marginalization? Whose definition of health, normality, universality, human nature, Self, and psyche informs it? Does it contain within its practice an examination of its enculturating role as well as processes to mitigate the transmission of ideology and social structure?

> History yields many sad examples of movements that began as liberatory and ended as controlling and repressive. At the same time, many schools of psychology [and types of therapy] intending to assist individuals in finding new potentials, stop short of critiquing and engaging the social limitations which make transformation impossible. Thus, often the mental health establishment helps to personalize, marginalize, and medicate what is essentially a protest against a dehu-

manizing and repressive social milieu. (Lorenz and Watkins 2001, p.295)

Homophobia as working example

To illustrate the various aspects of the conceptual model presented here, the issue of homophobia is used as a working example. In the case of homophobia, we can observe how societal biases against homosexuals have been institutionalized and transmitted through the various mental health traditions – including the American Psychiatric Association (APA). Until relatively recently, homosexuality was formally designated as "abnormal" and an expression of "psychopathology" (Friedman 2002). Homosexuality was defined as a type of sociopathic syndrome in the APA's *Diagnostic and Statistical Manual of Mental Disorders* (*DSM*) until *DSM-II* (APA 1968) and regarded as a sexual deviation or paraphilia until *DSM-III* (APA 1980). It was not until *DSM-III-R* (APA 1987) that ego-dystonic homosexuality was deleted as a mental disorder. Homophobia remains a pervasive societal problem (Franklin 2000), and there are still homophobic biases in professional therapeutic communities as Rauchfleisch (2003) and Twomey (2003) have documented in regard to Swiss and British psychoanalysts, respectively.

In this one instance, we can see how the values, assumptions, and ideology that privilege heterosexuals and the traditional nuclear family have been perpetuated, both consciously and unconsciously, even by "therapeutic" professions. By reinforcing oppressive societal structures (e.g. policies about marriage, spousal benefits, adoption, high-school sexual education, and so on), institutions of healing have served the interests of the majority voice of heterosexuals while marginalizing a significant portion of humanity. It is clear that any human enterprise, left unexamined, can be complicit in societal injustice and an instrument of the dominant voice.

The relationship between individual suffering and societal structures

Martin-Baro (1994), a proponent of liberation psychology, has been instrumental in making the connection between the suffering or psychopathology witnessed in clients and the cultural and socioecopolitical structures of society. Dominant culture frameworks for normality and psychopathology such as the *DSM* frequently mask the relationship between the symptoms that are expressed by individuals and societal imbalances. These frameworks

tend to situate the problem within the individual rather than within the broader collective context, and treat "the pathology of persons as if it were something removed from history and society, and behavioral disorders as if they played themselves out entirely in the individual plane" (Martin-Baro 1994, p.27). Situations like apartheid demonstrate that societal structures can directly result in diminished psychological well-being (Hocoy 1999a, 1999b, 2000). Less extreme conditions such as poverty, inadequate housing and education, unemployment, and social discrimination have also been indicated in lower mental health (Kleinman 1988). Archetypal psychotherapist James Hillman (1992) makes the link between individual and collective illness explicit:

> My practice tells me that I can no longer distinguish clearly between neurosis of self and neurosis of world, psychopathology of self and psychopathology of world. Moreover, it tells me that to place neurosis and psychopathology solely in the personal reality is a delusional repression of what is actually, realistically, being experienced. This further implies that my theories of neurosis and categories of psychopathology must be radically extended if they are not to foster the very pathologies which my job is to ameliorate. (p.93)

Junge *et al.* (1993) warn, "All too often [art] therapists heal what is already wounded and do not attend to the milieu which wounds and re-wounds again and more deeply" (p.149). A more contextualized perspective, consistent with both feminist (Alcoff and Potter 1993; hooks 1984) and systems or ecological (Goldenberg and Goldenberg 1991) approaches, also avoids the additional psychological damage of blaming the victim for the suffering she or he experiences.

The separation of individual psychological states from socioecopolitical realities betrays a certain orientation in worldview, one specific to a cultural paradigm premised on individualism and a particular configuration of the Self (Cushman 1990). The image of human existence as a web in which multiple levels of experience and order intimately interconnect often falls into the blindspot of a worldview for which the unit of social organization and responsibility is confined to that of the singular individual. It may not be an accident that this individualist ideology of human suffering coincides with societal structures that contribute to disparities between, and distress in, individuals. If personal psychological distress were seen as intimately related to particular social arrangements, these arrangements would be actively challenged. An individualist worldview and the distancing of personal

suffering from its societal context are instrumental and necessary for engendering acquiescence to the social order. As an example, epidemiological studies indicate that homosexuals have a higher prevalence of depression, panic attacks, generalized anxiety disorder, and general psychological distress than heterosexuals (Cochran, Sullivan and Mays 2003). And it is the conclusion of many researchers (Taylor 2002; Weishut 2000) that this psychological impairment stems from societal heterosexism. However, if these same mental health problems were identified as self-generated, deriving from homosexuals themselves, there would be no call for a heterocentric society to make changes in legislation and education that give equal status to homosexuals and relinquish the societal advantages (e.g. tax benefits and status in military, religious, and political organizations) conferred to the heterosexual majority.

Depth psychology and the interdependent self

Depth psychology (e.g. Jung 1961) provides a transpersonal framework for how the individual and society may be interrelated. This framework assumes that there exists a *unus mundus* ("one world") in which there is no separation between one's inner, psychological experience and the external physical world, but rather that these domains are inextricably interdependent. The conventional division of reality and experience into private and subjective, as distinct from public and objective, is unnecessary. In this view, the dominant voice in society finds expression in the ego (i.e. conscious awareness) of the individual, and the collective egos of society constitute the dominant voice. Those voices that are undesirable in society are pushed into the collective shadow or unconscious, which has its corollary expression in the individual as personal shadow or unconscious; reciprocally, the personal shadows of individuals contribute to the collective shadow. Lichtman (1982) suggests that a societal context of disparity necessitates the psychological repression of elements that are morally disturbing to one's ego and conscience; these elements, which would also be threatening to the status quo, get relegated to the unconscious.

The work of depth psychologist Mary Watkins (1992, 1999, 2000a, 2000b) has been essential in articulating the interdependent nature of human relationship, as well as providing contextualized definitions of selfhood and psyche in which individual and society interpenetrate one another. With this lens, the interdependent relationship between what is marginalized in the personal psyche and what is marginalized in society

becomes illuminated. It is not coincidental that those aspects of our identity and human potentiality that we as individuals reject in ourselves are also those aspects disdained by the collective. Just as the individual is shaped by societal pressures, society is impacted by the individual's response – which is often one of blind collusion and passive conformity to injustice. Individual and collective experiences and actions co-create one another in a reciprocal field.

Therapy: A microcosm of society

Art therapists and their clients recapitulate the dynamics of society in the microcosm of the therapeutic relationship; those areas in society that are unbalanced and require redress inevitably emerge in this relationship. Junge *et al.* (1993) write, "[We art therapists are] co-creators engaged together with our clients in their struggle, which is ultimately also our own" (p.150). Societal disparities can be either mutually reinforced or actively challenged in this context. Therefore, these authors propose:

> It is time for art therapists to take [a] conceptual leap – an activist leap. To begin, we must recognize ourselves and those with whom we do therapy as deeply interrelated. Next, we must acknowledge that we and our clients are part of larger systems… And we must see that struggle clearly and engage in it strategically and effectively beyond the boundaries of office walls and the psychic limitations of our own consciousness and denial. (Junge *et al.* 1993, pp.150–151)

Given the power they possess in the professional relationship, it is incumbent on therapists to address these internalized oppressive dynamics and not to transmit or reinforce them. In the example of homophobia, the therapist needs to address the social imprint of homophobia that marks her or his own psyche and consciously create an alternative space in the therapeutic context that is open to the marginalized voice of homosexuality.

In-depth psychology, bringing repressed elements from the unconscious into conscious awareness and integrating them with one's identity, is considered both therapeutic and central to the psychological development of the individual (Freud 1954; Jung 1961). Of course, this principle has direct implications for the therapist in terms of her or his personal wholeness and professional competency, in addition to being relevant to goal setting for the client. It also suggests that bringing those repressed elements within society into conscious awareness and integrating them with the collective identity is essential to the psychological health and development of the collective

whole. In other words, social justice may be essential to the well-being and maturity of society, as well as necessary for the psychic development of individuals.

Illuminating the therapist's shadow

> To the extent that our theory, as well as our practice, is determined by forces of which we are unaware, then it is no more than a verbal externalization of our own intrapsychic issues. (Rubin 1979, pp.1–2)

Do we silence in our clients the voices of difference that we have been socialized to silence in ourselves? An intentional and comprehensive introspection is a necessary first step in mitigating the unconscious influences in one's therapeutic practice. An effort toward this consciousness must be made or else the unconscious modus operandi assumes control, and our hidden personal agendas and de facto societal set-points become engaged.

The contents of a repository that is by definition inaccessible to conscious awareness are not easily identified, but they might be culled through careful and continuous observation. The material that consistently arises out of meditation, personal therapy, journals, artwork, dreams, reveries, and behavioral habits and patterns, as well as our interactions with and feedback from others and the world, might suggest the themes of our personal shadow. Conscious techniques, such as a deconstructionist self-critique (Foucault 1980) or the systematic examination of embedded biases through the creation of a personal "cultural genogram" (Hardy and Laszloffy 1995), may be useful in elucidating our latent agendas. The simple prescription in the American Psychological Association's Code of Ethics (2002) to "do no harm" may actually require an intrepid and sophisticated exploration of one's shadow, as well as conscious decisions in support of psychic and societal wholeness.

Social action praxis: In therapy and in society

Within the illusory boundaries of the Western construction of a flesh-enveloped Self, the intrinsic interrelatedness of the work of therapy and social action is easily obscured. From a transpersonal and interdependent view of the Self, however, doing clinical work that is cognizant of the societal implications *is* social action, and being politically active *is* doing therapy; these activities are understood to be interrelated processes. The lines of division between personal and societal, therapy and social action,

disappear through a lens that recognizes the interconnectedness inherent in our human existence.

Figure 1.1 illustrates how the work of the art therapist in social action and therapeutic practice may not be so different. The arcs of influence indicate that the difference might only be the context of initial impact by the therapist. Arrows A1 and A2 constitute an arc identified more traditionally as the work of social action: in arc A, the therapist directly addresses a societal injustice; this action in turn (and perhaps even simultaneously on some transpersonal or interpsychic level) affects the client and her or his ego-shadow composition. Arrows B1 and B2 constitute an arc identified more traditionally as the work of art therapy: in arc B, the therapist influences the client, who impacts in turn (or simultaneously) the balance of dominant-to-marginalized voices in the collective through her or his own shift. Of course, the therapist is reciprocally influenced by both society and client; however, arrows indicating this have been omitted to display the influence of the therapist.

To illustrate these dynamics with our running example, a therapist who is also a social activist begins by examining the potential for homosexuality in her or his own shadow and by integrating this potentiality in ego consciousness. This movement in the balance of ego-shadow material immediately shifts the balance in the collective, of which the therapist is a member. In addition, once homosexual feelings are accepted by the therapist, she or he might actively campaign for homosexual rights in greater society and work towards bringing homosexuality out of the collective shadow, which further impacts the psychic balance of the client. The shift in the therapist influences consciously and implicitly, actively and passively, everyone with whom she or he has contact. The client, on the other hand, impacts society by a similar shift in consciousness and by any social ripples in the collective created through the client's own social activism.

Figure 1.1 illustrates that working in the therapeutic context and doing social action work are entwined and that these activities are not incompatible; in fact, one inevitably necessitates the other. Through this diagram we can also imagine how the therapist might perpetuate societal biases (e.g. homophobia). In this scenario, the therapist internalizes the social transmission of homophobia – which would be represented by arrows of influence from society and client to therapist – and mirrors back homophobia. Uncritical therapists contribute to homophobia by actively and passively suppressing this human potentiality in themselves and in their contact with the world.

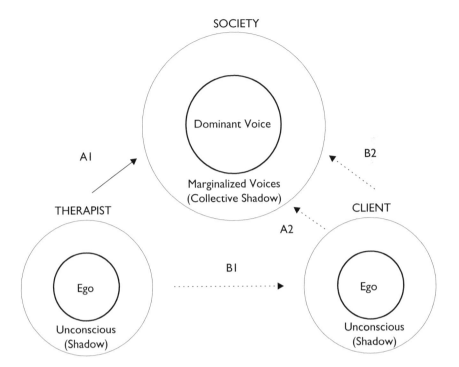

Figure 1.1: Arcs of influence

The art therapist as social activist

Because the work of art therapy always has social repercussions, what makes the art therapist also a social activist is an awareness of the interconnectivity between individual and collective, between a person's suffering and social imbalance, as well as an active commitment to personal and social transformation through advocacy for those aspects of individuals and society that are disenfranchised. In response to such inequities, art therapists engage as activists by addressing their own complicity and taking a conscious and ethical stand in redressing social disparities. This awareness and commitment should not be underestimated; in the fog of individualism that conceals the personal price of the social order, this clarity constitutes a transforming act of empowerment and revolution.

A contextualized analysis, conscientiousness in practice, and clarity in moral purpose move the work of therapy beyond the therapeutic space and the symptomatic manifestations of societal injustice found in individual clients. The art therapist as social activist chooses to give priority to those

parts of humanity that are marginalized, give expression to the voiceless, *re*-member the dispossessed, challenge destructive ideologies and myths, minimize power differentials, and seek wholeness in fragmented relationships. The activist-therapist understands that political neutrality and therapeutic passivity only serve the omnipresent forces of oppression and injustice.

Art therapy employing an action research approach

Given the diversity of communities in which art therapy may be found, the form a socially conscientious art therapy takes needs to be quite variable to be consistent with the values, beliefs, and healing traditions of the local culture and to avoid acting as an enculturating force (Hocoy 2002a). An approach art therapy might adopt is one that is akin to action research (Stringer 1996). This approach does not assume the validity of Euro-American philosophical suppositions or therapeutic methods, or even the value of the enterprise for another culture. It also submits that for any given community, "art therapy may not be the best or only intervention" (Hocoy 2002a, p.144).

An action research approach, although having a few variations, possesses three consistent elements: power, people, and praxis (Finn 1994). Action research operates with the awareness that power is central to the construction of reality, interpretation, and psychological experience (Foucault 1980), and works toward community empowerment through a democratization of knowledge and a critical analysis of societal conventions. It prioritizes the experience of disenfranchised peoples and is in service to their specific needs (Brown 1985). This approach also assumes that all action necessarily derives from some theoretical foundation, implicit or otherwise. "We [art therapists, then,] need to be careful…that the theory we espouse does not conceal unrecognized needs or conflicts within ourselves" (Rubin 1987, pp.318–9) or harmful political agendas. The praxis of action research explicitly derives from a critical awareness of the personal–political dialectic and the transformation of sociocultural structures through participatory democracy (Sohng 1995).

Having a sensitivity to potentially oppressive cultural forms, art therapy utilizing an action research approach would be both flexible and self-critical in its implementation while being open to new expressions including culturally syncretic or blended forms that integrate local ideals, structures, and concepts – especially those regarding community visions of wholeness,

balance, and health (Hocoy 2002b). Art therapy need not be a tool of colonization in which an inappropriate foreign practice or image is imposed (Hocoy 2002a). It can adapt to the particular needs and worldview of the host community rather than remain ideologically aligned to "tradition."

How can art therapy maintain its identity and be so flexible? The theory, practice, and purpose of art therapy can be held lightly and act more as guiding principles than as rigid dogma by keeping the interests of the client and local population paramount. Paradoxically, this might ensure the continued influence and longevity of art therapy as it develops in complexity and breadth and becomes more universally applicable. As Rubin (1987) suggests:

> Art therapists…need to develop an appropriate set of looking perspectives, so that we can look each time in a way that is truly consonant with the process and/or product in front of us. (p.318)

Community-based art therapy

Art therapy may have to take place outside the consulting room *and* outside the traditional "therapeutic frame," and engage according to community norms (Hocoy 2004). In the community, art therapy and social action would naturally be fused. An example of how art therapy might manifest in a collective context can be found in Boal's (2000) *Theatre of the Oppressed*, where psychodrama is taken out of traditional settings and performed in public venues (e.g. street corners, parks, and workplaces) and in which individuals express their personal oppressions and relate them to political, economic, and other societal conditions while generating new responses. Art therapy in the collective might resemble community psychology (Rappaport 1987) and involve vernacular expressions of ritual, myth, performance, and spirituality in addition to visual artistic expression and therapeutic facilitation. Contemporary manifestations of what could be considered community-based art therapy include exhibitions of the AIDS quilt (Junge 1999) and various forms of the community arts movement (Brown 2002; Timm-Bottos 1997), which have community residents, including the homeless, creating art as a form of personal transformation, community development, and political expression.

Implicit in art therapy as action research is an understanding of selfhood in which multiple levels of experience are interdependent – that is, in which the psychological-political, ecological-economic, cultural-social, corporeal,

and spiritual are entwined and interpenetrating. Given this view of personhood, art therapists would benefit from an openness to a multidisciplinary approach in which the knowledge and techniques of other disciplines are sought and the work of art therapy is executed with an awareness of the wider complexity of which its practice is only part. Because art therapy takes place within a web of multidimensional interdependence, its ability to effect social reconciliation and transformation is optimized when it acts creatively in complementarity with other forces of change.

Telos: Just and peaceful communities

The perpetual social evolution towards liberating suppressed aspects of humanity would seem to be an emergent process in which goals are in flux, transient, and resistant to definition. However, art therapy as social action might have one invariable *telos* or endpoint in mind – that of achieving just and peaceful human communities. Despite the many convolutions that may emerge in a liberatory process, peace and justice would seem to be enduring goals regardless of how society might be configured.

Figure 1.2 depicts the desired *state*, as in both "condition" and "republic." One of the features of this idealized state is a society in which there exists no monolithic, dominant voice that is impregnable to alternative voices, but, rather, a communal space where multiple voices, equal in status, are continually in dialogue and permeable to reciprocal influence. As a result of a balanced, equitable society, individuals who are both shaped by and constitute society are similarly balanced; their egos are in dialogue with other voices, which are open to reciprocal influence by one another as well. The ego here is decentered and open to transformation by voices it does not ordinarily identify with. Individuals in this ideal state would help to create and reinforce a structure of equality; the societal set-point and its attendant inertia would favor a fair distribution of resources and power. The emptiness of the center provides a metaphoric space for other potentialities to emerge and be expressed. In this dialogical space, heterosexuality, for instance, would not be dominant or central, but one of the many voices in the multiplicity of human experiences and potentials. Heterosexuals, homosexuals, bisexuals, intersexuals, and the transgendered in society, and their respective elements in the psyche, would be of equal status and open to mutual influence as well as yet unexpressed and emergent sexualities.

Clearly, this desired state is more a utopian ideal than an attainable reality. However, it does provide a direction and a viable process. And who knows?

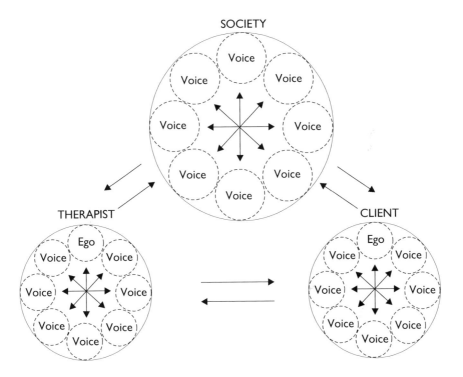

Figure 1.2: Desired state

The full possibilities for human creativity and development are still to be discovered. Who knows what synergies could develop once the process of acknowledging previously suppressed elements begins? The very diversity of human potential rejected by current societal structures may very well serve as the foundation to society's redemption and maturation.

Limitations of the framework

What is proposed here is a basic theory and vision for integrating social action and art therapy; more elaboration on the practical work of integrating these enterprises in the real world seems necessary. The application of this framework is likely to be more complicated than the theory presented may suggest. Although convenient, the example of homophobia, intended to ground the theory, is an issue about which an art therapist undertaking social action may already have clarity. It is easier to identify either systemic biases of the past or contemporary structures already known as potentially

marginalizing. Although homosexuality is an issue about which there is still considerable resistance (Franklin 2000), the real challenge may be in identifying elements that are not yet recognized as necessitating advocacy. For instance, it is less clear as to how to address individuals who find beastiality or pedophilia desirable; how do we ultimately discern between justified cultural disdain and monocultural discrimination against nontraditional sexualities? Related to this challenge is the natural divergence of moral positions regarding any single issue among cultural worldviews. What if there exists a proscription against homosexuality in the particular culture in which the art therapist works? Is it not then a cultural imposition to promote an openness toward homosexuality in a community for which it is considered a sin? One can imagine endless complications that can arise in practice. The directive to create a dialogical space may be insufficient when a clear direction is required.

Implications for art therapists

Art therapy is in a process of developmental evolution in which its "individuation does not shut [the therapist] out from the world, but gathers the world to [the therapist]" (Jung 1960, p.432). Despite its limitations, the model presented calls for new paradigms in art therapy, ones that integrate individual and collective transformation through seeing, healing, and activism. Robbins (1985) asserts, "[Art therapists] require a complex theory of treatment that integrates *psychodynamics* and *aesthetics* [emphasis added]" (p.68); perhaps it is time now to heed Jung's (1961) "moral obligation" (p.187) and add *social justice* to the list as well.

The interdependence of therapy and social action has some direct implications for us as art therapists:

1. We need to come to terms with our own unconscious or shadow material lest we inflict marginalized aspects of our psyches on the psyches of our clients and others with whom we have contact and, thereby, perpetuate injustices in the greater society.

2. We must come to realize that our *other* therapeutic work is in redressing social disparities in our communities and the world at large by empowering the disenfranchised and advocating for dialogue and equity at every opportunity.

3. We have to cultivate a perpetual awareness of the interconnectivity of life and understand these truths: No matter how much therapy we do and how self-enlightened we are, *there*

is no possibility to end psychological suffering until we work on the social disparities that result in intrapsychic trauma, and, no matter how much political activism and community service we do, *there is no possibility for social justice until we come to terms with the forces of marginalization within our own psyches.*

Acknowledgement

The author wishes to express his deepest appreciation to Mary Watkins, Ph.D., Helene Lorenz, Ph.D., and Aaron Kipnis, Ph.D., with whom many of the ideas presented here were developed.

All rights reserved. Reprinted with permission from the American Art Therapy Association, Inc. (AATA). In a slightly modified form, this chapter was originally published in *Art Therapy: Journal of the American Art Therapy Association 22*, 1, 2005, pp.7–16.

References

Alcoff, L. and Potter, E. (1993) "When Feminisms Intersect Epistemology." In L. Alcoff and E. Potter (eds) *Feminist Epistemologies* (pp.1–15). New York: Routledge.

American Psychiatric Association (1968) *Diagnostic and Statistical Manual of Mental Disorders* (2nd edn). Washington, DC: American Psychiatric Association.

American Psychiatric Association (1980) *Diagnostic and Statistical Manual of Mental Disorders* (3rd edn). Washington, DC: American Psychiatric Association.

American Psychiatric Association (1987) *Diagnostic and Statistical Manual of Mental Disorders* (3rd edn rev.). Washington, DC: American Psychiatric Association.

American Psychological Association (2002) "Ethical principles of psychologists and code of conduct." *American Psychologist 57*, 1060–1073.

Boal, A. (2000) *Theatre of the Oppressed.* London: Pluto Press.

Brown, B.A. (2002) "Empathy, connection, commitment: Community building as an art form (Part I)." *ArtScene*, January. Retrieved 11 May 2006 from www.artscenecal.com/ArticlesFile/Archive/Articles2002/Articiles0102/Bbrown0102.html

Brown, L.D. (1985) "People-centered development and participatory research." *Harvard Educational Review 55*, 69–75.

Cassirer, E. (1955) *Philosophy of Symbolic Forms: Vol. 2 Mythical Thought.* New Haven, CT: Yale University Press.

Cochran, S., Sullivan, J.G. and Mays, V.M. (2003) "Prevalence of mental disorders, psychological distress, and mental services use among lesbian, gay, and bisexual adults in the United States." *Journal of Consulting and Clinical Psychology 71*, 53–61.

Cushman, P. (1990) "Why the self is empty: Toward a historically situated psychology." *American Psychologist 45*, 599–611.

Elkins, D.E. and Stovall, K. (2000) "1998–1999 membership survey report." *Art Therapy: Journal of the American Art Therapy Association 17*, 41–46.

Finn, J. (1994) "The promise of participatory research." *Journal of Progressive Human Services 5*, 25–42.

Foucault, M. (1980) *Power/knowledge: Selected Interviews and Other Writings.* New York: Pantheon.

Franklin, K. (2000) "Antigay behaviors among young adults: Prevalence, patterns, and motivations in a noncriminal population." *Journal of Interpersonal Violence 15*, 339–362.

Freud, S. (1954) *The Origins of Psychoanalysis.* New York: Basic Books.

Friedman, R.C. (2002) "Male Homosexuality and Psychoanalysis." In C. Schwartz and M.A. Schulman (eds) *Sexual faces.* Madison, CT: International Universities Press.

Goldenberg, I. and Goldenberg, H. (1991) *Family Therapy: An Overview.* Pacific Grove, CA: Brookes/Cole.

Greenfield, P.M. (1997) "Culture as Process: Empirical Methods for Cultural Psychology." In J.W. Berry, Y.H. Poortinga and J. Pandey (eds) *Handbook of Cross-cultural Psychology* (Vol. 1). Needham Heights, MA: Allyn and Bacon.

Hardy, K.V. and Laszloffy, T.A. (1995) "The cultural genogram: Key to training culturally competent family therapists." *Journal of Marital and Family Therapy 21*, 227–237.

Hillman, J. (1975) *Re-Visioning Psychology.* New York: Harper and Row.

Hillman, J. (1992) *The Thought of the Heart and the Soul of the World.* Woodstock, CT: Spring.

Hocoy, D. (1999a) "The validity of Cross' model of Black racial identity development in the South African context." *Journal of Black Psychology 25*, 131–151.

Hocoy, D. (1999b) "Marginalization among Blacks in South Africa." In J.C.L.J. Adair and K. Dion (eds) *Latest Contributions to Cross-Cultural Psychology.* Lisse, Switzerland: Swets & Zeitlinger.

Hocoy, D. (2000) "Clinical Implications of Racial Identity in the Legacy of Apartheid in South Africa." In W.J. Lonner, D.L. Dinnel, D.K. Forgays and S.A. Hayes (eds) *Merging Past, Present, and Future in Cross-cultural Psychology.* Lisse, Switzerland: Swets & Zeitlinger.

Hocoy, D. (2002a) "Cross-cultural issues in art therapy." *Art Therapy: Journal of the American Art Therapy Association 19*, 141–145.

Hocoy, D. (2002b) "Ethnography as Pedagogy in Multicultural Competency." In P. Boski, F. van de Vijver and M.A. Chodynicka (eds) *New Directions in Cross-Cultural Psychology.* Warsaw, Poland: Wydawnictwo Instytutu Psychologii.

Hocoy, D. (2004) "Working with Asian-American Clients." In J.V. Diller (ed.) *Cultural Diversity: A Primer for Human Service Professionals.* Belmont, CA: Brooks/Cole.

Hocoy, D., Kipnis, A., Lorenz, H. and Watkins, M. (2003) "Liberation psychologies: An invitation to dialogue." Unpublished manuscript.

hooks, b. [sic] (1984) *Feminist Theory from Margin to Center.* Boston, MA: South End Press.

Jung, C. (1960) *The Structure and Dynamics of the Psyche.* Princeton, NJ: Princeton University Press.

Jung, C. (1961) *Memories, Dreams, and Reflections.* New York: Vintage Books.

Junge, M.B. (with Asawa, P.P.) (1994) *A History of Art Therapy in the United States.* Mundelein, IL: American Art Therapy Association.

Junge, M.B. (1999) "Mourning, memory and life itself: The AIDS quilt and the Vietnam veterans' memorial wall." *The Arts in Psychotherapy 26*, 3, 195–203.

Junge, M.B., Alvarez, J.F., Kellogg, A. and Volker, C. (1993) "The art therapist as social activist: Reflections and visions." *Art Therapy: Journal of the American Art Therapy Association 10*, 148–155.

Kalish-Weiss, B. (1989) *Creative Art Therapies in an Inner City School.* New York: Pergamon.

Kaplan, F.F. (1994) "The imagery and expression of anger: An initial study." *Art Therapy: Journal of the American Art Therapy Association, 11*, 139–143.

Kleinman, A. (1988) *Rethinking Psychiatry.* New York: Free Press.

Kuhns, R. (1983) *Psychoanalytic Theory of Art.* New York: Columbia University Press.

Lichtman, R. (1982) *The Production of Desire: The Integration of Psychoanalysis into Marxist Theory.* New York: The Free Press.

Lorenz, H. and Watkins, M. (2001) "Depth Psychology and Colonialism: Individuation, Seeing through, and Liberation." In D. Slattery and L. Corbett (eds) *Psychology at the Threshold*. Carpinteria, CA: Pacifica Graduate Institute Publications.

Martin-Baro, I. (1994) *Writings for a Liberation Psychology*. Cambridge, MA: Harvard University Press.

Rappaport, J. (1987) "Terms of empowerment/exemplars of prevention: Toward a theory for community psychology." *American Journal of Community Psychology 15*, 121–148.

Rauchfleisch, U. (2003) "Psychiatric, psychoanalytic and mental health profession attitudes toward homosexuality in Switzerland." *Journal of Gay and Lesbian Psychotherapy 7*, 47–54.

Robbins, A. (1985) "Perspective: Working towards the establishment of creative arts therapies as an independent profession." *The Arts in Psychotherapy 12*, 67–70.

Rubin, J.A. (1979) "Opening Remarks." In L. Gantt (ed.) *Art Therapy: Expanding Horizons*. Baltimore, MD: American Art Therapy Association.

Rubin, J.A. (1987) "Conclusion." In J.A. Rubin (ed.) *Approaches to Art Therapy: Theory and Technique*. New York: Brunner/Mazel.

Salgado, S. (1997) *Workers: An Archeology of the Industrial Age*. New York: Aperature.

Salgado, S. (2000) *Migrations: Humanity in Transition*. New York: Aperature.

Salgado, S. (2004) *Sahel: The End of the Road*. Berkeley, CA: University of California Press.

Schaverien, J. (1992) *The Revealing Image: Analytical Art Psychotherapy in Theory and Practice*. New York: Routledge.

Sohng, S.S.L. (1995) "Participatory research and community organization." Paper presented at the New Social Movement and Community Organizing Conference, Seattle, WA, November.

Stringer, E.T. (1996) *Action Research*. Thousand Oaks, CA: Sage.

Szasz, T. (1984) *The Myth of Mental Illness*. New York: Quill.

Taylor, G. (2002) "Psychopathology and the Social and Historical Construction of Gay Male Identities." In A. Coyle and C. Kitzinger (eds) *Lesbian and Gay Psychology: New Perspectives*. Malden, MA: Blackwell.

Timm-Bottos, J. (1997) "Joan Flynn Fee interviews Janis Timm-Bottos." *Salt of the Earth*. Retrieved 6 July 2006 from www.salt.claretianpubs.org/issues/homeless/bottos.html

Twomey, D. (2003) "British psychoanalytic attitudes towards homosexuality." *Journal of Gay and Lesbian Psychotherapy 7*, 7–22.

Wallace, E. (1987) "Healing Through the Visual Arts: A Jungian Approach." In J.A. Rubin (ed.) *Approaches to Art Therapy: Theory and Technique*. New York: Brunner/Mazel.

Watkins, M. (1992) "From individualism to the interdependent self: Changing paradigms in psychotherapy." *Psychological Perspectives 27*, 52–69.

Watkins, M. (1999) "Pathways Between the Multiplicities of Psyche and Culture: The Development of Dialogical Capacities." In J. Rowan and M. Cooper (eds) *The Plural Self: Multiplicity in Everyday Life*. Thousand Oaks, CA: Sage.

Watkins, M. (2000a) "Depth Psychology and the Liberation of Being." In R. Brooke (ed.) *Pathways into the Jungian World*. London: Routledge.

Watkins, M. (2000b) "Seeding Liberation: A Dialogue Between Depth Psychology and Liberation Psychology." In D. Slattery and L. Corbett (eds) *Depth Psychology: Meditations in the Field*. Einsiedeln, Switzerland: Daimon Verlag.

Weishut, D. (2000) "Attitudes toward homosexuality: An overview." *Israel Journal of Psychiatry and Related Sciences 37*, 308–319.

CHAPTER 2

The Art Therapist as Social Activist
Reflections on a Life

Maxine Borowsky Junge

Creative work must be in some ways kindred to the world, if not the world as it is, then the world as it will or might be. It flows out of the world and it flows back into it. Thus the creative person, to carry out the responsibility to self, the responsibility for inner integrity, must also in some way be responsive to the world. (From *Creative People at Work* by D. Wallace and H. Gruber 1990, pp.280–281, reprinted by permission of Oxford University Press)

Introduction

Life stories of creative people as a source for understanding human behavior and development have a long history in psychology and psychotherapy theory (Polkinghorne 1988). Freud's (1961) study of Leonardo da Vinci is an example, along with Erik Erikson's (1958, 1969, 1975) studies of human lives such as those of Mahatma Gandhi and Martin Luther. More recently, Howard Gardner (1993), in his book *Creating Minds*, has investigated creativity and supported his theory of multiple intelligences through the life stories of Freud, Einstein, Picasso, Stravinsky, T.S. Eliot, Martha Graham, and Gandhi.

Life story in the form of life history has also been an important element of most psychotherapy, counseling, and art therapy practice. That a person's history is an important formative process during a person's development is no secret. That many people attempt to overcome and survive the traumas of their lives is no secret either. But it is only relatively recently, with the

embracing of constructivist research paradigms, that narrative forms of therapy and therapy techniques have achieved legitimacy. Fortunately, we are in an era in American mental health where the life story is viewed as an important tool that allows the listener to capture and understand the teller's context from the teller's point of view. For the art therapist, this narrative approach means entering into the essence of the client's world in a deep and important way.

Much of this chapter is my life story as a social activist. I had twin goals in writing such a personal piece. First, it was my hope that some of my experiences from a long life committed to human service, social justice, and activism might strike a chord in others, even illuminate their own life paths and call them to the barricades. Second, it was my hope that I would rediscover myself at age 67 on the path of this sometimes lonely journey. For, as Audre Lorde stated:

> I have come to believe over and over again that what is most important to me must be spoken, made verbal and shared, even at the risk of having it bruised or misunderstood. (1984, p.40)

I am, at the time of this writing, a 67-year-old, heterosexual, secular Jewish woman. I worked in arts therapy fields before I had words for them or knew their names. But my "official" art therapy work began in 1974 when Helen Landgarten invited me to teach in the Immaculate Heart College's art therapy Master's program in California. (Before that, I had apprenticed to Helen in art therapy.)

Since the 1930s, the focus in art therapy and psychology has largely been on the individual and on individual development. For many of these years, there was neither the notion of a "global village" nor the current emphasis on diversity and multiculturalism. The world has become too complicated for individual thinking and conceptualizing. The obvious paradigm shift needed in art therapy – though not exactly new – is toward a *systems approach*. Because I always used my work to address social ills, I have found systems thinking to be a most helpful way of considering change, and I think it should be taught more in our art therapy educational programs. Systems thinking is natural to any painter. A painting is a system in which all parts must work together to make a whole. To change one thing is to change the whole. For example, altering a bit of color requires that the rest of the painting be adjusted to fit the change.

In addition to being an art therapist, I am a painter, photographer, writer, teacher, systems person, organizational development consultant, family

therapist, and a social change agent. It is actually quite simple: I combine the art of creative change in individuals, families, groups, systems, and myself in the work I do. Because I felt the outsider from an early age, I have always been interested in marginalized, "invisible" people. I have trained in social justice and social action at the Highlander Institute in Tennessee and the National Training Labs in Bethel, Maine. (Highlander, founded by Myles Horton, has been a seat of social action in the US since the 1920s. Rosa Parks was there the week before she refused to move to the back of the bus, and the protest song, *We Shall Overcome*, was written there.)

My family and childhood: Roots of social activism

I was lucky to be born into a family of artists. I was born and grew up in Los Angeles during World War II and the "blacklist" period in Hollywood. In the area where I grew up, there were few houses and lots of lima bean fields. Motor Avenue, which snaked through my neighborhood, had 20th Century Fox studios at one end and Metro Goldwyn Mayer studios at the other. (During World War II, my father rode his bike to work first at one movie studio, then the other.) With neighborhood boys – there were no other girls – I enjoyed much freedom and a vast territory in which to play that has unfortunately ceased to exist in urban areas today. Southern California then was a place on the edge of the Pacific Ocean without the constraints on behavior, manners, and feelings that existed in most Eastern cities. Despite this bucolic setting, an early memory is of watching from the sidewalk – I must have been about four – as a cross was burned on the lawn of the other Jewish family on the block. I remember going home to my parents and saying, "We aren't Jewish, are we?" They set me straight in a hurry.

I adored my father, a movie writer and later a professor of screenwriting and playwriting at the University of California in Los Angeles (UCLA). He was a novelist and a founder of the Writer's Guild, a pretty good watercolor painter, and a passable violist. He also listened to his students. But, most important for me, I knew him as a man who stood up and spoke out for what he thought was right. He hated anything that smacked of unfairness.

My mother, who had been a theatrical costume designer in New York and who had run the WPA[1] theater costume shop for the whole city of New York at age 21, went partially deaf soon after I was born and completely deaf after the birth of my brother in 1941. Her deafness was caused by severe sinusitis in the days before antibiotics or sulfa drugs. As a "stay at home mother," she did a good deal of informal counseling, listening, and encour-

aging people who were trying to get used to hearing aids. The one she had at the time was very large and included a five-pound battery pack worn on her leg. She taught a painting class in her garage studio, which continued with mostly the same participants until she died at age 76 of lung cancer. I consider myself today to be in the family business.

My parents neither issued admonitions about what was right nor instructed me in any way. They simply modeled a socially active life with social justice as their cornerstone. I took in the lessons even though they were not spoken directly to me. For example, they had many parties and gatherings at the house, which were always attended by people of different races, ethnicities, and gender orientations. The Hollywood writers were the local "intelligentsia." They were invited – but told not to talk shop – along with artists, historians, writers, gardeners, and maids, young and old. What made a good party for my parents were lots of different ideas and a warm inclusiveness.

There were many places in Los Angeles where Jews were not allowed in those days. As an aware child, I knew that certain private schools and country clubs did not allow Jews. I also knew of one country club that was Jewish and was integrated by a WASP movie director, a good friend of my family. He did not want to be a member of a club that excluded Jews, he said, and he wouldn't tolerate a Jewish one that excluded others. In 1967, when I moved to South La Jolla with my young children and my husband for his postdoctoral years at the Scripps Institute, I knew that, only a very few years before, Jews had not been allowed to buy houses there. It occurs to me that it would have been difficult for a Jew living through that period to be anything but a social activist!

From my father, I learned to have opinions and ideas and to stand up for them. From my father, I learned to attempt to make things better. From my mother, I learned about listening. From both, against the unfairness of the blacklist period, I learned about tolerance.

The power of art

When I began junior high school, I was put in the "dumb" class and stopped going to school regularly. My mother took on the school first, but in those days they didn't listen to parents. So when that didn't work – although she might have sent me to a therapist – she sent me at the age of 12 to a children's Saturday art class.

I have written elsewhere about that experience (Junge 1994):

The teacher, an energetic gray-haired woman named Eula Long, was interested in the psychological aspects of the creative process and, in particular, was a student of Gestalt psychology… She believed that a supportive emotional environment was essential to the creation of art – that no child's art should be criticized but only praised, and that the teaching of technique was not only unimportant but hindered or even stopped the child's creativity entirely…

Those three years of classes were not called art therapy and Eula Long did not refer to herself as an art therapist but I am convinced that that was what she was. I watched my drawings and paintings, at first stilted and self-conscious, take on a richness and excitement that began to be recognized by parents, teachers and friends. With Eula, I had the privilege of experiencing the therapeutic power and the possibility intrinsic in art. (pp.xv–xvi)

Thus began my life as a painter and as an art therapist – although I didn't know the words "art therapist" yet. My paintings were filled with people. Much later, when I began to do art therapy formally and saw clients, my paintings changed almost entirely to landscape. One of my first integrations of art and social change was a paper I wrote in high school: "Daumier, Goya and Ben Shahn: Painters of Social Protest."

Much social change in this country has been tied to music. *We Shall Overcome* is an example. It is an easier medium to carry along on marches and can meld a group together quickly. Nonetheless, images have power to make change that has long been recognized. Artists have frequently portrayed and predicted change. Andy Warhol's soup cans illustrate our culture of objects, providing a sense of what is perceived as important but is hard to bear. Gully Jimson, Joyce Cary's fictional hero in *The Horse's Mouth* (1965, first published 1944), saw a Manet in a store window in London and said, "It skinned my eyes for me and when I came out I was a different man" (1965 p.63). No one who has seen Picasso's *Guernica* is likely to escape that image nor think about the Spanish Civil War in the same way again. Goya's *Disasters of War* can make peace lovers of us all.

The image in art therapy is an illumination of a person's interior landscape. It illuminates what was, what is, and what might be. In its concreteness, it proclaims a reality that can be changed. In therapy, a person can change the image and may thereby change personal behavior, which in turn can change a family, a group, or the world. Images can also be used with groups to form a group identity, and with marginalized or invisible popula-

tions to give visibility, stature, and presence in the world. Imagery takes on iconic importance, symbolic of change. Although one may not agree with the Iraq war, the image of Saddam Hussein's statue tumbling is unforgettable.

The issue of *language* is an important one to all therapists. Unfortunately, spoken language is still the sine qua non of the educated person, and all too often the language of psychotherapy and of change. Language is what is valued and desired. (I used to have clients referred to me in a mental health clinic, because they would not talk and their therapists became bored.) As art therapists, we do not need reminding that expressive communication often does not come in spoken language, that many of our clients need imagery, and that "creative voices" can come in many colors and not in words at all.

Social action projects

In this section, I have described a few patterns that have been ongoing in my life as well as some projects I have undertaken. I have attempted to make things better in the areas of racism and anti-semitism, women's equality, gender equality, and art therapy as a profession. But it should be understood that the *use of Self* has always been central.

"Operation Adventure"

I wanted to march for civil rights in the South and participate in the Freedom Rides. But I had a young family and no money. One day in 1967, while living in San Diego, I saw a bulletin board advertisement for an art teacher in an enrichment program. I signed on and there met Sandy Turner, a Quaker community organizer. Together, we attempted to turn the group of parents toward a program in the ghetto areas of South San Diego. When we were unsuccessful, we started our own program.

"Operation Adventure" was an alternative education program using the arts as the vehicle. We figured that kids would want to learn anything (including Greek history and myths) if we used art and made the learning relevant and fun. With volunteers, who were not trained teachers but interesting people, the program grew in size and success. When I moved back to Los Angeles – my husband had been hired as an assistant professor at UCLA – I peddled Operation Adventure around town. I knew I wanted to do the program there and hoped that someone would pick it up. It was just after the first riots in Los Angeles and Black Power was on the rise. I figured it might be more acceptable for a white woman to be in a Chicano neighborhood

than in a black one. I ended up in the section called Boyle Heights at the International Institute located there.

Operation Adventure taught me to speak out for what I believed. In Boyle Heights, it grew bigger and even more successful. One summer we hired 38 minority college kids to teach the classes, and I, the nonverbal one, went downtown to publicly beg the Los Angeles city council for more money to pay them. I asked them how we could "enhance self-confidence" (a goal) if we paid our staff so little. That summer, though it wasn't much, we were the highest paid program in Los Angeles.

Additionally, I learned about group dynamics. With such a diverse teaching staff and a white woman boss, we had so much conflict that teaching could not go on. Because we didn't know what else to do, my Chicano assistant director and I sat staff members down and had them honestly talk to each other. Much to our surprise, relationships improved. (Later, I did some reading about the power of groups and, in our second summer, we hired a consultant who regularly ran groups with staff.)

Through Operation Adventure, I met and partied (dancing and parties are very important social action tools for blending groups) with a group of young Chicano men who started the first Chicano literary magazine in the country – *Con Safos: Reflections of Life in the Barrio.* They were lovely people, but to let a woman – and a white woman at that – on their staff was not something they did. I was allowed to publish a poem in their journal titled "Upon submitting proposals for federally funded summer programs." Operation Adventure went on for about four years, finally morphing into a project with alienated gang kids from Mexico. Thirty-five years later, I still have contact with some of Operation Adventure's staff and the kids we served. One young woman, a child of Operation Adventure and the low-income housing projects, received her Ph.D. in botany. But many are lost, in jail, or dead. (I recently heard that a project for male gang members in that area – the cleaning up of graffiti – had shut down, because of drive-by shootings and the fatal killing of two of the participants.)

Equality for women

> There are some places on earth where blacks are equal. There is no place on earth where women are equal. (J. Fisher 2001, personal communication)

I have long noticed the landscape of internalized sexism inhabited by both men and women and realized that even talented women have a hard time

(Junge 1988). I have long been aware that women are not equal in our culture (nor in any culture). I was brought up in a middle-class, male-dominated family that was usual for the time. Like many of my generation and class, growing up in the 1950s, marrying in the 1960s, and having two small children by the time I was 30, I was supposed to be bright, talented, ambitious, and give it all up for my husband's career. A family story was that humorist James Thurber said, "A woman's place is in the wrong!" Before the women's movement came along and gave permission for my secret strivings (and those of many women), I tried to stay at home with my young children. But I almost went crazy and started sneaking out to take life-drawing classes. Again, art saved my life.

Although "feminism" has bad connotations for many of the younger generation, feminism for me has always meant equality and equal opportunity. In addition, I have recognized that our culture is rife with internalized sexism, which pervades the thinking of women as well as men. It is interesting to me that, in the early days of the feminist movement of the 20th century, there was an emphasis on consciousness raising and assertiveness training – empowering concepts. These trends have changed to focusing on women as abuse victims and, at best, survivors – rather passive roles that seem more acceptable in today's cultural climate.

Nonetheless, I was surprised when I went in 1970 to talk with the (white male) Admissions Director of the UCLA School of Social Work. He told me, "We don't take any white, middle-class, middle-aged, Jewish women." Even before that, I had noticed that the Art Department at UCLA, which I had attended as a graduate student, had all male instructors except for one (and she was ridiculed) and was very hard on female students.

There are always the little things: where I now live in Washington state, I am part of a group that puts out a meeting roster. When I first saw it, it contained the male name of the married couple with the wife's name in parenthesis (this despite the fact that it was mostly women who came to meetings). I protested, and it was changed. After a health crisis this summer, I met with healthcare workers to try to improve the system. I noticed that they had a hard time calling me "Doctor," although they called themselves that. One male doctor stated that he met me at my house because he thought I might be intimidated if we met in an office! At the local dog park, a retired male doctor confessed to me (unsolicited) that he was sorry about how he had treated women in his practice. From the days in the 1970s when "refrigerator mothers" were said to cause autism, the mental health system has

changed. But there is still plenty of mother-bashing today related to children's problems.

Loyola Marymount University (LMU), where I taught and ran the art therapy program for so many years, was first a men's school established by the Jesuits. Previous to my coming there, it had combined with Marymount, a women's institution, to become co-ed. Nevertheless, when I started there in 1980, I was told by a male administrator, "The women will be gone soon." Why had our art therapy program been taken in when Immaculate Heart College, where it had started, was closed? I was told that the accrediting organization, Western Association of Schools and Colleges (WASC), had strongly recommended that Loyola Marymount have more women and more creative programs.

But new ideas or not, old ideas and paradigms die hard. I was on many a search committee in which I was the lone voice questioning what "fit" meant for a faculty member (usually, it meant hiring a white male if at all possible). And, every graduation, I stared at the emblematic seal on the podium that was for Loyola alone. It was only after a basketball player died on the court around 1995 that TV sportscasters began using the term "LMU," including Marymount at last, and the university followed suit. As Chair of the Committee on the Status of Women, I initiated and drove the Student Sexual Harassment Policy though the politics of the university. I believe it was my greatest gift to Loyola Marymount.

As teachers and students in a graduate art therapy program, we were outsiders in the male academy. When our program came to LMU, we were offered to the Art Department and to the Psychology Department. Both declined heatedly. Both departments were in colleges. To be in a college meant that the department and faculty had a dean and, theoretically, a certain amount of protection and advocacy. Probably because of WASC's urgings, the university decided to keep us, so they made us our own department in the Graduate Division – which offered no protection but a good deal of autonomy.

I have written about art therapy as a woman's profession (Junge 1994). For a recent fundraiser, I wrote the following statement to go with a chair I had painted and titled "The Superwoman Chair":

> Art therapy is predominantly a women's profession and yet, as far as I can tell, the meaning of this is not a conscious fact for most art therapists. In my almost 30 years of training art therapists, most have been women, and many of our clients are women. To understand that the

culture in America deprecates women and to help our clients under-
stand politics and that there is still a power differential and how to
approach and change it, are central tenets of Feminist Therapy and
should be central tenets for us all... Although humorous in style and
content, the [Superwoman] chair has a serious intent: Perhaps sitting in
it will raise the consciousness of women (and men) and enhance their
appreciation for all that they do and all they have to do. (Junge 2004)

Anti-racism and anti-semitism: Equality for both men and women

From my childhood and my days in the ghettos of San Diego and the barrio
of East Los Angeles, I have spoken out against inequities. But, during my
doctoral studies at the Fielding Institute around 1990, another student, a
faculty member, and I successfully integrated a program faculty. We did this
by finding well-qualified people of color, shepherding them through a fairly
laborious process, and working the system well enough so that, when the
to-be-expected resistances of "qualifications" and "fit" emerged, they were
dispelled. It was almost a full-time effort, and the president of the institution
worried that I would never get my degree. This change in faculty composi-
tion was a downright threat to the status quo. When one group gains power,
another generally loses. A white male faculty member attempted to head off
this shift: "If more women come as students and as faculty," he said, "then the
men will stop coming." Although it is my assumption that most people are
well intentioned and do not see themselves as racists, American culture today
is rife with internalized racism and unconscious stereotypes. Derald Wing
Sue (2001) states:

> This is precisely why it is difficult getting White folks to realize that
> their attitudes, beliefs, and behaviors may oppress and hurt others.
> Because they experience themselves as moral, decent, and fair-minded
> individuals, they find it intolerable to view themselves as oppressors.
> (p.48)

In my last five years in Los Angeles, I worked in the AIDS-HIV medical
practice of Dr. Michael Scolaro. Supporting my gay son's community, I did
art therapy with Scolaro's male patients. During this time, I wrote my article
"Mourning, memory and life itself: The AIDS quilt and the Vietnam
veterans' memorial wall" (Junge 1999).

However, a white woman who tries to act as an ally to oppressed groups
is often called names and oppressed herself. Recently, I was accused by
members of my profession of promoting another "form of exclusion" by

limiting my focus to certain minority individuals who were pioneers in art therapy. As a white female member of an anti-racism team of diverse people, I was excoriated. This reaction indicated that it was "safer" to lay abuse on a white woman than on other members of the team such as African-Americans. In my opinion, white women still have less power than many others have. For example, I was offered my first job, after graduating as a social worker, on a psychiatric ward at a general hospital in Los Angeles. Almost as quickly as it had been offered, the job was rescinded because I wasn't a "minority." To do social action work takes a particularly thick skin and the drive to go on in spite of everything.

To be fair, it is my opinion that there is also a good deal of anti-male sentiment in the land on the part of women and women teachers, and that this is one reason why we have so many boys today with the diagnosis of ADHD. We have all suffered, and we display our wounds in our interpersonal and intrapersonal relationships.

But some have suffered more.

The art therapist and the art therapy client

It has always seemed to me that a good therapist has to understand the existential world of the client as much as possible. I also believe that the good clinician not only understands the client's culture but works in the "real world" to make it a more enhancing and nurturing environment. For example, a good therapist needs to be in contact with a child client's teacher – to listen to her, to support her, and, if necessary, to help her make changes so that the school environment can become a better place for the child. The good therapist always makes the whole client a priority.

Using a systems perspective, the good therapist is a social activist who recognizes the family and the other people and factors that impinge on the client's world as a culture, and attempts to change this culture as well. External events such as earthquakes, tornadoes, hurricanes, 9/11, and movies also influence individual progress. Surely the ubiquity of the culture of television is central, promulgating "role models" whose body images and fictional lives are less than realistic or ideal.

Most art therapists are women (and white women at that). Often clients are not. This dyad poses an interesting and difficult power inequity. The art therapist must help women and minority clients understand the inherent inequalities in the culture, and she must, of course, understand how she might be viewed as part of the power imbalance. This approach is not to

squelch strivings, but to offer a reality that can ease guilt and shame. In the era of rugged individualism, it is all too often the individual who feels shamed, blamed, and guilty when it is the culture that constrains. On the other hand, for an art therapist to think she is like a client, because she may be of the same race or background, is a mistake. People are too varied.

Although a therapist may secretly hope for cultural integration, the reality that most people live in today is still racist. I heard race described once as a "mosh pit" of feelings. This can make doing therapy at all a tricky business. In the past, if an African-American single mother and her kids could not make it to a therapy appointment because she did not have bus money, it was labeled as "resistance." I hope we are past that. But, at a graduate program where I taught after my time at Loyola Marymount, there were two African-American women on the program faculty. Students chronically got their names mixed up and called one by the other's name. I heard one of these faculty members state, "We all look alike to them." Feelings are extraordinarily tender and wounds are often carried on the surface.

I believe that too much clinical work is done individually within the confines of the office or studio walls of the art therapist. Often, confidentiality is used as an excuse. And yet, to be an art therapist is more a "calling" than a career choice. The therapist can keep confidentiality sacrosanct and still reach into the client's world and, through the use of Self, perhaps even change it. Thomas Szasz (1961) and R.D. Laing (1967) argued that the proper response to a crazy world was to be crazy. Whether we believe that or not, certainly we could all agree that there is much wrong with the world and much to be done.

Mentors, role models, influences, and my own writings

Along with my parents and Eula Long, I have been lucky to have had a number of people in my life who have taught me, supported me in my social activism, and shown me the way. Art therapist Helen Landgarten stressed clinical practice with poor clients. One of my social work professors, Barbara Solomon, was the person who told me, "A good change agent doesn't get fired." Sandy Turner, the Quaker community organizer with whom I innovated Operation Adventure, was a fine role model. She also taught me not to practice on my own family or friends. In my doctoral program at the Fielding Institute, Anna diStefano, Charlie Seashore, and Will McWhinney mentored me and taught me much about racism and gender equality. At LMU Virginia Merriam taught me how to stand up for women, and Joe

Jabbra tutored me in patience, perseverance, and kindness. Other influences were Myles Horten and my training in social activism at the Highlander Center in New Market, Tennessee, where I was taught what I already knew: to work in my own backyard and to be a facilitator of change – not unlike the role that is played by a good art therapist. Also influencing me were the writings of Paulo Freire (1995, 2000) and Peggy MacIntosh's (1988) article "White privilege and male privilege: A personal account of coming to see correspondences through work in women's studies." (I had the privilege of sitting in the room with Freire in his last years, hearing him speak, and doing a drawing of him.)

My first book, *A History of Art Therapy in the United States* (Junge 1994), was written out of what I refer to as the "burr in the saddle" syndrome. It was written to right a wrong. I felt that previous histories of art therapy – usually a few pages at the beginning of a clinical book – had focused primarily on art therapists from the eastern part of the US. As a Californian, I knew this was *not* the whole picture. My second book, *Creative Realities: The Search for Meanings* (Junge 1998), was written because of a lifelong embarrassment about how the subject of creativity had been approached. I felt that many authors had simply missed the boat by leaving the art experience out of the equation. To remedy this, I studied creativity through examining different styles of artwork as "maps" of interior creativity.

Although much of my published writing had a social action bent, this became more direct in 1988 when I served on a panel called "Social Applications of the Arts" with Robert Ault, Gary Barlow, and Bruce Moon at the annual American art therapy conference. I focused on the family and stated:

> Many of us in this field, particularly those of my generation, have our roots in the relationship of the arts and social activism. And I would like to suggest to you that the time is now to renew and intensify our commitment to social responsibility as individual art therapists and as a profession… My dream is that in empowering ourselves we can empower others… And my dream is that sometime in the future we will truly be free to dream of the transformative nature of the creative process and of the sweeping power of expression and social change that lies within the arts themselves. (Ault *et al.* 1989, p.18)

In 1993, with Janise Finn Alvarez, Anne Kellogg, and Christine Volker, I wrote "The art therapist as social activist: Reflections and visions":

From a systems perspective, the role of the art therapist as social activist at a time of deep and crucial change for our clients, mental health systems, our country and the world, are discussed. Despite the fact that art therapists, through our artists' identities, are natural agents of change, our education and strivings for professional acceptance mediate against our natural proclivities in this direction. (Junge *et al.* 1993, p.148.)

In 1999, I published "Mourning, memory and life itself: The AIDS quilt and the Vietnam veterans' memorial wall":

Along with the Women's Movement, the Vietnam War and the AIDS epidemic are, I believe, the distinguishing events of the latter half of the twentieth century. They represent two markers of what America means at this unique historical moment... The art therapist provides art materials, a listening heart and mind – and a surround in which suffering can exist but be contained... [The art product] speaks of continuity in the face of loss and death; it represents and stands for a life. (Junge 1999, p.195)

Self-knowledge, truth talking, hope, and courage

A few years ago, with social psychologist Charlie Seashore, I presented to my art therapy students at Loyola Marymount what we called "The Good Girl Workshop." Not just for women, we hoped to address what we perceived as a virtually universal stumbling block for all novice art therapists (and plenty of advanced ones as well). The stumbling block addressed was *the desire to be liked.* This well-intentioned natural inclination, if not mediated against, is a real problem in doing good clinical work and effective social action. The therapist may covertly change his or her approach in order to avoid conflict and anger and to "keep the transference positive." In my view, this is a dire misunderstanding of the therapy process. Anger is a gift and a motivator for change. In our positive "have a good day," "get on with it" culture in which the word "confrontation" has gotten a bad name, we are seeing more of this covert behavior. Even the language has become more positive. For instance, I have no trouble saying "challenge" instead of "problem" and embrace the change in meaning; however, there are still such things as problems – some insurmountable. To pretend that they do not exist is likely to do ill to our clients. I believe the art therapist who aims to be a social activist must be self-aware and comfortable in her or his own skin. He or she must neither shy

away from conflict nor attempt to bury it. "Consensus" is a catch word today that means that all agree on something. This happens seldom, if ever. Sometimes it is the lone voice or action that makes a difference. A student of mine presented me with a mug with the following quote on it by Laurel Thatcher Ulrich: "Well-behaved women rarely make history."

The art therapist as social activist must assume that internalized racism and sexism are everywhere and in everyone, and he or she must still be a "cockeyed optimist." In spite of everything, I still believe change is possible, that the world can be changed for the better. One would hope that the proclivity for and the belief in hope and change are in all art therapists. But this is not as obvious as it seems: I once was in a group with a psychiatrist-in-training who, deep down, did not believe in change; he needed to find another way to make a living. Paolo Freire (1995) wrote:

> I certainly cannot ignore hopelessness as a concrete entity, nor turn a blind eye to the historical, economic and social reasons that explain that hopelessness – [but] I do not understand human existence, and the struggle needed to improve it, apart from hope and dream. (p.8)

The art therapist as social activist must be brave and courageous. It takes a lot to stand up for unpopular ideas and actions. Sometimes there are wounds, and it can be a lonely place. I can remember speaking in a group and hearing my voice shake – I went on. Certainly, a touch of humor helps if art therapists recognize and express the absurdity of it all and can even laugh at themselves. The art therapist who is not afraid of change can become a role model and an influence for others.

Some sage said that to do this work there are three rules: (a) don't push rocks uphill; (b) find a friend; and (c) stay alive. Although I have amended the first rule to "don't push *too many* rocks uphill," I believe these are useful edicts for art therapists. Social activism can be exhausting and energy draining. Therefore, to keep at it, I recommend a "Cuddle Group,"[2] or, at the very least, a friend you can speak with honestly. But social activism is the best work there is because, like the artist's social commentary, it is the art therapist's attempt to change the world so that opportunities are fair and equitable for all.

> Without a minimum of hope, we cannot so much as start the struggle… Hence the need for a kind of education of hope… One of the tasks of the progressive educator…is to unveil opportunities for hope no matter what the obstacles may be. (Freire 1995, p.9)

Notes

1 WPA stands for "Works Project Administration", started by President Franklin D. Roosevelt during the Great Depression of the 1930s to give work to artists and writers.

2 "Cuddle Group" is family therapist Carl Whitaker's term.

References

Ault, R., Barlow, G., Junge, M. and Moon, B. (1989) "Social applications of the arts." *Art Therapy: Journal of the American Art Therapy Association 5*, 1, 10–22.

Cary, J. (1965) *The Horse's Mouth.* New York: Harper & Row (Original work published 1944.)

Erikson, E. (1958) *Young Man Luther: A Study in Psychoanalysis and History.* New York: W.W. Norton.

Erikson, E. (1969) *Gandhi's Truth: On the Origin of Militant Nonviolence.* New York: W.W. Norton.

Erikson, E. (1975) *Life History and the Historical Moment.* New York: W.W. Norton.

Freire, P. (1995) *Pedagogy of Hope: Reliving Pedagogy of the Oppressed.* (Trans. R.R. Barr). New York: Continuum International.

Freire, P. (2000) *Pedagogy of the Oppressed* (20th anniversary edn). (Trans. M.B. Ramos). New York: Continuum International.

Freud, S. (1961) "Leonardo da Vinci: A Study in Psychosexuality." In J. Strachey (ed. and trans.) *The Standard Edition of the Complete Psychological Works of Sigmund Freud.* London: Hogarth Press.

Gardner, H. (1993) *Creating Minds.* New York: Basic Books.

Gruber, H. (1989) "Creativity and Human Survival." In D. Wallace and H. Gruber (eds) *Creative People at Work.* New York: Oxford University Press.

Junge, M.B. (1988) "An inquiry into women and creativity including two case studies of the artists Frida Kahlo and Diane Arbus." *Art therapy: Journal of the American Art Therapy Association 5*, 3, 79–93.

Junge, M.B. (1998) *Creative Realities: The Search for Meanings.* Lanham, MD and New York: University Press of America.

Junge, M.B. (1999) "Mourning, memory and life itself: The AIDS quilt and the Vietnam veterans' memorial wall." *The Arts in Psychotherapy 26*, 3, 195–203.

Junge, M.B. (2004) "The superwoman chair." Unpublished statement.

Junge, M.B. (with Asawa, P.P.) (1994) *A History of Art Therapy in the United States.* Mundelein, IL: American Art Therapy Association.

Junge, M.B., Alvarez, J.F., Kellogg, A. and Volker, C. (1993) "The art therapist as social activist: Reflections and visions." *Art therapy: Journal of the American Art Therapy Association 10*, 3, 148–155.

Laing, R.D. (1967) *The Politics of Experience.* New York: Pantheon Books.

Lorde, A. (1984) *Sister Outsider.* Freedom, CA: Crossing Press.

MacIntosh, P. (1988) "White privilege and male privilege: A personal account of coming to see correspondences through work in women's studies." Wellesley, MA: Wellesley College, Center for Research on Women, Working Paper Series No.189.

Polkinghorne, D.E. (1988) *Narrative Knowing and the Human Sciences.* Albany, NY: University of New York Press.

Sue, D.W. (2001) "Surviving Monoculturalism and Racism." In J. Ponterro, J. Casas, L. Suzuki and C. Alexander, C. (eds) *Handbook of Multicultural Counseling.* Thousand Oaks, CA: Sage.

Szasz, T.S. (1961) *The Myth of Mental Illness.* New York: Dell.

PART II

Acting and Reflecting on the Action

Facing Homelessness

A Community Mask Making Project

Pat B. Allen

Introduction

"Facing Homelessness" was a year-long collaborative effort between West Suburban Public Action to Deliver Shelter (PADS)[1] and Studio Pardes, a private artist-run community studio in Oak Park, Illinois. The goals of the project were to raise awareness about issues of homelessness, to break down stereotypes about who is homeless, and to experiment with art-based social action as a means of creating community and exploring a social problem.

Close to 300 people were involved in creating, exhibiting, and finally auctioning over 100 plaster gauze masks that were uniquely created and embellished. Each participant was interviewed and, in three exhibitions around town, vignettes from each interview were posted next to the mask along with myths and facts about homelessness, and inspirational quotations (see Figure 3.1). The silent auction of masks, along with a spin-off project creating note cards featuring a selection of mask images, contributed to raising over $3000 for PADS programs. Part of the initial funding for the project came from the Oak Park Area Arts Council, which also helped secure two of the public spaces for exhibition of the masks: a community bank and the Village Hall gallery space.

The Executive Director of PADS, Linda Scheuler, and I wrote a grant application to the Oak Park Area Arts Council to fund the project. The grant was modest, covering mostly materials, printing, supplies, and food. There was an enormous amount of in-kind support through the many volunteers. No artists received stipends of any kind. We were committed to asking for public support because we felt this was a project that would directly benefit the whole community by providing art-making activities to a wide range of

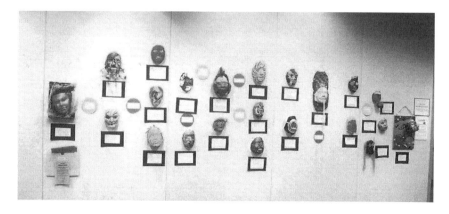

Figure 3.1: Masks on exhibit at Oak Park Village Hall

people at no cost to them. We felt that, even if the grant did not come through, we could probably have run the project by asking for private contributions and donated art supplies. It was in keeping with the philosophy of the PADS program to rely on the goodwill of the community to freely donate their time and effort.

We proposed to invite PADS guests (i.e. those who were receiving services), prominent figures in our community, artists, and the general public of all ages to make masks together. We agreed to interview each person who donated his or her face for a mask, and to post excerpts from the interviews alongside each mask in an exhibit to be held somewhere in our community. Our initial goal was to create 50 masks. By the end of the project, we had created more than double that number.

Part of my motivation was curiosity about the whole model of delivering services to homeless individuals in my community. PADS was originally set up to be an emergency program and yet had recently celebrated its tenth anniversary. As a volunteer, I was aware of the enormous effort involved in the program, which houses and feeds around 40 people each night. The effort of providing sleeping accommodation in a different church or synagogue basement each night, along with nutritious meals and some rudimentary social services, requires the work of hundreds of volunteers. Although I valued the work being done, I also wondered whether by bringing people together in the studio we would gain any insights about other ways to approach the problem. Additionally, I was curious about

whether I could, as an artist, participate in the work and offer something unique.

Groundwork

The amount of groundwork necessary to create a successful collaboration between an art therapist and a community agency varies depending on the existing relationships between the collaborators. Fortunately, Linda and I knew each other fairly well through my prior involvement with PADS. My family and I had all volunteered in many different capacities during the ten years of PADS' existence. To initiate the mask project, we met with shelter guests to discuss the idea. I brought along several finished masks, when we went to the shelter to talk about the project, so that people could visualize the process. Guests were very supportive of the idea of the Facing Homelessness project. They helped us formulate the questions for the interview, and gave advice such as not identifying which among the mask faces belonged to homeless people. They felt it would be more thought-provoking to let viewers wonder, and suggested that the questions in the interview should emphasize the universality of people in a good way.

Next, we ran a two-week pilot session with families from the PADS Transitional Housing Program. These individuals were in more stable situations, having moved out of the overnight shelter. However, because employment is a condition of transitional housing, clients' time was at a premium. Mask making was scheduled during a regular meeting time when people would normally attend a support session at the PADS depot. Out of necessity, due to materials and mess, our mask making took place at Studio Pardes.

During the pilot sessions we learned crucial lessons that shaped Facing Homelessness and clarified our goals. Originally, we wanted participants to cast the masks (donate their faces), exchange masks with a community partner and decorate their new masks. We envisioned an ongoing relationship of at least several sessions between the community volunteer and the PADS client. We hoped that person-to-person contact would break down stereotypes, initiate a dialogue, and possibly even yield ideas of better ways to serve the homeless members of our community. When only four of the original transitional housing participants showed up for the second session a week later, we revamped the idea to permit one-session participation. This allowed us to shift our focus to overnight shelter guests. Because plaster

masks need to dry and cure, a one-time session could only accomplish the first stage of the mask process.

A PADS board member, who is a lawyer, developed the consent and release forms, which went through many revisions to make them as simple as possible. We wanted guests to be able to receive the proceeds of the sale of their work if they chose to, but realized we would have to make that option available to every participant, which we did. A very small percentage of people asked to receive sale proceeds – an equal number of guests and others.

Recruitment was a constant aspect of the project. We created a "Donate Your Face" flyer and posted it around town, mailed it to the PADS volunteers and supporters, and sent it to local newspapers for coverage. We cast our first half dozen masks and conducted interviews. We set up a table with a sign-up list at the PADS end-of-the-season banquet. We brought a large poster with sample masks, flyers about the program, and a list with time slots for people to sign up to have their face cast.

The project
Donate your face

Casting the mask was the first stage of participation. We streamlined the process to take under one hour. The first masks were made at the First United Presbyterian Church, the Thursday night shelter site for PADS. We collected about 20 masks there over 4 weeks. At the same time, a letter went out to all PADS volunteers, staff, and supporters, describing the project and urging them to call the studio to make a time to come in and donate their faces. We usually had two artists casting masks and sometimes other volunteers conducting the interviews. A one-shot opportunity meant that all paperwork, release forms, and interviews had to be completed in one session. The interview was used as a get-acquainted time for artist and face donor, and the formality of the consent form was finished first so that the more intimate encounter of making the mask could take place in a relaxed way.

Once the PADS shelter season was over on May 1st, mask making was scheduled at Studio Pardes every Saturday and one afternoon and one evening per week. When summer arrived, we also attended the PADS summer picnic and cast a large number of masks in the park on a beautiful sunny day (Figure 3.2). Flyers were posted in the studio windows and around town to encourage participation. Visitors to the park were invited to join in.

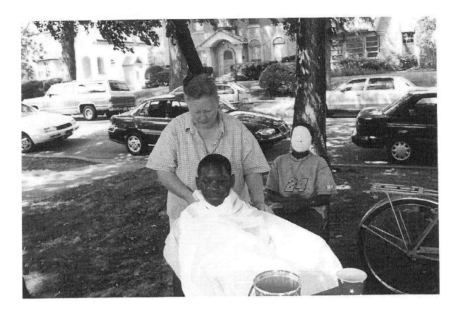

Figure 3.2: Mask making in the park

Materials and process

Plaster gauze face-cast mask making is a simple, low-cost art task that offers many exciting possibilities for aesthetic, decorative, and personally and emotionally meaningful creative work. Almost always, face donors ended up feeling relaxed and rejuvenated after the mask experience. We usually had quiet music playing in the studio and offered a cup of tea when we were done. We always had examples of masks on display to spark interest.

Consent and release forms are absolutely necessary for such a project if the object is to photograph, display, and auction or sell the masks. By definition, legal documents can be intimidating. The text of the forms was read aloud when necessary to participants with literacy issues so that terms and conditions were clear. Participants were offered the option of receiving any proceeds from the sale of their masks or of donating any profit to PADS. Consent forms were signed in duplicate or photocopied with a copy given to participants if they wished or, in the case of homeless persons, kept on file at the program site where they received service.

Many of those who donated their faces expressed how relaxing and nurturing it was to experience being touched in the process of mask making, and to receive such concentrated attention. Some of our homeless guests stayed in the drying phase for an hour or more, enjoying the meditative

quality of being cared for and watched over in this gentle way. Several clergy who participated as face donors actually fell asleep and later remarked it was a rare moment of relinquishing their professional "face" and truly coming to rest. For one volunteer, the act of applying the plaster to the face of a homeless man was an extraordinary act of service. She felt touched by his trust, and by an intimacy and love that deepened her overall experience as a PADS volunteer in the shelter program.

We invited and encouraged all face donors to come to scheduled open studio drop-in times to choose and decorate a mask donated by someone else. This contingency challenged our original vision of having ongoing interactions in the studio between homeless and housed individuals. We had scheduled one of the drop-in times to coincide with the ending of the PADS summer lunch program that met at a church not far from the studio. However, only a handful of guests were interested in a regular studio visit, even when transportation was provided. Many were happy to donate their faces when we brought our supplies to the lunch program, and so we collected more masks there throughout the summer.

Instead of the one-to-one exchange we had originally envisioned, participants who chose to decorate a mask would select one from an array displayed on a clothesline strung around the perimeter of the back wall near the ceiling of the studio. Each mask, along with a copy of the release forms and the interview, was contained in a plastic bag affixed to the line with a clothespin. The embellisher of the mask then read the interview for inspiration about how to proceed to turn it into a work of art that honored and respected the face donor and served the goal of the project. We found people very excited, moved, and inspired by the interviews. Reading the interview form – the final question of which was "How would you like to be seen by the person who decorates your mask?" – helped each embellisher have a clear intention to fulfill the wish of that person. In most cases, the embellisher and the person whose face had been cast in the mask did not meet.

Because our goal was wide participation, we recruited families, children, and teens as well as many adults who do not ordinarily consider themselves artists. The interview bridged that gap and transformed their efforts into an act of service. The embellishment became a meditation on a person and an entry point to thinking about being homeless or being housed. This helped clarify how to meet our goal of breaking down stereotypes and raising awareness about issues of homelessness. As the project developed, some of

the initial face donors encouraged other shelter guests and volunteers to participate as either face donors or mask makers. We did experience moments when all roles dropped away and we became artists together in the studio – for example, when a homeless man interviewed and applied the plaster for the mask of one of our village officials. This was the fulfillment of a goal of the project and one of the amazing possibilities inherent in making art in community: our common humanity revealed, amplified, and celebrated.

Embellishing the masks

Painting and decorating masks is fun and exciting, but it is very important, before beginning, to set clear goals for the finished masks. There was no question that masks decorated by professional artists auctioned for the highest prices. In many cases, masks that were embellished by children or artistically unsophisticated adults had charm and energy. A parent was proud and happy to buy a child's mask for a few dollars as a memento of a fun and significant learning experience. Many people bought the masks of friends or family and gave them as gifts. But, overall, masks created by locally known, professional artists had a visual power that surpassed the personal element (Figure 3.3). We chose to have a mix of people and to try to achieve several goals in a balanced way. We felt that, even if some masks did not sell, they could be either hung at the PADS depot or made into a teaching tool for

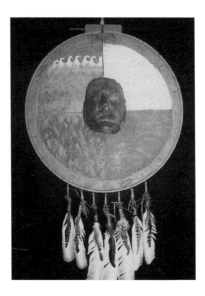

Figure 3.3: Mask titled "Local Warrior" by John, Township Youth Services Director

speakers from the agency who go to schools and other sites to raise awareness about homelessness.[2]

Most of the masks were embellished at Studio Pardes. All the necessary materials and tools were available, including access to sinks for cleaning up and opportunities to display finished masks to inspire creativity in newcomers. The professional artists who were invited to participate all took the masks they chose to their own studios to work on them. Had we used only professional artists, we would have greatly diminished the community participation aspect of Facing Homelessness.

Documentation

All masks were photographed with both print and slide film in order to provide images for illustrated talks, publicity pictures, and, as it turned out, a set of note cards. The documentation was done by Studio Pardes staff and interns. One mask by a PADS guest was chosen as the image for a postcard invitation to the final show and silent auction.

PADS staff created a spreadsheet database that collected all the names and contact information for all participants in the show, face donors as well as mask embellishers. They kept track of who had chosen to withhold permission for use of their images in publicity in addition to who wanted to receive remuneration if their masks were sold. This was a crucial resource when the time came to send out invitations and to generate bid sheets for the silent auction.

Exhibition and publicity

Once the masks were embellished, they were wired and ready to hang. We went through all the interviews to create vignettes by excerpting segments of the interviews. Our goal was to present the humanity common to all those who participated. PADS clerical staff typed a card for each mask with the names of both the face donor and the artist along with several excerpts from the interviews. We also prepared two other pieces of text to intersperse with the masks: "myth/fact" cards, which stated a common assumption about homelessness along with countervailing fact, and cards with an inspirational quote related to helping others from a source such as Martin Luther King, Jr., Mother Theresa, or the Bible.

We conceived of three exhibit sites to serve the goal of community education. Exhibits were scheduled both to coincide with Homelessness Awareness Month as well as to build interest in our final showing, a silent

auction fundraiser at Studio Pardes. We chose sites with a high volume of public traffic: Village Hall, a bank, and a public library. Bank staff reported that most customers spent considerable time looking at the masks and reading the supporting material. Posters about the final event were hung at each site. Because only a portion of the total number of masks was hung in each site, we hoped to build interest in the final event when all 105 masks would be available to be seen and purchased. We took advantage of any offer to review the mask show and auction – for example, we set up a display at the annual gala of the Oak Park Arts Council with a selection of completed masks, information about how people could get involved, and details about the upcoming events.

Final showing and silent auction

All the masks were returned to Studio Pardes for the weekend in December that coincided with a celebration in the arts district where the studio was located. The masks and bid sheets were hung on the walls and displayed on tables around the room. Studio artists hung the show, which had culminated in 105 embellished masks. PADS staff, experienced with many other auctions and fundraisers, took care of the auction, bid sheets, money, and food. A PADS volunteer, who is a professional cellist, brought a friend and provided music during the opening Friday evening. The auction went all weekend long with a final celebration on Sunday afternoon where refreshments were served and money for the masks was collected. Everyone who had participated in the project was invited to the event and many came throughout the weekend. In addition, because of the overall art district publicity, many more visitors saw the work than might have during an ordinary weekend. The timing of the event at the beginning of the holiday season encouraged gift-buying and generosity of spirit.

On Sunday during the culminating event, the House of Daniel Men's Choir, a group of formerly homeless men, performed their original acapella spirituals. Hundreds of people had been touched by the project and close to $3000 dollars was raised through the auction and the sale of the note cards. All but two of the 105 masks were sold.

An unmet expectation

One of our original goals was to offer a weekly open studio afternoon where, in addition to the mask making, general studio materials would be available to PADS guests following their lunch program at a nearby church. We

planned to open the session to the community at large so that a mix of people could experience the creative process. Although a number of guests came once to decorate a mask and most donated their faces, only two guests became sufficiently engaged in the project to come more often. Frequently, other community members were present making art and, during much of the summer, people were still coming in to donate their faces, a task with which some guests helped out. Saturdays were our busiest times with many drop-ins including college-student friends of our interns and PADS staff, volunteers, and family members.

Most PADS guests had numerous survival issues to attend to such as healthcare appointments, meetings with caseworkers, jobs, or other obligations that prevented regular participation. Once in the studio, issues of competence, feelings of being uncreative, and therapeutic issues surfaced. Making art reminded one man of the child he had abandoned, and the lure of art was not enough to overcome his sorrow or discomfort. Guests routinely expressed gratitude at having a chance to help PADS and to give something back to the community. Some also expressed enjoyment at the chance to relax in a safe space and create, but that reaction often mingled with a sense of needing to keep moving, keep up one's guard. For some, simply navigating to a place off their usual track was a great challenge. Although just a few blocks from the familiar site that offered a daily lunch program, several guests were disoriented when leaving the studio and needed help to find their way to the bus stop.

Unexpected outcomes

Although most of the embellishment by community members took place at Studio Pardes, we did travel a few times. We were invited to a class for teens on social justice at our local synagogue. The PADS Director spoke about the shelter program, and I provided masks for the students to embellish. Trusty cat litter buckets held paints, palettes, brushes, glue gun, rags, and decorative items. We covered the tables with newspaper and had the students work in groups of two or three, read the interviews, and decide how to work on the masks. In the course of less than two hours, the students decorated eight masks. Many of them had been PADS volunteers as the synagogue is a regular shelter site.

During the final months of the project, an unexpected opportunity presented itself. A PADS board member had initiated an unrelated project to make Christmas cards using drawings from the children of the transitional

housing clients. For some reason, this project fell through. Because we had slides of all the masks (many of which were striking works of art), because the board was already in favor of such a printed product and, most important, because we had good paperwork (i.e. release forms from every artist either granting or denying PADS' use of their art), we went ahead with a note card project. Five masks were selected and turned into blank notes and packaged in packs of ten cards for $10. An explanation of Facing Homelessness was inserted in each pack on a small piece of paper. A service club at the local high school packed all the cards, which were then offered for sale at local churches, at holiday bazaars, and at Studio Pardes during the final celebration as well as at other shops and galleries in the Arts District. Although we had not planned to create note cards, it was a great way to extend the effect of the project both artistically and educationally – artist and face donor were identified on the back of each card, and PADS and Studio Pardes' collaboration were described on the insert.

Summary and critique

As an educational and awareness-raising project, Facing Homelessness was a success. Hundreds of people saw the various shows and hundreds of people participated in mask making and perhaps thought differently about what it means to have a home, and who might be homeless, for at least a few moments. As an outreach endeavor to the homeless individuals in our community, it was less effective. In our plan, direct service was considered more of an auxiliary benefit of the project than a primary goal. Although about one-third of the participants were PADS guests, only one attended the final celebration – the event was announced at all the shelter sites and was planned for the afternoon so that it wouldn't conflict with getting to a site to secure shelter. Upon reflection, I realize that the project originated from my curiosity about how we choose to serve homeless individuals in my community and not from any stated need or desire on the part of the guests themselves. Facing Homelessness was designed primarily to meet the goals stated by the PADS administrator: to raise awareness and carry out community education.

Many unexpected moments of connection and insight occurred for everyone involved. I was walking down the street one day and a man I recognized from the shelter program smiled and pointed at me and said, "You're the Mask Lady," which reminded me that not all effects are known. The PADS staff sees ongoing positive effects in a feeling of shared pride and an

enhanced sense of community among staff and guests due to the presence of some of the finished masks in the offices of PADS. The masks serve as a reminder of something accomplished and as concrete proof of community participation.

The best result from the service point of view is that a PADS staff member initiated an ongoing arts program at the Thursday night site, the same church where we had done our original mask making. The existence of an ongoing program means that PADS guests can generate ideas for programs and projects that best serve their interests and needs.

The PADS staff member Kate Woodbury reports that what PADS guests want are concrete, goal-oriented projects. PADS had a very successful Christmas ornament-making project following the mask show. Guests were able to embellish ornaments and give them as gifts to friends and family. Kate observes that such a task allows guests to feel successful and to make something that can be given to another, restoring, if only briefly, a felt sense of dignity. She believes guests need a practical outcome that anchors them in what is going on around them. They are already too haunted by the circumstances of their existence and do not need to be reminded that they are without a home. Art programs that are too overtly "therapeutic" or issue oriented may harm guests by destabilizing them and activating fears and negative internal judgments that impair their functioning, even causing them to withdraw from services.

Facing Homelessness was successful by several measures – raising awareness, obtaining funds, creating opportunities for art making in the community. We, the housed members of the community, are the ones whose awareness needs to be raised, so this result deserves emphasis. Because we are the ones with the most power and resources to affect change in our community, putting the issue of homelessness in front of us has value. I don't know how many others continue to think about the seeds that were planted by the project. It may have been simply an enjoyable distraction for many or most.

I know I came to see how naïve my own expectations were, and I continue to wrestle with questions about how best to use my energy as an artist in the service of the exploration of social issues and social change. As artists engaged in practice that brings social issues into public view, we have the power to determine what is represented and the power to re-present new views. This is a large responsibility and one that requires continual awareness and critique of our work. Clarity of purpose and clear intention are the

bedrock of a successful social action art program. Humble recognition that not every issue yields easily to change will help us sustain our efforts as we face and face again iniquity and injustice in the world around us.[3]

Notes

1 The PADS model calls for different congregations to provide shelter one night per week so that responsibility is communally held by the various faith communities.

2 Additional images of the Facing Homelessness Project can be found at www.patballen.com.

3 For further discussion of these important matters, see the following chapter.

Wielding the Shield
The Art Therapist as Conscious Witness in the Realm of Social Action

Pat B. Allen

Art therapist as witness

Here is what I imagine as the ideal role for an art therapist in community art projects related to social action, social justice, or in the language of the Rockefeller Foundation, "cultural work" (Adams and Goldbard 2001). First, she moves in, takes up residence in the problem. She joins with the experts who are working on the issue at hand, the scientists who understand the biology of the die-off of the reefs, the political scientists who have tracked the tribal warfare, or the economists and sociologists who are working to redefine the role and power of the corporation in daily life. She sits with the research oncologists, environmentalists, and public health physicians who are aware of how we are creating conditions favorable to cancer in our everyday life. She joins with the priests and rabbis, the ministers, monks, and imams as they design rituals to support this work of facing and understanding what the true state of the world is today. She sits in meetings with the grassroots workers who provide shelter for the homeless or with those citizens who seek to address teenage drinking or toxic waste dumps in the neighborhood or other local issues. She puts her ear to the keyhole, sleeps on the floor, and dreams her way into things. She listens to the silence between the sentences spoken by those in every field, to those who are angry, to those who believe they know the answer, to those who are seen as culprits, to the victims as well as those who are designated recipients of service. She takes account of all stakeholders.

She herself has no agenda, no preferred outcome, but the highest good for all involved. She has swallowed and digested all her knowledge and

training; she leaves the names of diseases and the cant of social problems outside the door. She takes no rhetoric, no ideology, only her paints and her canvas and her naked soul. She listens, watches, and has conversations. She makes no plans, no interventions, no diagnoses, no grant proposals, no ten-point programs. She makes marks and she waits patiently for them to speak. She lives in the midst of the problem as an artist, a visionary, a conscious witness, a mendicant. She does not come to change things but to get to know them. She does this by creating images in response to her experience of the conversations around her. She midwifes the images that the soul of the world, *Anima Mundi*, sends to her.

Maybe she paints portraits of children who have been labeled delinquent, and these reflect back to them and to their community how, when the light falls on their faces, she sees God there. Maybe she walks slowly through a violent neighborhood day after day and photographs details of beauty. Maybe she creates an exposé of miracles. Maybe she collects found objects and installs them in the center of town, inviting others to join her and meditate on the items that have been discarded along with their stories. With the neighbors in an affected area, she creates a ritual for a park after the utility company cleans out the toxic chemicals found in the soil. She is a companion in the journey, a mirror, an informed witness. She receives images that offer commentary, bread crumbs marking the trail. She offers these gifts alongside the graphs of the scientists, the reports of the experts, and the charts of the doctors. And when these people are finished speaking, she invites them to join her to make images with her in the studio where she has hung the paintings that their work has called forth from her hand. She reflects back to community members in color and form the nature of their beliefs about the state of the world. And she receives images that tell her what *Anima Mundi* wishes to share. She makes those available to the others working alongside her. She initiates a call and response with *Anima Mundi* and all of us who are engaged with it.

Advocacy

Mary Watkins (2005), archetypal psychologist and disciple of James Hillman, has said, "Advocacy – what in other contexts might be called 'activism' – flows from noticing and the erotic connection it engendered" (p.6). In other words, the job of the activist is to connect with what needs activating, with what has been pushed outside the margins and silenced while listening

carefully to the silence that is charged with unspoken truth and giving it form through the image. Watkins continues:

> From the perspective of archetypal psychology social activism can be grounded in noticing, reflecting, seeing through, in reveries and in dialogue. Pathology is not overridden by premature eradication but listened to with patience and insight. (p.14)

This "seeing through" that Watkins posits lets the surface definition of a problem soften and yield its multiple dimensions to our embrace. Seeing through initiates a dialogue. The first step is for the art therapist to listen to herself to notice what calls for her witness. Where should she pitch her tent, her mishkan, the portable sanctuary she creates whenever she holds the space for images to arrive? Therefore, in her training to be a socially engaged artist, she should have been given ample time to make art in response to those stories, situations, and world sufferings that speak to her. She is not asked to design treatment plans or set goals but rather to give form to that which is waiting to be known, to see her way through to dialogue. Her contribution may be to the community soul, activating new pathways for those who are engaged in the day-to-day work to meet each other in new ways. Perhaps she holds the space where others connect:

> Attentively noticing the world, we find ourselves particularly attuned to certain issues, problems and situations. As though singled out by our temperament, history, wounds and passions, particular aspects of the world soul call us to them. The path of individuation is in part a fine tuning to the ways in which we are called and obligated. (Watkins 2005, p.15)

Art therapist as social activist

Art therapists are used to working with individuals and groups. But what does the art therapist do when confronted with the poverty, violence, or despair in which her client is located? Typically, she offers art as a respite, a momentary pause in an awful reality. She offers to stand with her client in his pain, to be present. If she is ambitious, she may seek the cause of distress in the images made in art therapy. She may offer insight: who is at fault? What can be changed? Remove the child from the home, increase the depressed woman's medication, sign the bully up for karate after school. Like most therapists, the art therapist will locate the source of suffering within the individual life of the person before her.

Joanna Macy (1991), Buddhist scholar and long-time social activist, has worked extensively with the feelings of despair that arise when the state of the world in which therapist and client are situated is authentically encountered. She has said:

> Psychotherapy, by and large, has offered little help for coping with these feelings, and indeed has often compounded the problem. Many therapists have difficulty crediting the notion that concerns for the general welfare might be acute enough to cause distress. Assuming that all our drives are ego-centered, they tend to treat expressions of this distress reductionistically, as manifestations of private neurosis... Such therapy, of course, only intensifies the sense of isolation and craziness that despair can bring, while inhibiting its recognition and expression. (p.19)

As a social activist, the art therapist must widen the lens of her vision. She must see the context of the person who is depressed: lack of health insurance, unemployment, divorce, chronic illness related to stress or environmental factors, fragmentation of families and their extended support systems due to the underlying despair that Macy talks about. If she is working within an institution, she must take into account the illness of that institution, not merely that of those individuals in her care. She must accept that her presence there as a caregiver does not inoculate her against the pathology of the system. If anything, her use of image making renders her more aware of systemic dysfunction even as her relatively low place in the hierarchy mutes her voice in institutional discourse. She must accept that the context defies her offer of paint and clay, and yet she must not turn away. She must accept the complete inadequacy of paint and clay to solve anything, and she must submit to paint and clay anyhow. For these tools are her passage to the place of all possibilities. These are her path to the imagination and hope. Here she can fall apart over and over, dissolving her resistance to her grief and strengthening her ability to say yes to life again and again – not merely on behalf of her designated client but on behalf of the institution and, most importantly, on her own behalf.

The art therapist as activist is not the "can do" American of our dominant myth who charges in, rolls up her sleeves, and pitches in, painting a rosy glow over all she sees. Instead, she must be willing to be in the paradox that, on one hand, making art is ridiculously inadequate, and, on the other, making art in service to the pain of the world is necessary. Macy (1991) said:

Recognizing the creative powers of imagery, many call us today to come up with visions of a benign future – visions which can beckon and inspire. Images of hope are potent and necessary: they shape our goals and give us impetus for reaching them. Often they are invoked too soon, however. Like the demand for instant solutions, such expectations can stultify – providing us with an escape from the despair we may feel, while burdening us with the task of aridly designing a new Eden. Genuine visioning happens from the roots up, and these roots for many are shriveled by unacknowledged despair. Many of us are in an in-between time, groping in the dark with shattered beliefs and faltering hopes, and we need images for that time if we are to work through it. (p.25)

Grappling with despair

I found myself stunned when reading Macy's words just a few months after closing my community studio, Studio Pardes. The word *pardes* means garden in Hebrew and, in the mystical tradition, refers to the Garden of Eden. I founded the studio as an oasis, a sanctuary, intending it to be a place for those who needed to be replenished to come and make art together. I did this because that was my need, to be replenished after six years of working with two other art therapists to establish the Open Studio Project (OSP), a community art studio in Chicago.[1]

One of the goals for the OSP was to provide a respite place for social activists to come and clear their vision, commune with the soul of the world. When I felt called to establish my own community studio in my home community of Oak Park, Illinois, I thought the vision would unfold naturally. I thought that, if sanctuary was offered, it would attract those who were doing the difficult work of social change. I thought that I could set up projects, like the mask project Facing Homelessness (see Chapter 3), and that those who were seeking to do the work of building a more just community would simply arrive and join in solidarity to do this work. I knew the process of art making with intention and witness was a powerful way to seek truth and to commune with the soul of the world (Allen 2005). I expected that the kind of activism described by Mary Watkins (2005) would simply manifest:

[It] arises less from egoic intention than from the slow dilation of self that Walt Whitman lyricizes; that rhythm of sympathetic inhalation of the world into the self, and the creative and erotic exhalation of the self toward the world that signals our belonging. (p.15)

I believed that, after witnessing the Self through intentional art making for a while, everyone – or at least some people who recognize the interconnectedness of all beings – would propose projects of social significance for which the studio could provide a centering place and source of support. In the beginning of the Facing Homelessness project, I felt I was attempting to lead the way or, to paraphrase the well-known phrase, to "be the change I wished to see" (attributed to Gandhi no date, paragraph 1).

What I learned was startling and somewhat devastating. I learned that I, along with most of those I encountered in the process, was in the "in-between time" described by Macy (1991), "groping in the dark with shattered beliefs and faltering hopes" (p.25). Yet, like the coyote in the road-runner cartoons, we continued to run at top speed toward our illusions, unaware that we had passed the edge of the abyss and hadn't yet looked down to see that there was no ground under our feet. Over and over, I watched individuals come to the dark places in themselves and in the world, and then seem to back away into images of light and wholeness seeking spiritual relief. To my horror, I found myself resenting the mandalas, the images of light and peace, which often felt cramped and inauthentic. Alarmed by the stubborn judging of others arising within me, I sought the source of my anger and feeling of isolation.

Around this time I returned to realistic oil painting, the art form I began as a young artist many years ago. I painted portraits and still life (Figure 4.1) and simply returned to seeing the beauty of the world and recording it with pleasure.

Although I continued to hold the intention to serve the Creative Source, I was not yet able to see through to what was occurring. As I sat with the work, it yielded very little witness writing – that is, dialoguing with the image and receiving guidance directly from the image (Allen 2005, pp.61–81). The work simply remained silent. Nagging in the back of my mind was the memory that I had felt called to enter a cave-like existence when I left OSP, a call I did not directly heed.

Months before I began to seek a studio space in my town there had been a number of small spaces available, but now there were none. I felt great internal pressure to have a space, and I did not want to leave one place without knowing where I would go next. A space became available that was quite large and not at all cave-like. I found myself again in a public space, a storefront on a busy corner. I assured myself that I wasn't really all that tired. Soon I was actively teaching, curating shows, designing projects, hosting a

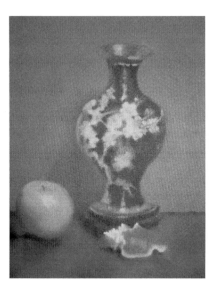

Figure 4.1: Still life

drum circle and a monthly minyan, participating in the politics of the arts district in which the studio was located. In addition, I found myself meeting with all manner of people who showed up on the doorstep or called seeking consultation, help, or collaboration with projects of their own. For the four years I ran Studio Pardes, I continually rearranged things to create a more and more cave-like personal space within the larger studio where classes, workshops, and shows took place. Everything happening was great, exciting, and appreciated; yet I felt a gnawing unease.

One day I happened to reread the brochure I had written that described the mission of the studio: "to provide a place to replenish the soul." For four years the studio had done just that for many people and, to some degree, for me as well. However, during those four years, I had been recovering from my separation from OSP, the transition of my only child to college, and my husband's dark night of the soul and career change that for several years challenged the continuation of my marriage. I continued to write, teach, and make art. Although the studio process held all of that and more, it was impossible for the cave-like state my soul was requesting to manifest amidst all the other activities and responsibilities.

The Facing Homelessness project with its many demands had finally surfaced all the residual fatigue from the life changes I had been through. I was forced to face the paradox that, although the work was exciting, was

succeeding, I was too often feeling overwhelmed and empty. Like many of the other studio artists I saw around me, I, too, had touched the pain of myself and the world. I wanted to leap ahead to solutions to larger issues without dwelling deeply enough on these issues and their images. I did not grasp the scale of time necessary to really think about homelessness, for example.

I could sit for several years in a painful marital transition with the support of the studio process to ground and instruct me. I listened as the images told me to meditate on a tree in a storm; I accepted paintings of myself as a tiny figure riding the enormous energy of the Serpent of Kundalini.[2] I knew how to live through the "groping in the dark with shattered beliefs and faltering hopes" on a personal level, and trusted that I would be led through the storm. But, when I sought to engage with the world, in effect to open the lens of my vision a few stops more, I neglected to notice or employ the rawness and vulnerability that had been created in me through the life changes I had undergone. I expected to simply set a goal and achieve it.

In every aspect of the Facing Homelessness project, I was confronted with the fact that it wasn't just the homeless individuals who were suffering and the other participants who were somehow not suffering and had the resources to offer help. Although I knew this on an intellectual level, I finally discovered that my underlying belief still was one of separation. Instead, I realized that all of us who were involved were in need of the same things: to be held and seen, to be affirmed and welcomed by the studio and the art-making process. All of us were living life as best we knew how. Watkins says:

> The imaginal registers and amplifies the calls of the world, awakening us through image and perception to what suffers and what is beautiful. With exacting specificity free arising images convey the way the soul perceives the daily realities we live amidst. Through its stark renderings, the imaginal cuts through our denial, dissolving our distance from grief and loss. (2005, p.17)

Finally, I was delivered to the shore of grief and loss, if not yet into its sea. I received an image that set me on the road to understanding my own denial, the denial of my own homelessness. My sense of unease was strong enough to make me stop and take stock at the end of the project. For a year, I sat with my sense of failure. In spite of all the positive aspects of Facing Homelessness, I felt myself blind to something essential. Something felt hazy and out

of reach. I interviewed many project participants, especially the staff of the homeless program with whom I had worked so closely. Seeing the work through their eyes, I located some clues about my distress and could release the notion of success. There were several strands of the work that had become entangled.

One strand was the provision of direct service. As an art therapist, I felt uneasy that I had not done more direct work with homeless people, even though the primary goals of the project were raising awareness and providing education. This strand in fact was addressed when a staff member began a weekly art program at one of the shelter sites. Her participation in Facing Homelessness had kindled the spark of her own creativity. I could then say, "Okay, that strand, while important, is not mine."

A second strand involved a breaking down of an illusion in my mind. I had imagined that those in a position of power in my own town could take action to end homelessness but, through ignorance, were dealing with it at times in an inhumane way. This issue shifted for me as I worked with clergy and public officials and recognized that their experience of the mask-making process simply met their *own* need for respite and recognition. They had their own fears of art and reluctance to risk. The universal joy at seeing themselves in the finished masks broke my heart and activated my compassion. I recognized that I had been harboring unreal fantasies of the location of power when in fact our goal had been to show the common humanity among our community members, housed and homeless. I had been acting as if being housed or having a position of responsibility conferred a particular set of values and powers. As I examined certain experiences that had led me to create Facing Homelessness, I became clearer still about the source of my failing.

One of the experiences that had initially inspired me was a news story in a local paper citing the purchase of new benches for a public space. The benches were constructed with a divider to make stretching out on them uncomfortable. It was stated matter-of-factly in the article that these benches were chosen to discourage homeless individuals from occupying public space. I literally felt weak at the knees reading that article, yet I did not protest; I did not write a letter to the editor. I now see my lack of response as denial of grief.

The second event that inspired me was the decision by our local arts council to spend several thousand dollars to rent a piece of sculpture from one of the international art fairs in Chicago and install it as public art.

The council did not have a sufficient budget to buy a large piece outright. The piece chosen was a carved stone sculpture created by an artist from New Zealand. Costs included cleaning and eventually shipping the piece back to the artist at the end of the rental period. It seemed ironic to me that the piece was meant as a meditation on space. The installation site was a few yards from the mall area of town where the uncomfortable benches were also placed. I was angry about this decision, believing that the money would have been better spent on programs for community members to make art themselves.

Again, I did not protest. Instead, thinking I was creatively channeling my disappointment, I engaged with the Public Action to Deliver Shelter (PADS) program director, co-wrote a grant for Facing Homelessness and presented it for funding to the same arts council. I did not reference the sculpture but I did hold out an alternative definition of public art that included the public as participant and not merely as spectator in the creation of culture. At the same time, I attempted to leapfrog over my anger and shame, my bewilderment at the feeling of being a member of a dysfunctional community that takes pride in making it hard for people to sleep on a bench or present an inconvenient image in public.

Here Joanna Macy (1991) offers help in untangling the strand that I had wound around myself to separate me from my unfeeling fellow citizens.

> Thanks to his teaching of the radical interdependence of all pheno-mena, the Buddha set compassion in a context that extends beyond our personal virtue; it affirms the basic nature of our existence. He taught that social institutions co-arise with us. They are not independent struc-tures separate from our inner lives, like some backdrop to our personal dramas, against which we can display our virtues and courage and com-passion. Nor are they mere projections or reflection of our own minds. As institutionalized forms of our ignorance, fears and greed, they acquire their own dynamics. Self and society are both real, and mutually causative. They co-arise or to use Thich Nhat Hanh's phrase, they "inter-are." (p.96)

The third and final strand had to do with my confusion about my identity. Who was I in relation to my community? An artist? An art therapist? An entrepreneur? A social activist? At times I functioned in any and all of these roles but without sufficient discriminating awareness. On some level, I was attempting to enlighten people while feeling quite separate, even superior. I *was not* like these people who despise the homeless. As we become aware of

the messy and uncomfortable feelings that becoming engaged in the world arouses, we must recognize our natural response to them. Some will deny through withdrawal into a circumscribed life, seeking an idealized surrounding where evidence of social problems is muffled:

> We can never avoid what we seek to escape, least of all the political and economic institutions into which we are born. But by virtue of their dependence on our participation, by vote or consumption, lobby or boycott, they can change. They mirror our intentions, our values and ideals. (Macy 1991, p.105)

Others, like me, will become active through an act of will, trying to avoid the step of falling apart. Yet Macy (1991) reminds us that we must work to realize that "going to pieces or falling apart is not such a bad thing. Indeed it is essential to evolutionary and psychic transformations as the cracking of our outgrown shells" (p.22). Still, to be active in the social realm means being acted upon as well:

> As doer is indeterminate with deed, modified by his own thoughts and actions, so are his objectives modified. For, however he articulates these objectives, they reflect his present perceptions of reality – which are altered, however slightly, by every cognitive event. Means are not subordinate to ends so much as creative of them – they are ends in the making. (p.105)

As an artist, therapist, and teacher, I am used to being able to construct my own reality – within certain bounds, of course, but with a great deal of freedom. I was surprised to find out that the aggregate of energy in some ways determines what can occur. In the realm of social action, a great deal of the necessary work involves building social and relational capital on a wide if not deep scale (Putnam 2000). This is far different from the relational capital of a therapist who builds deeply with a few people. Without a wide constituency, social projects cannot go forward. As an art therapist, it was difficult to modulate the level of engagement; my expectations of others were not in line with reality. I essentially projected my dreams and aspirations onto those with whom I had built modest relational capital as if they were collage elements in one of my art pieces. Volunteers in the mask project were delighted to participate in the activity as offered, but it did not arouse in them a need or desire for a deeper engagement with ideas about how to end homelessness, my personal grandiose and hidden agenda.

Toward resolution

Finally, all events led me to a place of profound disappointment, grief, and feelings of helplessness. I made my intention to understand myself as an artist in relation to community. Figure 4.2 emerged. In this image, a house speaks to a fool, a man of "disparate parts." I asked these images to speak to me.

> *House*: I am welcoming him home. He was off on a quest to receive his shield, now his disparate parts are not desperate. One cannot enter community without a shield. One cannot come in too open, too exposed or the rest of the group will tear you limb from limb. It is just a fact, not a failing. Human beings are hungry, and they will eat you. You will eat each other. I am a structure. I happen to look like a house because that is a structure that you understand, and a home is a good metaphor for community. But most people are homeless, if not literally then figuratively. If you show up looking like a house, they will move into all your rooms and eat your food and sleep in your bed. They will drop their socks on your floor. You cannot be a house. This poor guy is a little like a dunce; he isn't even a house and he invites everyone in until he can't stand it and has to fly away. But he isn't really a bird. He needed to go away to receive his shield.
>
> *I say*: House, I notice you do not have a door.
>
> *House*: That is correct, I told you, I am not really a house. I am an idea. Another idea is a shield.
>
> *I say*: Why? Shouldn't community be about putting down your shield?
>
> *House*: No, that is where you are mistaken. This shield concentrates power and mirrors it back to others; they can see themselves in its reflection and bask in its glow. Then they do not have to eat you alive. Creative works are shields – sometimes you can transform into a house, a boat, an oasis or a whip, a cave, a closet, a grassy hill, an ice cream soda – but you must be sure to know how to keep changing back into nothing. That is what the shield is for.

I did not have a shield. I did not take time to be a conscious witness to my own feelings about being a citizen in my community. I created a project about facing something from an intellectual place as if I knew something that others did not know. In fact, I did not know who I was. As I reflected on these matters, I remembered one of the men who became involved in the

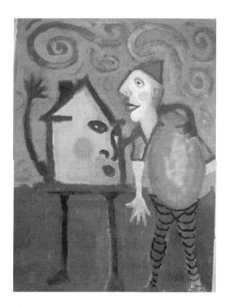

Figure 4.2: House and Fool

Facing Homelessness project. One day he asked me for a ride to the bus stop. Then, at the bus stop, he had no fare. A few days later, I saw him in the park and he needed money. He became one of my teachers of the shield. I entered into this work without sufficient preparation. I did not have a shield and was experimenting with my identity. Who was I, a therapist, a friend, a fellow artist, simply someone with more resources than someone else? It isn't possible to be all things or everything that anyone may want in real life as it is within the imaginal realm. Having the image process provides a shield that must be used with discernment both to mirror and to protect. One cannot be in the cave and on the street simultaneously. Perhaps the cave is where the shield is fashioned, the street where it is wielded.

Yet, Rabbi Tarfon (Telushkin 1991), the second century Jewish sage, says we cannot refrain from work in the world because it is too big for us to finish. Neither can we wait until we are ourselves complete, for it is in engagement with the world that we are completed. Periodic cave time with substantial reflection must precede and follow engagement in the public sphere. Using our shield to reflect reality to those around us is an artistic martial art. Before we enter into such work, we must chart the dark and grief-filled places, map them and dwell there. We must also remember to dwell in long time, remembering our heritage as atoms in the creation of the

universe, not merely the particular form we happen to take in our present life. When our work changes, we must take time to forge the appropriate shield to serve that work. Finally, we must periodically turn the shield toward our own face, gaze into it, and see who gazes back.

Notes

1 The Open Studio Project (OSP) moved to Evanston, IL, in 2000. Art therapist Dayna Block is the Executive Director. She has actualized the OSP as an arts and social service agency and continues to teach the studio art process there. For more information, see www.openstudioproject.org.

2 The basic principle of Kundalini in contemplative practice is the holding of energies so that they may dissolve into more subtle forms. See *Yantra: The Tantric Symbol of Cosmic Unity* by Madhu Khanna (2003, Rochester, VT: Inner Traditions). This image is available for viewing in color at www.patballen.com in the "virtual studio."

References

Adams, D. and Goldbard, A. (2001) *Creative Community: The Art of Cultural Development.* NY: Rockefeller Foundation.

Allen, P. (2005) *Art is a Spiritual Path.* Boston: Shambhala.

Gandhi, M.K. (no date) "You must be the change you wish to see in the world." Retrieved 27 February 2006 from www.quoteworld.org/quote/5237

Macy, J. (1991) *World as Lover, World as Self.* Berkeley, CA: Parallax.

Putnam, R. (2000) "Better together: The arts and social capital." *Proceedings of the Saguaro Seminar on Civic Engagement in America: John F. Kennedy School of Government,* pp.1–29.

Telushkin, J. (1991) *Jewish Literacy.* New York: Harper Collins.

Watkins, M. (2005) *On Returning to the Soul of the World: Archetypal Psychology and Cultural/ Ecological Work.* Woodstock, CT: Spring.

PART III

Resolving Conflict

CHAPTER 5

Art and Conflict Resolution

Frances F. Kaplan

Introduction: Conflict with a robin[1]

I've always thought of robins as charming birds, peaceful harbingers of spring that go "bobbin" along and pine for absent mates. But this past spring, a robin assaulted our house and my view changed. Day after day for several weeks, it repeatedly threw itself against the glass doors and the windows that faced the backyard. Thump, thump, thumpity, thump – the noise was both distracting and disquieting. At first, I thought the bird was deranged, and I worried for its health. Then, when it continued this noisy and annoying behavior apparently unharmed, I began to have some "dark" thoughts about how I might persuade it to desist.

Still, I remained intrigued by the bird's attacks. As my speculations about its behavior grew ever more fanciful (it was telling us off for letting our two cats go "bird watching" outside; it was the reincarnation of a dear departed trying to send a message; and so on), I decided it was time to seek more solid information. I started by asking people I knew, who turned out to be as puzzled as I was and tended to attribute the bird's actions to some kind of aberration. This wasn't getting me anywhere, so the next step was to seek out an expert in animal behavior. After a number of phone calls, I came upon an organization called "Critter Control" and finally obtained an explanation.

It seems that male robins are very territorial. During the spring mating season, a robin stakes out his turf and will not permit other male robins to come near. A problem arises (for the robin and for the home owner) when that turf includes reflective surfaces. The robin sees his reflection and reacts to it as though it were an interloper. The only "cure" is to cover reflective surfaces, such as glass in windows and doors and chrome fixtures on automobiles, until the mating season is over. It appears our particular robin was exhibiting normal behavior after all – behavior that had no intended

message for me or for any of the other members of my household. As a result of this knowledge, my anger and confusion dissolved, I had a way of stopping the behavior if I wished, and the robin lived to mate another season.

One of the first steps in the peaceful resolution of conflict is to look behind the obvious and learn what each party *really* wants. In the case of the robin, it was to be free of male competitors; he did not have anything against our house or its occupants. In our case, it was to obtain peace and quiet; we did not have anything against robins as a species and were generally happy to have them in our yard. Sometimes just knowing the truth of the matter is all it takes.

Robins, of course, aren't well equipped for either talking about their motivations or making art. When it comes to people, however, art along with dialogue can be a helpful way to get at the motivations underlying serious disagreements. Indeed, I contend that art techniques can be useful in a number of ways that assist conflicting parties in arriving at mutually beneficial resolutions. In what follows, I build my case by briefly tracing the association of art and conflict with human affairs, and by providing a few illustrations of the application of the one to the other. But first, some definitions are in order.

Definition of terms

Art and *conflict resolution*: "apples" and "oranges"? This question brings to mind a scene in a film that was popular a few years back (Zwick 2002). Two young people from very different backgrounds are getting married. The father of the bride, initially resistant to a union that would connect the groom's dour parents with his ebullient and extensive family, conveys his developing acceptance with words to this effect: "They are apples; we are oranges. We are different, but we are all fruit!"

And so I believe it is with *art* and *conflict resolution*. These are broad and somewhat "mushy" terms, which I will not define in a comprehensive way. I assume that the reader has a general working knowledge of the concepts involved, and I will present only the somewhat specialized manner in which each is used throughout this chapter. When referring to *art*, I do not mean the contents of museum exhibits and public performances created by professional artists (although in certain cases these may qualify), but rather the products of the type of creativity that can be a pleasurable and expressive activity for just about anybody.

Those familiar with the arts therapies will recognize this conception of art as similar to that embraced by the practitioners of these disciplines. In fact, the approach to art making that I will be discussing overlaps with but is not quite the same as an art therapy approach. For one thing, I will give scant attention to the resolution of inner conflict, which is a major focus of therapy. For another, although the information and techniques presented in this chapter may prove useful to therapists, they are also intended for a wider audience, which includes conflict resolution specialists, practitioners of the arts, teachers and students in a variety of fields, and members of the general public. Further, the reader should be aware that, although my examples and overall focus will be on the visual arts (my area of greater expertise), other art forms – drama, dance, music, poetry, storytelling – can and have been used to further the cause of peaceful conflict resolution.

In regard to *conflict resolution*, the emphasis here is on constructive rather than destructive means of resolution. This definition denotes that, although the conflict may involve violence, the approach to resolving it will not. Also, it implies that the resolution will provide a certain amount of satisfaction to all parties involved (i.e. it will be a "win-win"). Moreover, *violence* is used here in the broadest sense as meaning either words or deeds that are hurtful to the persons targeted. To be consistent with human psychology as we now know it, the old playground chant about "sticks and stones" would be closer to the truth if it concluded with "but words can *really* hurt me."

With these definitions in mind, the case for the congruence – or for the "fruitiness" – of art and conflict resolution is ready to be considered. The major evidence comes from the importance of these activities to human bio-logical and cultural development. Both art and conflict resolution have long histories that may even predate the appearance of Homo Sapiens on planet Earth. Not only are they among the class of behaviors that have been cited as "what makes us human," but they can also be grouped with the kinds of human conduct that have helped us to survive until today.

In support of my position and to give credit where it is due, there is precedent for my thesis. I am not the first to bring art and conflict resolution together. Art therapist Marian Liebmann (1996) has edited a groundbreak-ing book entitled *Arts Approaches to Conflict*. Furthermore, the chapter following this one also attests to this precedent. The author, Anndy Wiselogle, is a community mediator who was influenced by Liebmann and had been employing art as a means of introducing others to conflict

resolution before I did so. (I have left it to her to tell you about our eventual collaboration.)

Conflict and humankind

We humans are an aggressive species. We are also capable of a high degree of peaceful cooperation. Indeed, instances of engaging more or less simultaneously in both types of behavior are relatively common. This fact was brought home to me some years ago when the US and the USSR were busy stockpiling nuclear weapons as a means of keeping each other at bay. During this period, my husband and I joined a small group of "citizen ambassadors" traveling to Moscow and Leningrad (now St. Petersburg). Rather to my embarrassment, we all sported large purple nametags bearing the legend "Ambassadors for Planetary Peace." In spite of our grandiose pretensions, we were treated with a wary but generally consistent courtesy during our trip. But it wasn't so much our reception by Soviet citizens that impressed upon me the paradoxical ability of enemies to cooperate; it was the vast amount of technological collaboration that allowed me to speak by phone from my hotel room in Moscow to my son in New Jersey.

The question arises, then, as to why we have so much trouble ridding ourselves of violent tendencies when we are not only capable of scientific and other forms of cooperation but also recognize its desirability for the successful functioning of an increasingly interdependent world. To approach an understanding of the hold violence has on us, it is necessary to explore briefly our species' beginnings.

Evolutionary roots of cooperation and conflict

We share with many other creatures a fight/flight response to perceived threats. This more or less automatic response mechanism has obvious survival value and is part of our biological heritage. But what about more complex behaviors such as cooperative interaction and aggression used for purposes other than spur-of-the-moment defense? Can a case be made that these, too, have a biological base? I think it can.

Cooperation and unprovoked aggression also exist among animals other than humans. Most especially, our closest relatives – the apes – are adept in these behaviors. Chimpanzees, for example, hunt collaboratively, fight each other for dominance, and have even been known to resolve conflict by intervening between combatants within their own group (de Waal 1996). Such actions by our primate relatives suggest that, at least to some degree, both

peace making and aggressive tendencies are built into our genes. What is more, plausible explanations for the advantages they have afforded in the struggle for survival of early humans support this notion.

It is generally acknowledged that early humans lived in small hunter-gatherer bands. And until the middle years of the 20th century, when they had largely dispersed, hunter-gatherers roamed the deserts in remote areas of Africa and Australia (Klinghardt 1998; Peasley 1983). This allowed modern social scientists to study their ways and reconstruct how our ancestors probably lived as well as gaining insight concerning basic human nature. For example, reciprocity was a significant feature of hunter-gatherer social interactions, and apparently forms part of our inherited propensities today (Glantz and Pearce 1989).

Recent-day hunter-gatherers lived by complex social rules that included the equitable sharing of food and other necessities. The antelope or kangaroo brought back by the successful hunter belonged to the whole group and had to be distributed in a prescribed manner. The huntsman (women were generally the gatherers) was required to give up most of his kill, but benefited over time through reciprocal participation in the bounty of others. Infractions of the communal rules for sharing – or any other restricted behavior – resulted in certain painful forms of punishment meted out by the group's elders and calculated to make offenders sorely regret their conduct. (Breaching marital restrictions was considered so serious by some Australian Aboriginal groups that offenders were put to death [Ellis 1994].)

This "tit-for-tat" social structure of hunter-gatherer societies undoubt-edly served to maintain interdependent living among early humans. As a consequence, it ensured that individuals – who would not have survived well on their own – were able to thrive in the demanding environments of their era. Such considerations have led zoologist Matt Ridley (1996) to conjec-ture, "Perhaps Tit-for-tat is at the root of the human social instinct" (p.70). Certainly, one doesn't have to think very hard to realize that we tend to treat with kindness those who are kind to us, and to be less kind to those who are not. This form of behavior can be considered a reasonable approach to conflict resolution within relatively small, isolated groups. Unfortunately, reciprocity has a considerable downside when practiced in our global society.

The origins of non-violent conflict resolution

Burnham and Phelan, in their book *Mean Genes* (2000), have pointed out how our genetic heritage impels us to behave in self-defeating ways in today's complicated world. Pertaining to reciprocity's negative side, they state, "To regulate and earn respect, we punish our enemies and even our loved ones for deviations from friendly behavior" (p.233). And Ridley (1996) has made the problem more explicit with these words:

> When an IRA gunman in Northern Ireland, aiming at a British soldier, kills an innocent Protestant bystander, the mistake can spark a revenge murder of a randomly selected Catholic by a loyalist gunman, which in turn is avenged, and so on *ad infinitum.* (p.75)

Conflict resolution expert William Ury (1991, 2000), on the other hand, does more than identify the problem. He points out what is wrong and then outlines ways to make things right. He has declared:

> Of all the factors influencing the success of a [relationship] … the single most critical is the ability to resolve conflicts cooperatively. The same holds true in every other relationship – between friends or business partners, neighbors or nations. (2000, p.xv)

Along with Roger Fisher (Fisher, Ury, and Patton 1991), Ury can be considered one of the architects of the modern conflict-resolution movement. This movement employs both *negotiation* (the process by which the conflicting parties move toward a mutually satisfactory resolution) and *mediation* (the process by which the conflicting parties strive to reach the same goal with the assistance of a neutral third party or *mediator*). The former is the primary focus here, and the process, in simplified form, includes specific steps for the parties to follow:

1. Identify what you want and why.
2. Communicate the results to the other party.
3. Brainstorm solutions.
4. Eliminate solutions that either of you rejects.
5. Select the solution that satisfies you both.
6. Agree on a plan for implementing the solution. (Adapted from Fisher *et al.* 1991)

These steps are not as simple as they appear. In particular, steps 1 and 3 are two places where people can get hung up. Identifying the true "why" of a

conflict can be tricky, and suspending judgment so that creative brainstorming can occur is almost impossible for some people. As I continue to maintain, art has the potential to assist in overcoming such difficulties. It is now time to view art in context to see how this might work.

Art and human development, past and present

Like conflict and conflict resolution, art has been with us almost from the very beginning (Wilford 2002). It arises from places deep in the brain that until recent times have seemed mysterious, accounting for much of the power that it has exerted over us throughout history. Even though neuroscientists and researchers in allied fields are in the process of dispelling the mystery, art has been such an integral part of human evolution and ongoing development that it undoubtedly retains a significant ability to influence our behavior in important ways. Where this ability comes from and how it can be used for social betterment is still something of a matter of speculation. However, careful scrutiny of what we do know, and the implications of this knowledge, can bring some useful clarity to these questions. Furthermore, the precarious state of our increasingly interdependent world suggests that we should leave no avenue unexplored that has potential for easing tensions at all levels of society, from the interpersonal to the international.

Biological bases of art making

Neurobiologist Semir Zeki (1999) has studied the functioning of the brain's visual system and theorized about the connection with visual art. He defines the function of vision as acquiring knowledge "about the enduring and characteristic properties of the world" (p.5). He points out that the world we see is continually in flux – that we view objects and terrain from different angles, under changing light conditions, and from varying distances. Yet, in order to successfully navigate in our world, our visual systems must be able to abstract, to see the constant in the ever-changing. Zeki conjectures that visual art is an extension of this function because it, too, searches for constancies. Others have come to similar conclusions. For example, brain researcher V.S. Ramachandran (Ramachandran and Blakeslee 1998) has postulated that visual aesthetics is a form of visual training. He has suggested that the artist who portrays the essentials of an image and eliminates excessive detail reinforces the "rules" of the visual system for both artist and viewer.

Anthropologist Alexander Alland (1977) foreshadowed the reasoning of these two thinkers. He proposed that people have an innate aesthetic sensitivity that may have facilitated adaptation for early humans by promoting certain types of sensory discrimination. He can also be credited with planting the seed that art historian Ellen Dissanayake (1992, 1995, 2000) later carefully tended, bringing forth a complex theory of the evolutionary advantages of art making. It should be sufficient here to note a few of the important points that she has made.

First, throughout most of human history, what we today call "the arts" were not separate from daily life. Anyone could and did participate in artistic behavior, which included singing, dancing, poetic storytelling, body painting, and the decorating of possessions. Second, making art was originally a way of calling attention to and reinforcing all that has significance for humankind. Finally, art supported survival by being intimately bound up with ritual. Among other things, rituals served the purpose of strengthening bonds between participants, thus ensuring survival of the group under the harsh conditions of prehistory.

The implication of Dissanayake's ideas is that art has served a major adaptive function for us humans. Not everyone completely agrees. Psychologist Steven Pinker (2002), for instance, believes that art is not itself an adaptation but a by-product of other adaptations. But, in Pinker's words, "Whether art is an adaptation or a by-product or a mixture of the two, it is deeply rooted in our mental faculties" (p.405). Thus, its specific biological origins are of less importance than determining to what extent we can continue to build upon the advantages art has provided us over the eons. Below are three advantages that have especial relevance for the cause of conflict resolution and creating a less violent social order.

Transforming emotions

It is a truism that peace begins at home. The more peaceful the person, the more peace pervades that person's surroundings. It has been claimed that doing or experiencing art of all types can decrease stress and promote relaxation, thereby increasing a sense of peace. And there is some evidence to back this up (Curry and Kasser 2005; Grossman 1981). Certainly, anecdotal reports abound. For example, I recall one of my students relating how doing watercolor painting to music had an especially calming effect on her. What seems to happen in such instances is that a shift occurs in the brain so that internal babble is suppressed while sensory modules are activated. Doing art,

then, appears to be another method of "quieting" the mind – the goal of most forms of meditation. The health benefits for both mind and body of taking breaks from inner rumination have been well documented (e.g. Benson 1975).

Aside from decreasing stress, spontaneous art can often dissipate troubling emotions. I remember a time when I was unreasonably irritated with my husband (it is indicative of the pettiness of my displeasure that I no longer remember what caused it). Instead of choosing to directly express my feelings to him, I withdrew to sulk. Fortunately, I also picked up the art journal I was keeping at the time and began to work on a doodle-drawing – that is, I made some spontaneous flowing lines and began to develop them with color and shape. Suddenly, a cartoon-like face emerged on the right side of the drawing. I identified this as my husband's face and began to laugh because it struck me as slightly goofy. Miraculously, the laughter carried away my irritation and enabled me to put the whole incident into perspective. There was no need to involve my husband in some possibly difficult negotiation process. I was simply able to let the matter go.

More enduring emotions such as chronic anger and persistent aggressive tendencies can also be addressed through art (see the chapters in Part 4 of this book). But, before declaring that art is a panacea, a caveat should be tendered. Like so many other human endeavors, art can be used for good or for ill. In his book *War Is a Force That Gives Us Meaning* (2002), Chris Hedges makes reference to art (songs, films, poems, and so on) as a means of supporting armed aggression. And our experience tells us this is true – as far as it goes. But we must bear in mind that Hedges is talking about the officially sanctioned arts. Within the arts there is another stream; this stream goes underground, sometimes traveling great distances, ultimately to disgorge offerings of truth that are hard to obtain by other means.

An inspiring example of this latter type of art can be found in needlework produced by women in Santiago, Chile, during the dictatorship of Pinochet (Agosin 1987). Plying a traditional craft, these women stitched small appliquéd and embroidered tapestries called *arpilleras* – so named for their burlap backing. But, instead of the usual cheerful depictions of markets, festivals, farming, and so on, the women created scenes of deprivation, death, and torture as well as memorials to family members who had disappeared under the harsh regime. Creating these scenes served as a form of therapy for the women involved and helped to ease their grief. After completion, many of the *arpilleras* also served as a form of communication with the

outside world. They were smuggled out of the country and sold, resulting in some needed income for the artists but, more important, spreading the word about the true situation in Chile at a time when other forms of communication had been suppressed.

Some years back, I was privileged to see an exhibition of these truly amazing creations. Looking at them was a two-step process that tended to set one back on one's heels. My first impression of the little tapestries with their bright colors, semi-detached forms, and child-like compositions was that here were some charming examples of folk art. Then the shock of what was actually being portrayed took hold. The juxtaposition of pleasing form with very disturbing subject matter was shattering. It made me realize that what we call "craft" is by no means a lesser form of art.

The above examples indicate that art can be used to diffuse emotions both prior to and after experiencing the consequences of conflict. In the first example, my doodle-drawing actually obviated the need to engage in conflict-resolution dialogue – as engaging in art activities can sometimes do. In the second, the women of Chile had experienced traumatic national upheaval over which they had no control. Making art about their experiences was a way they could begin to come to terms with what was happening, while also taking some correction action.

Communication

Beyond supporting our survival instincts, art has played a major role in advancing culture through its association with language. Drawings and paintings made by early humans on rocks and cave walls were undoubtedly precursors of written language. Moreover, the same abilities that made visual representation possible may have been involved in the development of language itself. Recent findings in neuroscience are suggestive. Biologist and science writer Matt Ridley (2003) has summarized studies on primates and humans that indicate links between parts of the brain responsible for imitating what one sees, coordinating the hands and fingers, and moving the muscles needed for speech. When we consider that imitation and fine motor skills are involved in making pictures, we are tempted to conclude that drawing and painting facilitated language acquisition for our ancestors. Perhaps the two symbol systems, language and art, co-evolved. And, even if this is not the case, making visual representations may today promote the development of verbal language in the very young and those with language impairments. Concerning this last, there are educators and therapists who

believe this to be so and have marshaled a degree of supporting evidence based on their work (e.g. Eubanks 1997; Silver 1989).

What we can take from this mixture of speculation and discoveries is that pictorial representations appear to constitute at least a rudimentary form of language. This "other" language can be used to replace or extend words. Indeed, for us highly visual beings, it can have an impact that is stronger than words. Brain scans have shown that mental images activate the same neural pathways as images from the external world (Kosslyn and Koenig 1995). This supports what we know from experience: to varying degrees, we respond to pictures as though they were real. (Certainly, advertisers have staked their careers on the existence of this response.)

This ability of art can be especially useful during the first two steps of the negotiation process. Drawings can help each party to "see" the problem from the other party's perspective. It can also be helpful at this stage, or prior to initiating negotiation, for each person to do a drawing from what they imagine the other person's perspective to be. Here is an example:

A woman in an art and conflict-resolution group talked about difficulties with a daughter-in-law and wondered how to approach her. When asked to do a drawing from the younger woman's perspective, she produced a simple yet potent image. It contained a stick figure (the daughter-in-law) in a circle (an island) surrounded by wavy lines (water) pierced by sharp triangles (shark fins). This image displayed a degree of compassion that had not been present initially and that led to a more empathic discussion of the daughter-in-law's behavior.

But drawings being what they are – a means to convey several messages simultaneously – a less positive (and unacknowledged) message may well have been present. Isolated and in dangerous circumstances, the daughter-in-law appeared to have been "put in her place." Still, covert expression of hostility can provide a sense of satisfaction that, coupled with increased empathy, can pave the way to a conflict-resolution process that is more likely to succeed.

Solving problems

Another significant way in which visual art has benefited humankind is its relative permanence – that is, its ability to form a record of imagery upon which one can reflect. Neurophysicist and vision researcher Erich Harth (1993) has stated:

> We imitate reality, first only by producing mental images, pictures-in-the-head, nebulous structures that in their fleeting existence are able to spawn more images. When man learned to externalize images and place them alongside reality, he had taken a giant step. The great paleolithic cave paintings are mental images stored in pigment, thoughts frozen into stone so they can be recalled at will and reexamined. (p.168)

In essence, when people learned to objectify their inner visions, the raw material for invention became available. Planning a dwelling or designing a flying machine would hardly be possible if we were not able to concretize the initial inspiration. Thus, in addition to conveying ideas in special ways, graphic depiction provides the means – sometimes the only means – for certain types of creative problem solving. Using art, then, as part of brainstorming solutions, or of laying out the problem situation in full, has the potential to assist the conflicting parties in coming up with a solution that works.

Years ago when I was leading art therapy groups in psychiatric facilities, I sometimes introduced a problem-solving activity. I asked each participant to draw a problem on one half of a sheet of paper and then exchange drawings with another participant. The next part of the activity involved drawing solutions to each other's problems. Now and again, participants came up with solutions that not only gave something to the originator of the problem but also supplied a helpful hint about what they could do about their own problem. Indirect methods such as this can be very beneficial when parties to a conflict are stuck for a workable solution. Art offers a way to let the less conscious parts of the mind go to work while conscious attention is focused elsewhere.

A concluding anecdote

This chapter and the following one make, I think, a convincing case that art has something to offer the conflict-resolution process. Besides being useful in preparing for and facilitating conflict resolution and for confronting ongoing conflict, art can be helpful in yet another way. The experience of a woman student in a conflict-resolution master's program is a case in point. She told one of my colleagues that she derived considerable benefit from my course on art and conflict resolution. She explained that she had previously thought of herself as lacking creativity, but that the art activities done in class

had awakened a creative imagination she didn't know she had. As a result, she now felt that she had an important new ability that could be applied in her future conflict-resolution work.

Artists and arts therapists of all backgrounds have a tendency to argue about which is more important: the *process* or the *product* of doing art. Whatever the resolution to that conflict might be, there certainly are cases where the message is in the process, *not* the content.

Note

1 I have used this example elsewhere to illustrate why we do research (Kaplan, F.F. [2005] 'Editorial.' *Art Therapy: Journal of the American Art Therapy Association 22*, 2, 66–67). I believe it applies here as well; at the very least, an informal type of research is often needed to effect successful conflict resolution.

References

Agosin, M. (1987) *Scraps of Life: Chilean Arpilleras.* (C. Franzen, trans.) Trenton, NJ: Red Sea Press.

Alland, A. Jr. (1977) *The Artistic Animal: An Inquiry into the Biological Roots of Art.* New York: Anchor Books.

Benson, H. (with Klipper, M.Z.) (1975) *The Relaxation Response.* New York: Avon Books.

Burnham, T. and Phelan, J. (2000) *Mean Genes: From Sex to Money to Food, Taming our Primal Instincts.* New York: Penguin Books.

Curry, N.A. and Kasser, T. (2005) "Can coloring mandalas reduce anxiety?" *Art Therapy: Journal of the American Art Therapy Association 22*, 2, 81–85.

de Waal, F. (1996) *Good Natured: The Origins of Right and Wrong in Humans and Other Animals.* Cambridge, MA: Harvard University Press.

Dissanayake, E. (1992) *Homo Aestheticus: Where Art Comes From and Why.* New York: Free Press.

Dissanayake, E. (1995) "Chimera, spandrel, or adaptation: Conceptualizing art in human evolution." *Human Nature 6*, 2, 99–117.

Dissanayake, E. (2000) *Art and Intimacy: How the Arts Began.* Seattle, WA: University of Washington Press.

Ellis, J.A. (1994) *Australia's Aboriginal Heritage.* North Blackburn, Victoria, Australia: CollinsDove.

Eubanks, P.K. (1997) "Art is a visual language." *Visual Arts Research 23*, 1, 31–35.

Fisher, R., Ury, W. and Patton, B. (1991) *Getting to YES: Negotiating Agreement Without Giving In* (2nd edn). New York: Penguin Books.

Glantz, K. and Pearce, J. (1989) *Exiles from Eden: Psychotherapy from an Evolutionary Perspective.* New York: W.W. Norton.

Grossman, F.G. (1981) "Creativity as a means of coping with anxiety." *The Arts in Psychotherapy 8*, 3/4, 185–192.

Harth, E. (1993) *The Creative Loop: How the Brain Makes a Mind.* Reading, MA: Addison-Wesley.

Hedges, C. (2002) *War Is a Force That Gives Us Meaning.* New York: Public Affairs.

Klinghardt, G. (1998) *Hunter-gatherers of Southern Africa.* Retrieved 22 February 2006 from www.museums.org.za/sam/resource/arch/hunters.htm

Kosslyn, S.M. and Koenig, O. (1995) *Wet Mind: The New Cognitive Neuroscience.* New York: Schocken Books.

Liebmann, M. (ed.) (1996) *Arts Approaches to Conflict*. London: Jessica Kingsley Publishers.

Peasley, W.J. (1983) *The Last of the Nomads*. South Fremantle, Western Australia: Fremantle Arts Centre Press.

Pinker, S. (2002) *The Blank Slate: The Modern Denial of Human Nature*. New York: Viking.

Ramachandran, V.S. and Blakeslee, S. (1998) *Phantoms in the Brain: Probing the Mysteries of the Human Mind*. New York: William Morrow.

Ridley, M. (1996) *The Origins of Virtue: Human Instincts and the Evolution of Cooperation*. New York: Viking.

Ridley, M. (2003) *Nature Via Nurture: Genes, Experience, and What Makes Us Human*. New York: HarperCollins.

Silver, R.A. (1989) *Developing Cognitive and Creative Skills Through Art: Programs for Children with Communication Disorders or Learning Disabilities* (3rd edn, rev). New York: Ablin Press.

Ury, W. (1991) *Getting Past No: Negotiating with Difficult People*. New York: Bantam Books.

Ury, W. (2000) *The Third Side: Why We Fight and How We Can Stop*. New York: Penguin Books.

Wilford, J.N. (2002) "When humans became human." *The New York Times* 26 February, pp.D1, D5.

Zeki, S. (1999) *Inner Vision: An Exploration of Art and the Brain*. New York: Oxford University Press.

Zwick, J. (Director) (2002) *My Big Fat Greek Wedding* [Motion picture]. Burbank, CA: Warner Bros.

CHAPTER 6

Drawing Out Conflict

Anndy Wiselogle

I had been a mediator for a few years when I took a workshop led by art therapist Marian Liebmann (1993) at a conference on peacemaking and conflict resolution. Her workshop inspired me to explore the junction of art and conflict resolution and to develop my own workshop, which I called "Drawing Out Conflict." One Thursday in November there was an uneven number of participants in the workshop, so I had to partner with someone for the exercises. At this point, I had led the workshop several times, and each time I had seen wonderment in the participants' faces at the personal insights they received. That night I had the opportunity to share in the insights by *drawing out* one of my own conflicts.

The Drawing Out Conflict workshop

The first drawing exercise of this one-session workshop is a warm-up, introduced as a way to become familiar with the drawing materials. I encourage participants to draw with the abandon of an eager 5-year-old playing with paper and crayons. I also encourage them to use their non dominant hand to ensure that judgment or evaluation of their representational ability is set aside. The drawing assignment is "squiggles," adapted from Marian Liebmann's (1996) work, an exercise during which one partner makes a squiggle (with no particular definition) and the other completes it. The partners continue to take turns. Each pair has a box of crayons to share and a

> **Squiggles**
> Have fun with crayons and paper! Working in pairs, the first person makes a squiggle, then the second person completes it. Take turns with who makes the first squiggle and continue.

large piece of drawing paper. The only rule is that there is no talking during drawing exercises.

As it turns out, this simple and fun exercise creates trust and bonding between the paired participants. During the silent drawing time, I often hear laughter and then see quizzical faces followed by the transformation that happens when two strangers with crayons evolve into a playful team "dancing" together. This bonding and trust are important for the next drawing exercise.

Draw Your Conflict

Draw a conflict that's bothering you. This can be a conflict within yourself or with another person.

The following exercise is to draw a conflict that's bothering you. Participants are asked to think of a conflict with someone such as a neighbor or someone at work. I ask them not to choose their heaviest family issue but something they're comfortable thinking about in the class. Then participants draw their conflicts in whatever manner they want. This is done individually, each person having her or his own piece of drawing paper and plenty of time to think and draw. Tissues are available because the exercise can stir up sadness and other strong emotions.

That November evening when I needed to be part of a pair, I thought about which conflict I would draw. Should I do something light like the misunderstanding I had with a co-worker that day, or should I take on the unresolved difficulty with my stepmother from childhood? Without time to evaluate, I let my non-dominant hand choose the color and begin to draw. The childhood issue slowly revealed itself. Through my drawing, I got insights about my past situation and how I felt at the time. I was also able to begin to consider how it was for my stepmother as I represented her on the paper. By seeing what I'd drawn, I was able to observe the conflict from another viewpoint. This was incredibly helpful to me. I could begin to understand how the situation was for her, and I could have some compassion.

The next step in the workshop is for people to discuss their drawings with their partners from the initial exercise. Guidelines for these discussions are as follows:

1. Suspend all judgment of your own and others' work.

2. This is a good time to practice active listening.

3. Don't give advice or suggestions.

4. Everything said and drawn in the workshop stays in the
 workshop. Keep confidential what you hear and see.

As the instructor, I don't interfere with these intimate discussions. This gives people a chance to reflect more on their conflict drawings, to give voice to the depicted stories, and to be acknowledged. It also allows each participant the chance to acknowledge another's conflict, thus establishing conflict as normal.

After listening to my partner's description of her drawing, I was able to voice my thoughts and feelings about my own drawing and obtain some validation for my experience. I remember a simple observation she made. She said, "And you've drawn yourself so small." "Aha!" I said to myself. As an adult, I did not have to be the helpless, small child. The fact that I saw myself as disempowered was keeping me stuck. This drawing exercise and discussion loosened the logjam of that childhood conflict and, with more work and reflection, I was able to move well beyond it.

Participants in these workshops draw a variety of conflict situations. "Allen" (not his real name) was a creative artist who loved making music, writing, and other art endeavors. His conflict (see Figure 6.1) was that he spent too much time managing apartments, which was his source of income. The huge apartment building, leaning oppressively inward, was cutting into his art time. However, Allen realized that he needed the income to support his art.

The third and final drawing exercise of the workshop is to draw the personal tools and resources you have for working with conflict. Often there are a lot of blank looks when I give this assignment. "I don't have any resources; if I did I wouldn't be in this dilemma!" But that's the assignment, so people reflect and draw and come to see that they are not so helpless. Just as people who think they can't draw come up with valuable and powerful drawings, so people who think they have no tools for handling conflict end up realizing they possess several such tools.

Your Conflict Skills
Draw the tools, skills and resources you have for dealing with conflict.

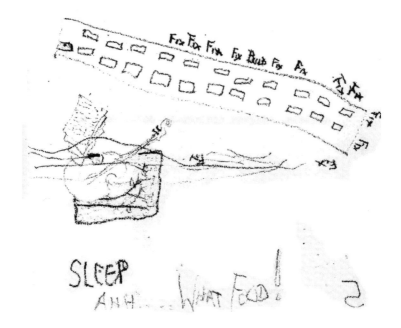

Figure 6.1: Allen's conflict situation (photograph by Richard Fung)

After drawing about a conflict with her boss, "Teresa" drew herself embracing several tools for working with conflict (see Figure 6.2). She drew large eyes representing vision and large ears for listening. She represented patience that endures "sun up to sun down" by a bright yellow sun in a blue sky on the left and a darker sky with a moon and stars on the right. The blue waterfall flowing over her shoulder indicates calmness through changing forces. The figure is embracing a many-colored rainbow reflecting her valuing of diversity. Teresa captured the smile of calmness. The peace dove at her forehead is a familiar symbol of peace and reconciliation.

After participants draw their tools for working with conflict, I again ask them to discuss their drawings with their partners. The final activity is to go around the room so each person can hold up her or his drawing and point out one tool she or he has. This is affirming and educational and leaves everyone with feelings of hope, possibility, and empowerment. In their evaluations, participants often say they found this closing exercise particularly useful.

Participants in these workshops are not expected to be artists. "No artistic ability allowed!" is humorously written on the workshop flyer.

Figure 6.2: Teresa's tools for working with conflict (photograph by Richard Fung)

Crayons are used because they are familiar drawing implements. Over and over I hear from participants: "I am not at all an artist. And your workshop opened up so much to me." Indeed, that was my personal experience when I first explored with chalk pastels as an adult. Experienced sketchers are welcome, of course, and they bring their own level of art. All are equal participants in this simple yet powerful workshop. Many remark that the workshop is fun.

By reflecting on a conflict, drawing it on paper, and discussing it, people gain many benefits and insights. Participants have given these comments:

"I felt a physical release."

"This helped identify my own role in the conflict."

"I got clarity about my conflict."

"Seeing it on paper let me remove myself from the situation."

"Talking with my partner was very useful to me."

But I must add that the workshop is not necessarily a great moment when the heavens open up and all is truth and light. Working with conflict is a struggle, and participants have to be willing to make that struggle.

Initially I taught Drawing Out Conflict to mediators, who already have good listening skills, and who deal with other people's conflicts but don't necessarily get time to address their own. It's refreshing to give mediators a new look at conflict, and it is incredibly valuable for them to deepen their awareness of how they respond to and work with their own conflicts. As experts in the field of conflict resolution, we have to be mindful of our own foibles and successes in regard to conflicts. More recently, I've learned that this workshop can be effective with youth, church groups, artists, graduate students, and the general public. People sign up because they have some interest in either art or conflict resolution. My goal with these workshops is for participants to gain some insight concerning their conflicts. Talking about conflict is a personal, vulnerable activity, and I strive to offer safety and confidentiality in these workshops. I respect the privacy of the drawings, and the intimacy of the discussions between partners during the exercises. I don't require people to show their conflicts to the group or to me.

What I like most about teaching Drawing Out Conflict is that I see people empowered to address their conflicts. Participants gain clarity and are then able to move forward toward making a decision to resolve the conflict. When people gain the strength to improve a situation, they gain confidence, self-assurance, and, ultimately, a resolution that benefits both parties involved. Having the ability to resolve one's own conflicts is very powerful. This method is less hierarchical and more interdependent than more traditional conflict responses (i.e. authority decides, conflict is avoided, or people fight). I believe we need to adopt this method in our social interactions. Non-violent conflict resolution is important on the personal level, on the community level, and on the international level. If we don't start with our own conflicts, we will not be successful on the global scale.

Parallels between drawing out conflict and mediation

I am a mediator by profession, so I look through the lens of conflict resolution. When I found that drawing out a conflict gives many of the same benefits that a mediator offers to disputants in a meeting, I was delighted. Highlighted below are several of the benefits common to both mediation and drawing out conflict. Each of these is introduced by a comment or comments that have been made by workshop participants.

Neutral, non-judgmental space

"Drawing allows for a non-judgmental view."

When you sit down with a blank piece of paper and a set of crayons, there is no-one to evaluate you, to say you're right or wrong, to tell you what to do. These are key principles of mediation: the mediator sets up neutral space and judgment is suspended. This allows the party the freedom to explore their own thoughts and just tell the story as they see it.

Clarification and reduced confusion

"This brought my conflict to the front."

"It helped me see the history of the conflict."

"It let me focus more on the details."

"This helped me see the magnitude of the conflict."

By drawing and reflecting, sketchers gain clarity about their points of view and sometimes about their options. One of the goals of the mediator is that participants gain clarity, so they can make better, more informed choices.

Other perspectives

"Drawing made it easier to look at, from outside myself."

"It gave me a different perspective."

"I could see the other person's point of view."

By drawing the conflict on paper, people get to observe what they have drawn. This separates the problem from the person, another key tool of mediation. The conflict becomes a contained problem to be solved rather than something overwhelming. Some sketchers also gain insight concerning how the other person in the conflict might see the situation – for example, "Jeremy" drew a disagreement he'd had with his supervisor. When looking at his drawing of his supervisor, Jeremy realized that the supervisor was under a lot of pressure from his department head and that that had affected their interaction.

Participants make decisions and are empowered

"It helped me prioritize and narrow my focus."

"This was transformative; it opened up a stuck place for me."

"I realized I have a choice, and I can let go."

"Drawing it helped with the resolution, and I can move forward."

"This brought out a desire for me to do something."

"This was an accomplishment to draw and gives me momentum to work on the resolution. It was a metaphor, which I can use for a strategy to get out."

The participant can evaluate what's said in mediation and can accept it or not. The participant gets to decide whether to "take it or leave it" when it comes to thoughts, ideas, or options. So, too, in drawing a conflict: the sketcher can choose to observe and reflect on any aspect of the drawing and on any comments from his or her partner.

Time for emotions

"It felt good to express my feelings (love, anger)."

"This was a stress reliever."

"I realized I don't have to feel guilty; it's okay to deal with it."

"I felt an emotional charge while putting it on paper. Then I could step back as a neutral observer and deal with it. Drawing helped create the calm so I could look at the conflict."

As a mediator, I allow and encourage the expression of emotions. In the drawing process, participants slow down to reflect on what they are going to draw, what color to choose, and what to represent and how. This gives them time to express their emotions, to sit with them, to honor themselves as whole persons. With acceptance and understanding of the emotions, a person can then engage in rational thinking. All this helps good problem solving.

Not all mediators and not all mediations embrace emotional expression as part of the work to resolve a conflict. For my work as a mediator, I believe that emotions are important to acknowledge. As brain research is showing us, emotions are key to making decisions and steering us through life. Indeed, the first inkling one has that there might be a conflict is an emotional signal (anger, frustration, sadness, and so on).

A final similarity between mediation and drawing out conflict should be mentioned. Participants in mediation come of their own free will, not because they are forced to. They choose to come and to participate in good faith in the interests of resolving the conflict. The decision to work on the conflict is a first step toward resolution. There is a parallel here to drawing out a conflict: the sketcher is willing to explore the dilemma on paper, with the hope of gaining insight leading toward resolution.

Although I am thrilled by the parallels between mediation and drawing out conflict, there are also huge differences. The most significant difference is that in mediation both people are present. In mediation, each person has the opportunity to hear directly what the other's experience was, and together they create possible solutions to the problem. I do not mean to imply that one person drawing can replace the success of mediation. Drawing offers another tool to explore conflict.

Discoveries through drawing

I have also co-led with art therapist Frances Kaplan (author of the preceding chapter and editor of this volume) several four-session workshops that employed additional drawing exercises for conflict resolution. These workshops, called "Discoveries Through Drawing: Insights on Conflict and Conflict Resolution," included an exploration of emotions, consideration of the other's perspective, and the concept of interests versus positions. These workshops were for interested members of the general community. The drawing exercises and general sequence of the workshop are detailed below. (There were also some non-drawing exercises such as negotiation and active listening that are not discussed.)

Emotions

The first session of the workshop focuses on emotions. When rational thought became highly prized in the age of Descartes ("I think, therefore I am"), emotions were relegated to the lowest rungs of the ladder of importance. Emotions became trivial, in the way, and were thought to reveal an inadequacy in the person feeling them. Thankfully, recent scientific explorations of the brain and the mind have shown the essential value of emotions in our decision making and in our humanness. Daniel Goleman's *Emotional Intelligence* (1995) is a key volume that speaks to the importance of our emotions. Our brains function in such a way that the first indication we have that we are experiencing conflict is an emotional response, not a rational one.

We feel angry, upset, disappointed, or scared before we think through, for example, that we are upset because a co-worker didn't include us in the important meeting. If it didn't bother us (emotionally), it wouldn't be a conflict. The emotions are key to conflicts.

Many people have difficulty identifying their emotions and working with them. Drawing conflict emotions (adapted from Bellard and Baldoquin 1996, p.72) helps people identify feelings, learn from others about feelings, and look at ways to manage emotions in conflict situations. First, the whole group is asked to name the emotions that come up when one is in conflict. The responses, which are listed on a flip chart, typically include anger, anxiety, fear, sadness. Then participants are asked to work in small groups of three or four, and each group chooses one named emotion to illustrate. Group members first draw a large human silhouette and then represent on the figure how that conflict emotion is felt.

Drawing Conflict Emotions

Working together in groups of three or four people, draw a human form on a large piece of paper. Then represent on the form how one emotion of conflict manifests itself in the body. Next, each group brainstorms a list of "ten things you can do so the emotion doesn't overwhelm you." Write these in the margin of the drawing.

One group in a workshop chose to represent anger. The figure had jagged red and orange flames coming from its right. Steam was coming from the head. The cheeks were red and the neck had tight red lines across it. The fists were clenched. The black heart was blocked off by a square, and the stomach area had a jumble of green, black, and red lines representing knots in the stomach. This example is fairly representative of the type of images that emerge. When the groups are finished drawing, they display and explain their drawings. This is a generally enlightening activity concerning emotions; everyone thinks and reflects and learns from others about several feelings.

The next part of the exercise helps ground people in ways to work with these feelings. The same small groups are asked to brainstorm ten things they can do to calm themselves down so that the chosen emotion doesn't overwhelm them. The brainstormed list is always educational. The lessons are (a) people can learn to manage their own emotions, and (b) there are a variety of techniques to try.

Sample:

Things you can do to manage your anger:

- Take a walk
- Go out in nature
- Breathe deeply
- Take a bath
- Talk to a friend
- Exercise
- Listen to music
- Do yoga, tai chi
- Pet the dog
- Draw!

Your safe place

Participants are assisted in bringing to mind a safe, comfortable place through relaxation and guided imagery. They are asked to close their eyes and find their safe place through a gentle description of some perfect, calm, happy location. After letting them be there and allowing the image to become fixed in their memories, the participants are brought back to the room and invited to draw their special place in whatever way they want to remember it. Many draw outdoor scenes (the beach, a colorful garden, a hilltop). We remind them to save their pictures and to look at them when they want to feel the comfort and safety of that place. This gives them another tool for dealing with over-intense emotions.

"I"-statement cartoons

The workshop's second session focuses on communication. We teach some active listening through demonstrations and practice. Then we talk about "I"-statements as an effective speaking tool. When individuals speak about their own feelings and needs, they are being honest and non-threatening. This is much more effective in a conflict than initiating dialogue with "You should...!" or "You never...!" The drawing assignment is to depict an assertive confrontation with a cartoon bubble containing an effective "I"-statement. This helps participants think through and put on paper the

I-Statement

I felt _____ when _____ (*optional*) and I need

first steps in resolving a conflict. As a cartoon, it's lighthearted and non-threatening.

Perspectives

When in a conflict, people tend to get tunnel vision: I'm right, they're wrong/bad/stupid. In reality, there are two perspectives at play, and unless the disputants consider that, the conflict will probably continue. There may have been a misunderstanding (7:30 a.m.? Oh, I thought you meant 7:30 p.m.!), or there may be entirely different assumptions based on deep-seated values. I remember an Anglo woman trying to ask her Latino neighbors to turn the music down at 11:00 p.m. The neighbors' response was to bring her a beer and invite her to the party. That's what was done in Mexico, after all!

The topic of perspectives is dealt with in the third session of Discoveries Through Drawing. Before asking participants to draw the perspective of the other person involved in a personal conflict, it is explained that people nearly always work from their best intentions. People act with good intentions based on their experiences, their values, their needs, their assumptions, their complete beings. Of course, we don't know all of a person's background or thinking. We have to try to imagine how it was for him or her. Assuming the other person was operating with best intentions, we are forced to consider the positive intentions that person might have had in taking action.

> **How Might the Other Person View the Situation?**
> Take a moment to consider how the other person in your conflict might view the conflict. What does she or he want? What are his or her needs? What are his or her values? What's important to her or him?

"Gina" was reluctant to consider her sister-in-law's point of view in a conflict over the next holiday gathering. She started by drawing eyeglasses to pave the way. She drew her sister-in-law isolated and alone in an empty space. A red "forbidden" sign and a hand blocking a stuck-out tongue indicated she didn't want angry communication. But her sister-in-law wanted to make purchases for herself such as new clothes and travel, and the curious green blob in a drawing otherwise composed of reds and blacks was interpreted by Gina as jealousy, which she realized was coming from both her sister-in-law and herself (see Figure 6.3.)

Figure 6.3: Gina's perspectives drawing (photography by Richard Fung)

When drawing a situation from the other person's perspective, one could well be wrong. Nonetheless, this drawing exercise of another's possible perspective can be rich and insightful.

Interests versus positions

The concept of "interests versus positions" is a valuable one for conflict resolution. In the fourth session, I explain this concept with an iceberg drawing (see Figure 6.4). The iceberg metaphor is used for a multitude of issues where what you see is but a small part of the whole. In a conflict, the presenting issue is the problem you can easily name – say, the neighbor's encroaching hedge – and you leap to your "position": they've got to trim that hedge! The position is the tip of the iceberg. But what's more useful in working through the conflict is your "interest" or what is hidden underneath. Your interest answers these questions: why is this important to me? What does it mean to me? How will I benefit from a particular solution?

Take the example of wanting your neighbor to trim her hedge. Why do you want your neighbor to trim her hedge? Or, what would it mean to you if

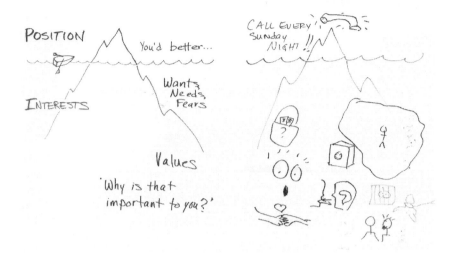

Figure 6.4: Interests versus positions: the iceberg (photograph by Richard Fung)

your neighbor trimmed her hedge? It could be that the hedge looks ugly next to your yard, and beauty is an important value of yours. It could be that you're afraid of prowlers hiding in the bushes, and safety is a paramount need. It could be that the hedge blocks your vision of the sidewalk when you back out of your driveway, and you almost hit a pedestrian yesterday. To look at interests is to look at your needs, wants, and values.

To help cement the concept, I give a conflict situation and invite the group to think of possible interests behind the stated position. In Figure 6.4, the conflict was about an adult son calling his mom, and his mom's position was "He's got to call me every Sunday night!" As the group named possible interests, I drew representative icons beneath the water line. The purse indicated that mom couldn't afford to call her son. The isolated stick figure stood for feeling lonely. The heart over touching hands represented her love for her son. The barred window indicated that she felt like a prisoner in the nursing home, and the clock that mom was so busy the only time her son could be sure to reach her was Sunday evening. The value of understanding interests is that they are easier to find solutions for than the demands of a position. If mom's interest is loneliness, a solution could be to find activities she can share with other people. If the interest is wanting a loving connection with her son, and the son understands that, he might find other ways to connect with her more often.

After this explanation, participants are invited to draw their own interests behind a particular conflict. When a person identifies what his or her real interest is, he or she could seek easier ways for that interest to be met. Participants are also sometimes asked to draw the other person's interests. This requires the sketcher to be willing to consider the other person's perspective, the other's needs and wants, and to set aside their own interests. Some find this exercise too difficult. It takes time to process one's own and another's views in a conflict. The concept of positions and interests is not an easy one for even new mediators to understand, and the graphic metaphor of the iceberg also helps when I train mediators.

Draw Your Interest in the Conflict

Reflect on your conflict. What do you need and want, and why is it important to you? Draw your interest(s).

Applications

I encourage workshop participants to think about how they can use the drawing exercises outside the workshop setting. I have personally found it very useful to sit down and draw when I feel I'm stuck in a conflict or am uncertain about some part of myself. Recently, I found myself pacing back and forth across my living room, not knowing why I was so angry. I spread out a sheet of drawing paper, set out a 16-pack of Crayolas®, and just let my left hand choose the colors and shapes I wanted to make. After ten minutes I felt finished, put the crayons down, and looked at the drawing. I turned it upside down, sideways, and just looked at what was there. From my random lines and colors emerged a pregnant woman, lots of spirals, jagged lightning bolts of red and purple, and a blue border surrounding everything. Looking at the drawing, I drew a parallel to my feeling that I'd been creating something but it wasn't quite born yet. The blue border and the image of pregnancy gave me comfort that the due date was coming and that this was normal. With that understanding, I was no longer angry but eager and expectant. I didn't know what was going to come, but it would be a new and good adventure.

One participant in a four-week workshop described his success in bringing to his housemates the concept of "drawing out conflict." "Sam" said that he posted his drawing of a household dispute on the refrigerator. He encouraged his roommates to draw how they saw it, and this led to a

discussion that ended with a shared understanding about the kitchen dishes, the yard care, and the car. Several participants who work with youth have incorporated the drawing-out-conflict idea in their programs. Youth don't have the resistance to drawing that adults have. One social worker reported opening up a valuable communication link with a 12-year-old who didn't talk much.

Other uses of art

In addition to the workshops I've described, there are three other situations in which I use some form of graphic representation. These are in training mediators, in facilitating groups, and in mediation sessions.

Training mediators

I train mediators on an annual basis. To introduce trainees to thinking about conflict, I have them draw their responses to the word "conflict." The drawing is done with crayons, the universal drawing tool, to make it less intimidating. As always, I invite people to let go of judgment and draw with the abandon of a 5-year-old. The drawings are always different. Some have jagged lines with lots of reds and blacks and browns. Some fill the page; some have sad, isolated faces. Some draw specific conflicts, either personal or international conflicts. A couple of drawings may point to the benefits of conflict – that conflict can lead to improvement.

Draw "Conflict"
Reflect on the word "conflict," and draw your response to the word.

After drawing, trainees discuss their artwork in pairs. As in the workshop Drawing Out Conflict, talking in pairs allows for an intimate discussion about a personal response. Participants get to share their reactions and talk about a topic that's difficult for many. For mediators, this is an important first step in feeling comfortable around conflict. Besides having trainees do their own drawings, I use illustrations such as the iceberg representing positions and interests.

Group facilitation

When working with a group, visuals can be used to provide focus and a sense of "where we are" for the participants. Most facilitators use a written agenda and other worded flip charts. I like to add pictures to enhance this work. A cheery sun with orange and red rays on the welcome page helps people feel glad to be there. This is not art that the group members do; so it is not participatory art, but it is useful nonetheless. I draw icons by items on the agenda. "Announcements" gets a megaphone; the brainstorming session gets a light bulb; lunch usually gets a steaming bowl of soup. People who walk into a room and see the pictures think, "We're going to have a good time today." People have said to me, "I didn't know what was going to happen, but I wanted to be there."

If the group is working on a process that will take several sessions, I'll use a graphic representation or map for the process. I worked with a department to determine how to change its organizational structure. After the first meeting to plan our process, I made a 12-foot-long chart showing, from left to right, the task force (figures at a round table), how this task force would assess the current situation (symbol of a voter's ballot highlighting "works" and "doesn't work"), brainstorming options (brain and light bulb), drafting a recommendation (paper with writing on it and a trial balloon), surveying employees for their feedback (another ballot), making revisions (the eraser end of a pencil), and submitting the final plan (a scroll as a formal document). Colors were used to identify groups of people: the task force was purple, support staff was red, and managers were green. Arrows directed the flow of tasks. As the task force meetings progressed, additions needed to be made – for example, time for the process became short so an alarm clock was added. The visual representation helped everyone to see where we were, where we were going, who would be involved, and how it all led to the goal. A timeline in months was shown at the bottom so we could see the monthly goals to be met.

Mediation sessions

Many have asked me if I have mediation participants use drawing during the mediation. Because drawing is not common to adults in our society, I don't introduce this unfamiliar and threatening medium ("What? I can't draw!"). Adults are willing to sketch maps, however. So, if I'm mediating a neighbor versus neighbor dispute, I'll ask one of the parties to draw a map. "Help me understand the situation; could someone draw a map of the properties?"

Then one of the people will sketch out the houses, the fence line, the bushes, or whatever is the problem. If the other person isn't watching and nodding that the map is correct, I'll ask him or her for corrections. Agreement that the map is okay is a first step toward working together. With the map on the table, the problem is now on a piece of paper – contained and therefore more solvable. Drawing the map is a useful tool for solving problems between neighbors.

Youth have no qualms about picking up drawing materials and expressing their concerns. When I taught Drawing Out Conflict to a group of 16 teenagers, there was no hesitation. In fact, they were quite comfortable about illustrating very difficult conflicts, such as abuse from parents. Some mediators who work with teenager–parent disputes cover the meeting table with butcher paper and provide colored felt pens. Participants can pick up the pens and draw or doodle during the meeting. Often the doodles lead to richer insights when the mediator brings them into the discussion.

For mediating group conflict situations, it can be fun to start by asking everyone to sketch how he or she sees the situation. This is a great way to bring out the different perspectives. When all the drawings are displayed, everyone gets to see them. One department head who had drawn herself as captain of the boat was astonished and embarrassed that her employee had drawn her as a swashbuckling pirate.

Conclusion

My experiences in exploring conflict through drawing have shown me the many insights and benefits that can be gained. People who do their own drawings around conflict get a better understanding of themselves, of their situation, and of the other person. Drawings can be used as the start of a dialogue between disputants. Further, in group settings, images can give focus, clarity, and direction to help the group work together. People gain strength, confidence, self-determination, and a sense of positive interdependence by resolving their conflicts among themselves. These are values that I believe build a healthy community. And, because I invite people to draw with the fun of a 5-year-old, drawing is an enjoyable way to make social change!

References

Bellard, J. and Baldoquin, H.G. (1996) *Face to Face: Resolving Conflict without Giving In or Giving Up.* Washington, DC: National Association for Community Mediation.

Goleman, D. (1995) *Emotional Intelligence.* New York: Bantam Books.

Liebmann, M. (1993) "Art and Conflict Resolution." Workshop presented at the National Conference for Peacemaking and Conflict Resolution, Portland, OR, May.

Liebmann, M. (1996) "Giving It Form: Exploring Conflict Through Art." In M. Liebmann (ed.) *Arts Approaches to Conflict.* London: Jessica Kingsley Publishers.

PART IV

Confronting Anger
and Aggression

Anger Management Group Art Therapy for Clients in the Mental Health System

Marian Liebmann

Introduction

I have been working in the mental health system for several years now, but prior to that I worked in the probation service as a probation officer. During that employment, I helped to run anger management groups for adult male violent offenders. Attendance at these groups was often by court order, although other offenders could attend voluntarily in the early days of the program. The groups were often heavy going, but I gained considerable satisfaction from being involved in them – partly because there were quite a few "success stories" and partly because I could engage in this work with integrity as there was a psychological job to do. Work with offenders who had committed thefts often revealed their poverty, about which I could do very little except apply to local charities for small handouts.

When I first became involved in therapeutic work, I subscribed to the prevalent therapy philosophy that it was good to be able to express anger and "let it all hang out." This fitted in with the fact that I had experienced problems expressing my own anger, and it was indeed a good thing for me to learn to express some of that. However, coming face to face with violent offenders and what they had done challenged this whole idea. Here were people who had no problem expressing their anger – often causing severe injuries and damage all around. I realized that the model I had espoused needed a radical rethink. There was a job to do in helping violent offenders to "bring it back in" and not express it all over other people, to learn more satisfactory ways of handling difficult situations. The probation anger man-

agement groups were conducted along cognitive-behavioral lines to help offenders think differently about their offences and develop new strategies (Novaco 1975, 1986; Novaco, Ramm and Black 2000).

When I moved to mental health work, there were times when everyone seemed to have angry clients on their caseload. And about once a week there would be a distressed and angry service-user in the waiting room banging on the glass window because his or her needs were not being met. There seemed to be a need for anger management groups here, too. Now working as an art therapist, I had extra tools in the form of art materials, which might sidestep the wordiness of the verbal programs and give service-users a deeper experience.

Art therapy has several particular things to offer in work on anger management:

1. It helps people who find it hard to articulate verbally why they get angry.

2. The process of doing the artwork slows participants down and helps them to reflect more on what is going on.

3. Sharing the artwork helps people realize that they have things in common with each other, and overcomes isolation.

4. Using art is often enjoyable and a less threatening way to approach issues.

5. Doing artwork enables a group to include both those who "act out" their anger on others and those who "act in" their anger on themselves (in a verbal group it is often difficult to include both of these in the same group).

I developed a ten-week, theme-based art therapy group using the main ideas from verbal anger management groups as art therapy themes. I wrote handouts to go alongside each session for those who found them useful. The program covered the following:

1. Introductions and ground rules.

2. Relaxation and guided imagery.

3. What is anger?

4. Physical symptoms of anger; anger – good or bad?

5. What's underneath the anger?

6. Early family patterns.

7. Anger and conflict.

8. Feelings and assertiveness; "I"-messages.

9. Picture review.

10. Group picture and ending.

I saw formulating ground rules as particularly important in making the group a safe place to work on a subject often seen as frightening. For the same reason, including relaxation was important – both to teach it as a method to help with anger and as a way of letting go of any upsetting feelings at the end of a session. Several different forms of relaxation were planned, as well as guided imagery, with one session devoted to it entirely. Thereafter, a short relaxation at the end of each session would help participants to practice it and also to let go of the session.

There were handouts for most sessions, as follows:

1. "Relaxation – Method 1 – Relaxing Muscles."

2. "Relaxation – Method 2 – Guided Imagery."

3. "Relaxation – Method 3 –Tension and Relaxation."

4. "Positive and Negative Aspects of Anger/Ways of Dealing with Anger."

5. "Recognizing Our (and Others') Anger."

6. "Feelings Underlying Anger."

7. "Early Family Patterns."

8 "Positive and Negative Self Talk."

9. "Assertiveness."

Some people found these useful, some not. Several clients asked for sets to be sent to their key workers after the group.

The group

The ten-week group ran for two hours each week in the morning, with individual interviews beforehand (to assess suitability) and review meetings afterwards. It took place in the art therapy room at the Inner City Mental Health Service. My co-facilitator was a male colleague who was a community psychiatric nurse and had run verbal anger management groups in a forensic mental health unit.

The art therapy group was publicized in the team as an opportunity for people to look at ways of managing anger so that it was less destructive to themselves and others. Each session included artwork and sharing, and finished with relaxation. Members of the group were expected to attend all the sessions. It was hoped that the group would include six to eight clients and two therapists-facilitators.

The participants

The group arose at that particular time from an expressed need by one of the team's two psychiatrists for something for his "many angry clients." Referrals were open to all service-users associated with the Inner City Mental Health Service and two neighboring mental health centers.

The 17 referrals came from the following sources: psychiatrist, psychologists, art therapist (myself), community psychiatric nurses, occupational therapist, community care workers, homelessness team, and the local hospital. Seven of these referrals failed to attend the pre-group interview. Two attended the pre-group interview and were accepted but did not turn up to the group. Three dropped out during the first half of the group because they found it too intense, and we had to ask one young man to leave because he was too disruptive. Of the four who finished the group, two attended all ten sessions, one attended eight sessions (Steve had to go to court twice, see later), and one attended five sessions.

There seemed to be a gender issue. The group that started consisted of four men and four women, whereas the group that finished was made up of three men and one woman (who attended five sessions). She had actually decided to leave, but was persuaded by her consultant to write a letter expressing her reservations. This is what she wrote:

> I have been wondering anyway if this is the right group for me as some of the group dynamics I found to be a bit too male-orientated, which I understand cannot be helped as people are the way they are. I cannot expect to change that, but even so, I don't want to attend an anger management course to be around the kind of negativity I found there.

We read this client's letter to the group and then wrote to her inviting her back. She did come back and was able to say how she felt and suggested that stricter boundaries around "air time" would help – that is, equal time for each person to speak.

The problems with anger expressed in the pregroup self-assessments by the eight people who started the group were as follows (the number responding to each item is given in parentheses):

1. If things go wrong, I get angry and lose my temper. (4)
2. Get stressed and wound up in lots of situations, leading to anger. (4)
3. Totally overreact and flip. (4)
4. Violent to other people (including women). (3)
5. Punch walls and windows. (3)
6. Verbally violent. (3)
7. Thoughts of harming others. (3)
8. Self-destructive/internalizing anger. (3)
9. Cannot handle family situations. (3)
10. Express anger in a negative way. (2)
11. Store up resentments. (2)
12. On my guard all the time. (2)
13. Not able to calm down. (1)

STEVE

The unfolding of the group will be described session by session in general terms and then with particular reference to one of the group members, Steve. Steve was 32. He was referred to the group by his psychiatrist. Steve had been seeing a psychiatrist for depression following the breakdown three years ago of a relationship of 11 years' standing (including a son). He had also been attacked by his ex-partner's new partner and needed 120 stitches as a result. He was on regular medication for depression.

From his early teenage years, Steve had had problems with alcohol and anger. He had left school without any qualifications, had been in prison four times, and had numerous convictions for drunk driving, robbery, and violence. Sometimes Steve could not remember what happened when he "lost it," and he admitted that at times he had been very violent, using knives. He believed that, if a woman did him wrong, then he had just as much right to hit her as he would a man. He did think he had a problem with anger but had tried a course in prison, which made him angrier rather than helping him. So he was quite wary of the group and very skeptical about art therapy.

Steve attended the pre-group interview and filled in the assessment form (with help from me writing down what he said), listing his problems with anger and rating them from 1 to 5 in terms of the severity (5 being the highest):

1. I do violent things and afterwards can't remember why, or even what happened. It can be for no reason. Prozac has helped me with this. (4)

2. My relationships with girls – I would like not to hit them. It doesn't happen often, but it's worse than hitting blokes. (3)

3. I totally overreact and flip most of the time. (4.5)

4. I'm verbally violent – swearing, etc. (5)

5. I'm on my guard all the time. (5)

The second part of the form asked him to list the ways in which he wanted to change:

1. I'd like to be calmer.

2. I'd like to be able to argue and put my point across without being aggressive and violent.

3. I'd like to be able to handle wrong looks, bad-mouthing, etc., with different strategies.

His goal for attending the group was to "become a calmer person."

The process
SESSION 1: INTRODUCTIONS AND GROUND RULES

The first session concentrated on introductions and ground rules, which gave rise to a good open discussion and helped the group to gel. There was a lot of nervousness, but the group settled well, and Steve found he had some issues in common with one of the other men: both felt they had to be on their guard all the time and wanted to be better examples to their 12–13-year-old sons.

Steve was quite nervous at the start of the session but joined in well and was supportive of others. In his picture introducing himself to the group, he drew a "bad day" on the left and a "good day" on the right (see Figure 7.1). The bad day shows Steve in black and red, chained to a post, teeth gnashing, eyes bloodshot and staring, fist clenched. The good day shows a green tree, the sun shining, and sheep grazing in a field.

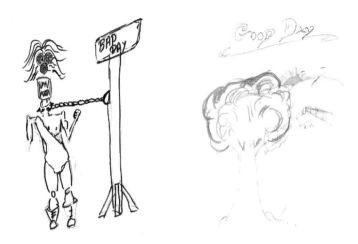

Figure 7.1: "Bad Day – Good Day"

For this and most of his pictures during the first sessions, Steve used pencils and thick or thin felt-tip pens. As it was the first session, we did not ask any questions of the participants, concentrating instead on helping them to start using the art materials.

SESSION 2: RELAXATION AND GUIDED IMAGERY

This session concentrated on teaching relaxation and guided imagery, to be used as a basis for the short relaxations at the end of all subsequent sessions. Participants were taken slowly through a physical relaxation, then a breathing exercise, then asked to imagine a peaceful place where they felt safe. This provided group members with a "safe place" to go back to in their minds when they were feeling stressed. Some of them later reported using this safe place in their daily lives.

For Steve, the only place he knew where he could be at peace and off his guard was a cemetery. He would go there when he was feeling particularly stressed. He drew a picture of this (see Figure 7.2).

SESSION 3: WHAT IS ANGER?

In this session, participants started to draw and share occasions when they had been angry. This led to a big discussion between the men about incidents in pubs when they felt they were being challenged and often felt that

Figure 7.2: Peaceful place/cemetery

violence was the only answer. Although this was clearly a key issue for the men, this may have been one of the sessions that alienated the women participants.

Steve's picture (see Figure 7.3) was very graphic. It consisted of tools of violence, some of them being used: a big hammer, a car he used intentionally to ram another one belonging to someone he hated, a CS canister spraying gas, a dagger dripping blood, and a baseball bat. He added a title "ANGER = VIOLENCE." He related an incident in which someone in a pub had made a putting-down remark to him. He left the pub, went home and thought about it, and then went back to the pub with a knife as he felt he couldn't let an incident like that pass.

SESSION 4: PHYSICAL SYMPTOMS OF ANGER; ANGER – GOOD OR BAD?

This session included a look at the physical symptoms of anger, which we drew on an outline of a body, everyone adding their symptoms to the same picture. Steve contributed staring eyes and a clenched fist, similar to his drawing of the first session. The resulting fierce apparition showed the effects of anger dramatically and was useful in helping participants become aware of their own anger and that of others.

Figure 7.3: "ANGER = VIOLENCE"

Looking at "anger – good or bad?" helped people recognize some of the good aspects – energy, protecting their families, power. Steve's picture on this topic reflected the recent results of his court case for assault. He was very relieved to have escaped another prison sentence. He was given a two-year probation order on the understanding that he would continue to attend psychiatric appointments, including the group. The picture (see Figure 7.4) shows again the close connection in Steve's mind between anger and violence, this time entitled "ANGER = CRIME." The top left shows Steve's partner and son divided from Steve, who is behind bars. At the top right, he drew a bomb with a lit fuse, followed by an explosion and then destruction. The picture at the bottom shows Steve's response when someone was shouting at him – feeling "confused, muddled, violent, defensive," heart pounding and body shaking.

SESSION 5: WHAT'S UNDERNEATH THE ANGER?
SESSION 6: EARLY FAMILY PATTERNS

These two sessions were emotional ones. Group members found it quite hard to look at some of the emotions underlying their anger – sadness and illness featured here, but people found it hard to express these. The same was true for the sixth session on family patterns.

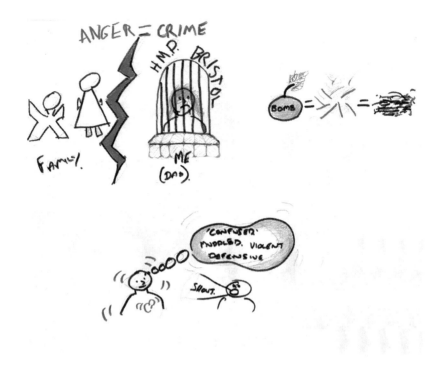

Figure 7.4: "ANGER = CRIME"

Steve missed both these sessions. For the first one he sent apologies, and for the second one his probation officer rang to explain that Steve had a court appearance. We feared the worst, but it turned out to be an offence committed before the previous court appearance that had to be dealt with at a different court.

SESSION 7: ANGER AND CONFLICT

This session looked at the positive and negative messages in people's heads and led to discussion of the mental health system and gender roles. Steve's picture was the focus of considerable discussion (see Figure 7.5). He wanted to illustrate how he had learnt "not to bite" and how he was now managing to stay calm. The picture shows Steve lying on a sofa with his partner on the right going, "Nag, nag, nag." He drew three different responses, each with a heading and thought bubbles:

1. "Get Angry" (right-hand side): "Don't or I'll freak." "Shut up or I'll shut you up." "'F' off."

2. "Stay Calm" (left-hand side): "She's being pathetic." "Let it go." "Ignore it."

3. "Turn the Tables" (top): "Pretend you're somewhere else." "Take no notice." "Blank her out." "Smile." "Walk away."

Steve thought the third one was the most effective. He was clearly making efforts to find alternative strategies. Then someone in the group asked why he was on the sofa doing nothing – maybe that was why his partner was nagging him? He responded, "You don't keep a dog and have to bark yourself"; he had been brought up to expect women to look after him. However, checking with the other men in the group showed that they all took it for granted that they participated in household chores – shopping, cooking, ironing, and so on. This led to much animated conversation.

SESSION 8: FEELINGS AND ASSERTIVENESS

In this session on assertiveness, the artwork focused on "the real you." This was preceded by an initial round about "a time I felt good about myself,"

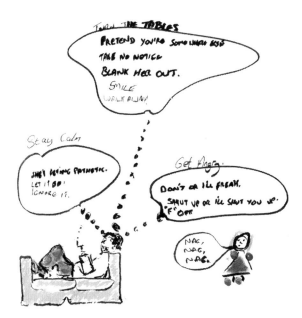

Figure 7.5: Positive and negative images

which showed that this was a very rare experience for the three men present at that session – in one case, the only occasion had been 30 years previously. Again, it was an emotive session.

In the initial round, Steve said he had only felt good about himself when he was "pulling girls." He found it hard to start a picture about his real self but chose pastels (a new medium for him) and soon became involved. The picture (see Figure 7.6) shows Steve playing football with his son in the park, bikes on the ground, tree in the background, sun shining. He talked about feeling good himself when enjoying playing with his son, walking in the park – little things. He wrote the words "PEACE," "HARMONY," and "HAPPINESS" at the bottom. It was the first complete picture he had done. Also in the picture (top left), is a 10,000-pound weight moving up, surrounded by clouds and the words "ANGER," "STRESS," and "HURT." Steve felt these were being lifted off him. He said:

> On the surface, I sometimes think that coming to this group hasn't done much for me – but it must be, on a subconscious level, because I've not really lost my temper since coming to the group.

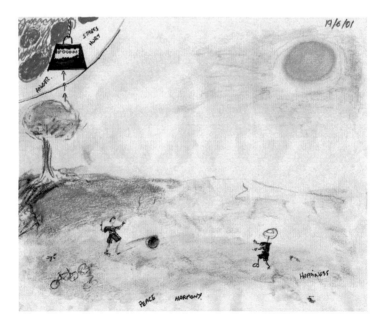

Figure 7.6: "Peace/Harmony/Happiness"

He talked about being able to let down his guard just a bit and not having to always walk round with his chest puffed out, ready for battle – he related this to moving to a quieter part of the city. He was also very supportive of other group members, one of whom got quite upset during the session.

SESSION 9: PICTURE REVIEW

The ninth session was a review of the pictures done during the first eight sessions, followed by a picture on an important aspect to sum things up. Steve's picture was another new departure, as he used paint for the first time (see Figure 7.7). He painted a large brown cross and some grass on an even larger yellow sun. This symbolized the grave of a friend of his who had died. Steve visited the grave every month and felt peaceful and safe there. He painted a tree and sky at the top right, labeling it "PEACE" and adding "RELAX/ART" to the main part of the picture. He said he felt more at peace generally with his house move and starting his probation order.

However, he was still quite fatalistic about the possibility of further trouble. In the top left corner, he drew a dagger dripping blood, a bomb with a lit fuse, and himself behind bars (as in Figures 7.3 and 7.4). He said he could use the techniques he had learnt with "normal" people, but was resigned to using the "old" coping strategies if trouble came round the corner. He had clearly made much progress but still had a way to go.

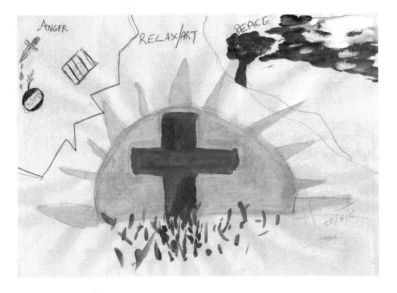

Figure 7.7: Anger and peace

SESSION 10. GROUP PICTURE AND ENDING

The final session, rounding things off, was a group exercise on "gifts" in which everyone drew metaphorical gifts in each other's boxes and baskets. One man was so touched he was nearly in tears, going home clutching his gift picture carefully.

Steve drew a basket for his gifts. From group members he received a glass of beer and a set of decorating tools (his trade). From therapists he received a "clear road ahead," a book of self-knowledge, and a "trouble-free future" for his son. Steve said he felt lucky that his son was so normal and well behaved, considering his own previous way of life. He didn't want to take his pictures home, preferring to leave them with the community mental health team.

Evaluation

The group was evaluated in several ways:

1. A "group book" for ongoing comments (this was only used by one person on one occasion).

2. Post-group evaluation sheet for participants' views of the group.

3. Pre- and post-group self-evaluation sheet for individual progress and learning.

4. Post-group interview to help each person evaluate his, or her group experience, and see how any learning could be applied and consolidated in work with professionals having a continuing role.

Steve's evaluation

Steve attended the post-group interview with his probation officer. He said he had found the relaxation aspect very useful. He was surprised that he had managed to stay out of trouble this long. He admitted that he had found the idea of the group and doing art therapy very weird but had found it OK, and this had helped him to be more open to changes he might make. As mentioned earlier, Steve still had a way to go, so he and his probation officer planned more discussions. Steve was also trying to cut down on his drinking, as this was another contributory factor.

Steve's comments from his evaluation form included:

1. I enjoyed the group very much.

2. It benefited me quite a lot.

3. What I liked best overall was hearing new ideas and listening to how others felt.

4. What I liked least was that the starting time was a bit early for me.

5. The group helped me learn how to deal with some bad situations.

6. I enjoyed the group but it would have been good to get help quicker, before all the trouble I've been in.

He filled in the post-group personal evaluation as follows (the first number shows his pre-group rating, the second his post-group rating):

1. I do violent things and afterwards can't remember why or even what happened. It can be for no reason. Prozac has helped me with this. (4, 2)

2. My relationships with girls – I would like not to hit them. It doesn't happen often, but it's worse than hitting blokes. (3, 2)

3. I totally overreact and flip most of the time. (4.5, 2)

4. I'm verbally violent – swearing, etc. (5, 1)

5. I'm on my guard all the time. (5, 3)

As can be seen, Steve's ratings moved a total of 11.5 points in a less serious direction. He said he had learnt to "relax and calm down quicker" and "try not to get violent over silly issues." He felt he had achieved his goal of becoming a calmer person "quite a bit."

The other group members in brief
PARTICIPANT A

He found the group hard but came every week. His earlier pictures were all outline drawings in one color felt-tip pen but, as he made progress in the later sessions, he introduced more colors and his drawings were more creative. He was very talkative – in fact unable to stop on several occasions. Initially, he found the relaxation very difficult, but was much more able to settle into it by the end. He came to see that he could tolerate others different from himself and let go of the need to "sort them out," getting on more with his own life. As a result, he became less intimidating and more relaxed and open. He was able to deal with upsets in a different, less threatening way. Other people noticed the difference. At the end, he said it was the first group he had ever completed and had found doing the relaxation and the pictures

very useful. He admitted to a "lump in his throat," which had troubled him greatly but which had gone by the end of the group. He formed a bond with Steve as they both had young sons who were the focus of their resolve to do something about their anger problems.

PARTICIPANT B

He was someone who had internalized his anger of many years. He found the artwork very useful in helping him to "express the inexpressible" and build a bridge towards beginning to communicate his anger and distress associated with his adoptive family. At times, his emotions became too much for him, so that on one occasion he could not participate in the artwork. But other members of the group supported him, and this particular session proved to be a turning point. He was particularly moved by the gifts from other people in the gifts exercise at the end of the group.

PARTICIPANT C

She was the only woman to continue to the end, and she attended five sessions. She enjoyed the artwork and was very creative and imaginative. She was put off by the male-dominated nature of some of the conversation, but came back to the group and was able to explain her point of view. She found the review session very useful in noticing patterns in her artwork, and learnt something about making space to think about situations instead of just reacting.

Conclusion

The anger management art therapy group seems to have provided a vehicle for helping a few clients to make significant changes in the way they handled their anger and expressed themselves. The artwork and the relaxation were both significant factors in this, as was the group support and building of relationships.

Steve used the group well and was supportive to others. His first drawings were quite violent, as that had been his life, summed up by one drawing: "ANGER = VIOLENCE." He found a common bond with another man in the group in that they both had sons 12–13 years old, and both felt it was impossible for them to admit any kind of vulnerability as men. He found the relaxation and the artwork unexpectedly useful and was pleased and surprised at the end to find that he had not lost his temper and had stayed out of trouble for the duration of the group. His later pictures were less violent

and more peaceful, he was more experimental in choosing materials, and he made whole pictures. He admitted at the end that he had thought the group would be a waste of time, but it was not. He had clearly made a lot of progress but still had some way to go.

The other participants also gained benefit from the group and enjoyed it to different degrees. In addition, my co-facilitator found the group interesting and stimulating and "a totally different experience from a verbal anger management group – much deeper and richer." Although the group did not suit everyone (several people dropped out, and the lone woman left had criticisms to make), those who completed the course made measurable changes in a fairly short time.

Given the increasing number of angry people in our world, there is a clear need for more work of this kind in which a relatively short input can make a significant difference. Steve's comment (mentioned earlier) sums it up: "I enjoyed the group but it would have been good to get help quicker, before all the trouble I've been in."

References

Novaco, R.W. (1975) *Anger Control: The Development and Evaluation of an Experimental Treatment.* Lexington, MA: D.C. Heath.

Novaco, R.W. (1986) "Anger as a Clinical and Social Problem." In R. Blanchard and C. Blanchard (eds) *Advances in the Study of Aggression,* Vol II. New York: Academic Press.

Novaco, R.W., Ramm, M. and Black, L. (2000) "Anger Treatment with Offenders." In C. Hollin (ed.) *Handbook of Offender Assessment and Treatment.* London: John Wiley and Sons.

Symbolic Interactionism, Aggression, and Art Therapy

David E. Gussak

Introduction

While I was working in a California psychiatric hospital in 1987 as a behavioral specialist, a diminutive 15-year-old Hispanic boy, Rick, was admitted to the locked unit for adolescents. Despite his small stature, Rick presented himself as tough and seemed quite strong. He had difficulty in school for acting out, and was in trouble with the law for gang activities. His family admitted him because of his tendency to become violent. He believed himself tougher than all the others on the unit, including the staff. Rarely did a day go by when he did not try to attack a peer or a staff member for what he perceived to be disrespect, and he would often end up in restraints.

Proud of the gang to which he belonged, Rick constantly "tagged" his gang moniker on the walls of the unit. As there was a rule against displaying gang insignias, as well as against writing on the walls, he was constantly in trouble with the staff of the hospital. He became very angry when the graffiti was removed and at times attacked those who were cleaning up the drawings. What was obvious was that he closely identified himself with his gang. By removing the graffiti from the walls, we were conveying to him that he was not respected and therefore unacceptable; the perceived disrespect resulted in anger.

After several other similar incidents, I sat down with Rick and, with permission from the unit administrator, made a deal with him. I reiterated the hospital regulations; however, if he agreed to work with me, he could do the gang tags on separate sheets of paper and keep them in his desk drawer. He also had to promise that he would not hang up the drawings. He agreed to this, and he spent several afternoons drawing quietly with pencils on white

paper. Each drawing was meticulously completed. After he had completed several of these drawings, I suggested that, instead of illustrating his gang's name, he should do a drawing of the name his gang called him.

Eventually, the drawings evolved into an embellishment of his real name. These he could show proudly and hang on the wall in his room. By the time he left the unit, he was much more compliant with staff directives and decidedly less aggressive than before. It was then that I realized the importance of interacting with Rick in a manner that accepted and validated him. As a result, his behavior was altered to conform to social norms and, simultaneously, his own self-concept was strengthened. He saw himself as an individual within a societal context, and his aggressive tendencies were moderated.

From this experience, I learned first-hand the benefits of art with aggressive and violent clients. Art provided an avenue for Rick to feel valued, offered a means of acceptable interaction, and paved a way for him to develop and maintain a new sense of identity. In future job settings, I would encounter many aggressive and violent people. However, it was Rick who taught me the value of art as a means to divert and redirect anger and aggression. Now I am an art therapist specializing in working in what many consider to be hostile and violent environments.

Various theoretical perspectives on aggression

Psychological perspectives on aggression

There are prevailing psychological explanations about what causes a person to act aggressively. Freud believed that aggression was a form of "psychic energy," a drive that resulted from the clash of the life force (Eros) and the death force (Thanatos) (Gay 1989). Lorenz (1967) likened aggressive reactions to those experienced by animals. Energy from the fighting instinct is spontaneously generated. Aggressive actions come from the sudden release of this accumulated energy. If this energy is not released gradually, it is let loose in what is likened to an explosion – a process illustrated by what has been termed the "hydraulic model."

Horney (1992, first published 1945) indicated that aggression was a response to narcissistic injuries. According to Horney, compensatory grandiosity and pathological rage come from the pain of not being loved and accepted by parental figures. This situation forces the individual to develop a false self, one that is idealized yet vulnerable. And this, in turn, results in a protective need to push people away, causing further anger about not being

loved or accepted. A seemingly never-ending cycle is created that continually feeds the rage. This rage is eventually expressed through hostility or violence. Horney also theorized that aggression could result from a neurotic need for power, social recognition, personal admiration, and achievement.

The cognitive approach to understanding violent and hostile behavior challenges the view that anger is always an initial response to feeling threatened (Beck 1999). Cognitive theorists claim that a chain reaction begins when a person is in distress. It is this feeling of distress that triggers the "I have been wronged" response, which can then lead to violent retaliation. Understanding that stress is part of the equation offers therapists clues to interrupting the cycle of violent behavior:

> We take the role of the protagonist and the other players are our supporters and antagonists… Our egocentrism also leads us to believe that other people interpret the situation as we do; they seem even more culpable because they "know" that they are hurting us but persist in their noxious behavior anyhow. In "hot" conflicts, the offender also has an egocentric perspective, and it sets the stage for a vicious cycle of hurt, anger, and retaliation. (Beck 1999, p.27)

These major psychological views have been used to dissect aggressive and violent responses. What is significant is that, aside from Freud's perspective, the majority of the psychological theorists take the position that interaction with others triggers and perpetuates aggressive responses. In other words, it is social interactions, and the interpretation of these interactions, that contribute to and maintain aggressive and violent propensities. So, although a psychological theory may seem sufficient to explain aggressive tendencies, the sociological perspective of symbolic interactionism can be used to further elucidate aggressive actions, as well as to shed light on how to alleviate aggressive tendencies.

A sociological perspective on aggression: Symbolic interactionism

Phua (no date) stated, "Symbolic interactionism *is* [italics added] a social action approach". However, he makes it clear that "social action" in this case means "social interaction" rather than action to produce societal change. Still, by placing the origins of human behavior in a societal context, symbolic interactionism admits the possibility of modifying behavior through social interchange. And because the "symbolic" in "symbolic interactionism" refers to "human communication as…a process involving

the exchange of symbols", the door is opened for the exchange of symbols involved in art therapy to serve as an appropriate intervention.

In order to make sense of social behavior, researchers, specifically sociologists, focus on the *inter*action that occurs between individuals. James (1918, first published 1890) believed that the social Self is the result of the interaction between the individual and social groups. Cooley (1964) indicated that a mutual interdependence exists between the social environment and individuals. Mead (1964) understood that the Self developed from the "process of social experience and activity…[which] develops in the given individual as a result of his relations to that process as a whole and to other individuals within that process" (p.199).

Meaning emerges from the interaction between people (Blumer 1969). It is through the continual act of interpreting – redefining each other's acts – that a societal context and the roles of humans within this context are defined. "By making indications to himself and by interpreting what he indicates, the human being has to forge or piece together a line of action" (p.64). Ultimately, people are defined through interactions; therefore, meanings and interpretations are social products. Aggression and violent responses can emerge from interpretations of unsatisfactory or misperceived interactions.

Aggression and violent tendencies emerge from social interaction. Whereas a person may *feel* angry, they *act* aggressively or violently towards others or themselves. According to the ideas explored earlier, an unacceptable interaction with someone can result in an aggressive response; aggression can also emerge from a desire to bully someone to bring about a "desired social and self identit[y]" (Anderson and Bushman 2002, p.31). Similar to Horney's and Beck's aggression models, the social interactionist perspective maintains that "aggression is often the result of threats to high self-esteem, especially to unwarranted self-esteem" (Anderson and Bushman 2002, p.31). Aggression may emerge through how a person sees him- or herself within a social context.

Aggression is perpetuated through repeated social interaction as well. By their very nature, aggressive and violent acts are deemed unacceptable by society, and those who engage in such acts are usually labeled deviants (Becker 1991, first published 1963; Sagarin 1975). Because aggression is frequently created and defined through social interaction, a person can become identified with aggressive acts. Once a person is labeled "aggressive" or "violent," this moniker tends to be maintained by social means. Bartusch

and Matsueda (1996) believed that the mechanisms of role-taking and labeling were a major influence on delinquency in adolescent boys and girls. Labels provided by parents and teachers perpetuated the delinquent identity. Unless this public characterization is lifted and accompanied by a change in identity, aggression may continue. Rick's aggressive tendencies were maintained and supported by his gang. The staff at the hospital reinforced his identity by their strong reaction to his reputation and behavior.

Zimbardo *et al.* (1973) also recognized that people may develop aggressive and dominating characteristics after roles and labels are assigned and accepted. In their study, a Stanford University class was divided into two groups; one group role-played prison guards and the other played the inmates. The purpose was to:

> understand more about the process by which people called 'prisoners' lose their liberty, civil rights, independence, and privacy, while those called 'guards' gain social power by accepting the responsibility for controlling and managing the lives of their dependent charges. (p.38)

The guards locked up and watched over the inmates in the basement of the psychology building. The study had to be terminated earlier than originally planned because both groups inhabited their roles more seriously than anticipated. The original identities of the students were quickly transformed. The guards became aggressive towards their wards, and the inmates became docile and cunningly resistive. The researchers soon realized that aggressive actions or reactions emerged from role-taking and labeling.

Social interaction, aggression, and art therapy

It is through social interaction that aggression is defined, propagated, and maintained. Conversely, it is through social interaction that aggression can be redirected or alleviated. It is through relabeling of people or removing the detrimental labels, validating new behaviors and identities, and redefining their actions, that aggressive and violent tendencies can be modified and perhaps reversed. The art therapist uses the art-making process to aid in developing appropriate interactions and to decrease aggressive tendencies.

Blumer (1969) indicated that social interaction can occur between people and objects as well as between two people; meaning is:

> not intrinsic to the object but arises from how the person is initially prepared to act toward it... Objects – all objects – are social products in

that they are formed and transformed by the defining process that takes place in social interaction. (pp.68–69)

It is through using, sharing, and interpreting the use of objects that action and interaction are defined. The introduction of art materials to an aggressive client creates a scenario whereby a new interactional pattern begins to occur. By interacting with the art materials and the art product, a person can begin a process of redefinition.

A relationship is also established between the client-artist and the therapist. Both now belong to the same socially acceptable art world, constructed and maintained through the shared conventions of the media (Becker 1982). Teaching a client how to use art materials for self-expression creates a new mode of interaction. Mastery of the materials promotes a new sense of self-worth independent of previously established hostile identities.

In summary, the art-therapeutic process provides a means to interrupt the cycles of violence and aggressive identity by strengthening a sense of self, by providing an avenue to express negative emotions such as distress and sadness that can result in anger and aggression, by creating new meanings, and by tapping into empathic responses (Gussak 1997, 2004; Gussak et al. 2003). Although it is common to believe that the client creates an art piece with little thought to the viewer, it is likely that all artists take into account what the viewer may think of the result:

It is crucial that, by and large, people act with the anticipated reactions of others in mind. This implies that artists create their work, at least in part, by anticipating how other people will respond, emotionally and cognitively, to what they do. (Becker 1982, p.200)

Even when the artist creates an image with hostile content, he or she may be doing it as a means to "attack" the viewer. However, art is an acceptable way to express hostility, and the therapist can use such images to promote self-acceptance and feelings of success. As sessions continue, the client understands that these images, and, by extension, the person who made them, are accepted. Once a client feels validated, the images may begin to evolve into more complex and thoughtful products.

Case examples

The following case examples are about clients seen in two very different settings. Jason (a pseudonym), an adult prison inmate, was a member of an art therapy group. Eric (a pseudonym), an 11-year-old boy, was involved in out-

patient art therapy and seen in individual sessions. Both had different histories and needs, while having problems in common with aggression.

PRISON CULTURE

A few words about prison culture are necessary as a prelude to Jason's case. In prison, not only is aggression acceptable to inmates, it is often rewarded. In an environment where the weak are taken advantage of and the strong reign, attempting to curb aggressive and violent tendencies is met with strong resistance. Inmates' hostility and aggression generally emerge from the loss of freedom and control, the need for hypervigilance, the lack of individualism, and the loss of a sense of identity (Gussak 1997). Regardless of whether they acknowledge deserving this situation, their reactions are generally hostile. Yet, simply talking with prison residents is not always successful in redirecting their hostile and aggressive tendencies. Art therapy has proven to be extremely beneficial for men in prison (Gussak 2004); there seems to be a natural tendency toward artistic and creative expression in prison settings (Gussak 1997; Kornfeld 1997; Ursprung 1997). Art allows for the sublimation and redirection of aggressive impulses (Dissanayake 1992; Kramer 1993; Rank 1932). Making art has also been shown to decrease the number of disciplinary reports written on inmates who participated in an arts program (Brewster 1983). Art therapists can take advantage of these benefits, and alleviate anger and aggression in prison by providing a means for inmates to express themselves that is acceptable to those who otherwise consider inmates as deviants.

CASE VIGNETTE: JASON

Jason was a 23-year-old man who was in prison serving a life sentence for first-degree murder. While a member of the US Marine Corp, he shot someone after a drunken altercation in a bar and was sentenced to prison. Jason was a "Nazi skinhead." He was a tall, lanky man, covered with tattoos of Nazi iconography (e.g. swastikas, SS lightening bolts, eagles) on his arms, neck, and head. His tattoos culminated in a four-inch cockroach on his head. He rarely smiled and would often pepper his conversations with profanities. He generally kept to himself and was often aggressive, specifically towards inmates from different cultures. He believed in "Aryan superiority" and would often get into altercations with African-American inmates. He was in the fourth year of his prison term when the art therapy sessions began.

Despite (or because of) his tendency to keep to himself and his difficulties with authority, he enjoyed doing art. However, once the sessions began, he was often hostile to the African-American inmates who made up the majority of his particular art therapy group. The African-American group members positioned themselves away from Jason to avoid interacting with him; the other group members also tended to shy away from him.

Jason revealed his aggressive nature quite early in the group's history. During the first group meeting, he grabbed the group leader's pen, hefted it as if it was "shank" (a stabbing implement), and acted out a stabbing motion. He announced that he "could easily use it to puncture someone in the neck." Although the group leader did not feel directly threatened because Jason was not directing the action toward anybody, his behavior served to set up the hostile identity that he had cultivated for so long. It took several minutes of redirection before he gave the pen back – just short of having to call in reinforcements. It was only afterward that he indicated that he was "playing."

It was only because of his enthusiasm for art that Jason was allowed to stay in the group; he indicated that he loved to do art and to be around the materials. As the group progressed, he became increasingly enthusiastic and more verbal. He interacted well with others in the group and even said, "I made friends with the oil pastels." He expressed disappointment when the eight weeks scheduled for his group ended and, along with the other members of the group, reflected on how much he had enjoyed working with the others. Thus, at the end of the eight-week period, Jason indicated that he did not want the group to end.

Initially, Jason's primary visual symbols were Nazi iconography, specifically the swastikas and the SS lightening bolts. One of the first projects involved completing an inside-outside origami box. The group members were asked to consider what facade they showed others within the prison and what they were reluctant to show. The outside of Jason's box was covered with the Nazi SS symbol and a swastika. Inside the box was a smaller box he made from the scraps, with a lock drawn on it (see Figure 8.1). He said, "What you see on the inside, no one sees; if someone were to ever get in, they would see this." He turned over the locked box that was inside the larger box and on its surface were swirls of blues, greens, and black. He described these designs as "my true core of a whirlwind of emotions." He made it clear that he was inaccessible and hid behind or within the aggression that he presented. Even if someone managed to break through, there would still be a cyclone of emotions to contend with.

Figure 8.1: Jason's inside-outside origami box

As the group progressed, Jason was accepted by his peers because of his exceptional creativity. The lightening bolts he created were ultimately adopted by the group as symbols of unity and group cohesion, and as a means to connect and interact with him. For example, during the second to last session, he participated in a group mural on which the six members of the group drew their "self-symbols." At a bottom corner of the mural, Jason drew two figures holding up the SS lightening bolts surrounded by two strands of barbed wire with a ring of fire in between. This image essentially separated Jason from the rest of the group and reflected his propensity to maintain his self-definition of being isolated and hostile. However, the rest of the men in the group used lightening bolts to reach out from their sections and penetrate the boundaries of his image. At this point, Jason responded by drawing lightening bolts coming from his image and permeating the space around him. Thus, he interacted openly with the others through the shared iconography of the lightening bolts (see Figure 8.2). Although he remained isolated, the mural reflected his need for camaraderie and was an example of symbolic interaction.

In the last session, the group was asked to draw a mandala. Each group member was provided with a round piece of paper and asked to simply draw within the circle. During previous drawings, Jason had sketched disembodied or free-floating eyes, some with tears dripping from their corners. On this

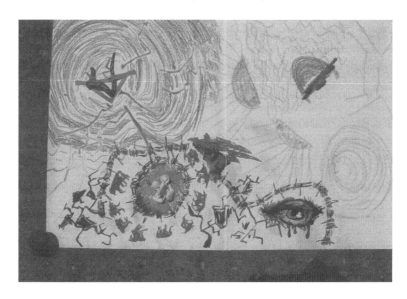

Figure 8.2: Prison project mural (detail of Jason's section)

final piece, Jason started with the same stylized eye. This time, he used the eye to begin drawing a face (see Figure 8.3). Although the image was incomplete, he had begun to create a more cohesive self-image. Through the positive interactions and acceptance that he found within the art therapy group sessions, his aggressive self-identity had slowly been replaced with one more acceptable to the group. Essentially, this final project illustrated what Mead (1964) described as the self developing through appropriate social experiences and activities.

CASE VIGNETTE: ERIC

Eric was an 11-year-old boy seen in private practice. He was referred to art therapy because he needed someone who could address his anger. It was also concluded that he would benefit from being seen by a male therapist. He was a slightly built Caucasian boy dressed in sagging slacks and oversized baggy shirts. He spoke with a rapper's lingo. His parents were divorced; he lived with his mother and saw his father inconsistently once every several weeks. He was under medical care and on medication for attention deficit disorder.

Eric talked about his admiration for rap artists and would often recite some of the more aggressive lyrics. The presenting problems included having trouble in school due to difficulty following directions, and being in trouble with his mother for acting out. His outbursts resulted in his getting

Figure 8.3: Jason's mandala drawing

into trouble. His school problems led to further belligerence from him, resulting in his getting into trouble with his mother. This cycle seemed continuous.

In the first session, Eric's affect was flat and blunted. He was extremely controlled in both his behavioral presentation and his drawing style. When he spoke, he told fantastical and exaggerated stories. He required constant redirection. After the first several sessions, as he became more comfortable with the therapeutic interaction, he began to exhibit more aggressive and resistive tendencies. During one early session, he spent the entire time alternating between loud outbursts while attempting to rip up the paper on the table and sitting sullenly with his face towards the wall.

When he was in a good mood, Eric exhibited a sense of humor and once came to a session with yellow caution tape, which he had found at a construction site, wrapped around his forehead and arms. However, even when in a good mood, he had difficulty focusing and would need several prompts to stay on task. Regardless of his mood or behavior, he was provided with consistent direction on what was expected and was responded to with patient but firm redirection. Sessions began with him describing what had happened during the week, followed with quick check-in drawings. After a few rapid drawings, which were generally superficial and schematic yet

energetic, he would be able to sit and concentrate on the main therapeutic tasks for the day.

Eric enjoyed using clay and used it to create three-dimensional images. During one session, he was given Styrofoam blocks (used for packing material), large Popsicle sticks, and paint, and was asked to create a sculpture with the materials provided. He worked diligently on the project. At first, it was difficult to ascertain what he was working on, but eventually he indicated that it was a torture chamber (see Figure 8.4) and that he got the idea from a program he had seen on the Discovery Channel the night before. The image is quite graphic. A poorly developed human form lies on top of what appears to be a torture platform. Jutting out and through the form are the sticks, with red paint highlighting the places where they emerge. He knew the sculpture was somewhat graphic, and he was surprised when it was placed carefully on a shelf, not to be disturbed during the remaining weeks he was in therapy.

Figure 8.4: Eric's torture chamber made of Styrofoam blocks and popsicle sticks

After this episode, Eric talked more during the sessions. Although he still had periodic episodes of aggressive outbursts, he talked more about the things that made him angry at school and at home. He spoke about the way he responded to his mother and even problem solved about various ways he could handle difficult situations with his parents.

During what was to be one of his last sessions, Eric spoke of his anger as a separate animal. He was asked to sculpt what his anger-beast would look like. Using Model Magic sculpting compound and paint, he created what he claimed was a "Rastafarian-scorpion anger beast" (see Figure 8.5). This sculpture was completed with a large "E" on its chest, his own initial. In contrast to the torture chamber, this piece was meticulously constructed and painted over several sessions. While he was working on this piece, he rarely needed direction when he arrived but would immediately start on the piece. After he was finished with it, he proudly showed it to his mother and explained to her what it was. He was able to talk about how he felt, using the piece to illustrate his frustration and aggressive reactions. Essentially, his final piece reflected the Self presented in a much more acceptable fashion. Albeit still reflecting an aggressive nature, the image was one that he took pride in. Unfortunately, therapy had to end due to scheduling conflicts; the further development of an acceptable self-image had to be put on hold.

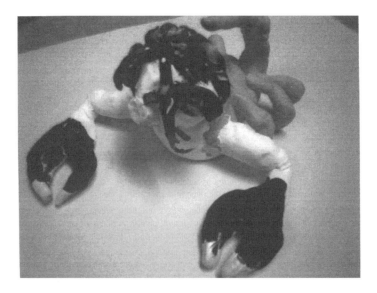

Figure 8.5: Eric's "Scorpion anger Beast" made from Model Magic

Conclusion

Although there are some widespread psychological beliefs about the mani-festation of aggression in people, the social interactionist perspective offers a means to clarify aggressive actions and make clear how such tendencies can be alleviated. Through interaction, aggression is defined and maintained.

Equally, it is through interaction that aggression can be assuaged. The art therapist has unique tools that can create new interactions to aid in relabeling people, validating and reinforcing new behaviors and identities, and redirecting the actions associated with aggressive and hostile tendencies. Rick, Jason, and Eric were three different people all experiencing various aggressive tendencies. However, all three reacted positively to the art and demonstrated marked improvement in their behavior. The art process interrupted the cycles of aggressive identity by strengthening their sense of Self, and by creating new interactions and ways to interpret these interactions.

Acknowledgement

Special thanks to Lariza Fenner, Florida State University Ph.D. student and Research Assistant, who coordinated the prison art therapy project that Jason attended and for taking the photographs of his work.

References

Anderson, C.A. and Bushman, B.J. (2002) "Human aggression." *Annual Review of Psychology 53*, 27–51.

Bartusch, D.J. and Matsueda, R.L. (1996) "Gender, reflected appraisals, and labeling: A cross-group test of an interactionist theory of delinquency." *Social Forces 75*, 145–176.

Beck, A.T. (1999) *Prisoners of Hate: The Cognitive Basis of Anger, Hostility, and Violence.* New York: HarperCollins Publishers.

Becker, H.S. (1982) *Art Worlds.* Berkeley, CA: University of California Press.

Becker, H.S. (1991) *Outsiders: Studies in the Sociology of Deviance.* New York: The Free Press. (Original work published 1963.)

Blumer, H. (1969) *Symbolic Interactionism: Perspective and Method.* Berkeley, CA: University of California Press.

Brewster, L.G. (1983) *An Evaluation of the Arts-in-Corrections Program of the California Department of Corrections.* San José, CA: San José State University Press.

Cooley, C.H. (1964) *Human Nature and the Social Order.* New York: Schocken Books.

Dissanayake, E. (1992) *Homoaestheticus: Where Art Comes From and Why.* New York: The Free Press.

Gay, P. (1989) *Freud: A Life for Our Time.* New York: Doubleday.

Gussak, D. (1997) "Breaking Through Barriers: Art Therapy in Prisons." In D. Gussak and E. Virshup (eds) *Drawing Time: Art Therapy in Prisons and Other Correctional Settings.* Chicago, IL: Magnolia Street Publishers.

Gussak, D. (2004) "A pilot research study on the efficacy of art therapy with prison inmates." *The Arts in Psychotherapy 31*, 4, 245–259.

Gussak, D., Chapman, L., Van Duinan, T. and Rosal, M. (2003) "Plenary session: Witnessing aggression and violence – responding creatively." Paper presented at the annual conference of the American Art Therapy Association, Chicago, IL.

Horney, K. (1992) *Our Inner Conflicts: A Constructive Theory of Neurosis.* New York: W.W. Norton. (Original work published 1945.)

James, W. (1918) *The Principles of Psychology*, Vols. 1 and 2. New York: Henry Holt. (Original work published 1890.)

Kornfeld, P. (1997) *Cellblock Visions: Prison Art in America.* Princeton, NJ: Princeton University Press.

Kramer, E. (1993) *Art as Therapy with Children* (2nd edn). Chicago, IL: Magnolia Street Publishers.

Lorenz, K. (1967) *On Aggression.* New York: Bantam Books.

Mead, G.H. (1964) *On Social Psychology.* Chicago, IL: University of Chicago Press.

Phua, K.L. (no date) *Brief Guide to Sociological Theory.* Retrieved 23 July 2004 from www.phuakl.tripod.com/socio2.html

Rank, O. (1932) *Art and Artist.* New York: W.W. Norton.

Sagarin, E. (1975) *Deviants and Deviance: An Introduction to the Study of Disvalued People and Behavior.* New York: Praeger Publishers.

Ursprung, W. (1997) "Insider Art: The Creative Ingenuity of the Incarcerated Artist." In D. Gussak and E. Virshup (eds) *Drawing Time: Art Therapy in Prisons and Other Correctional Settings.* Chicago, IL: Magnolia Street Publishers.

Zimbardo, P.G., Haney, C., Banks, W.C. and Jaffe, D. (1973) "The mind is a formidable jailer: A Pirandellian prison." *The New York Times Magazine*, 8 April, p.38.

The Paper People Project on Gun Violence

Rachel Citron O'Rourke

Life of a Gun

Destruction of a human,
Destroyed by another,
Could've been your
Cousin, sister, father, or
Were the hands on the trigger your little
Brother's?
Bullet with no name
Taking a life is a
Shame
Violence must stop,
The consequences are
Deep
Making the wrong choice
Causes one to Weep
Leave the guns alone
Since we can't stop the
Production
Choose to say NO to save a life from
Destruction.

(Bey undated)

The demise of the 1994 assault weapons ban

"Assault weapons were designed for rapid fire, close quarter shooting at human beings… They are mass produced mayhem" (Bureau of Alcohol, Tobacco, Firearms and Explosives, cited in Brady Campaign undated, paragraph 6). The federal law banning the sale of semi-automatic assault weapons, known as the "Federal Assault Weapons Ban," was passed as part of the Violent Crime Control and Law Enforcement Act of 1994. President Bill Clinton signed it into law on September 13, 1994 (Brady Campaign undated). On that date, domestic gun manufacturers were required to stop production of semi-automatic assault weapons and ammunition clips holding more than ten rounds except for military or police use. Opponents of the ban argued that such weapons only "look scary."

The truth about assault weapons is that they are designed for military purposes and equipped with combat hardware such as silencers, folding stocks, and bayonets, which are not found on sporting guns. Assault weapons are also designed for rapid fire and many come equipped with large ammunition magazines allowing 50 or more bullets to be fired without reloading. The public is frightened for a reason and is at increased risk when these guns are on the streets. The 1994 assault weapon ban expired at 12:01 a.m. on Monday, September 13, 2004, due to President George W. Bush's inaction (Brady Campaign undated).

Gun violence: A worldwide public health crisis

In a World Health Organization report (Krug *et al.* 2002), it was estimated that at in 2000 at least 500,000 people died worldwide from gun-related violence. Using death certificate data, the National Center For Health Statistics, an agency of the Centers for Disease Control and Prevention, determined that "a total of 32,436 persons died from firearm injuries in the United States in 1997" (Bonderman 2001, p.3). More than half these deaths were suicides, 41.7 per cent were homicides, and the remaining 4.1 per cent were accidental deaths.

In a single year, 3012 children and teenagers were killed by gunfire in the US, according to the latest national data released in 2002. That is one child killed every three hours, and more than 50 children killed every week. Additionally, at least four to five times as many children and teenagers suffer from non-fatal firearm injuries (National Education Association Health Information Network undated).

Gun violence impacts people from all socioeconomic and geographic boundaries, from rural communities to inner cities to suburbs, in schools, public meeting places, streets, homes, and workplaces. Gun-violence victims and survivors are African-American, Asian, Latino, Caucasian, male and female, young and old. The victimizers may be either intimately related to their victims or strangers.

In spite of the pervasive nature of gun violence, some demographic groups are disproportionately represented in the victim population. Gun homicide victims are disproportionately young and predominantly male (National Center for Injury Prevention and Control undated). The circumstances of firearm violence differ significantly for men and women. Women are far more likely to be killed by a spouse, intimate acquaintance, or family member than by a stranger (Kellermann and Mercy 1992).

For every firearm death, there are approximately three non-fatal firearm injuries treated in hospital emergency rooms in the US. According to *Criminal Victimization 1998* (Rennison 1999), victimizations involving a firearm represented 23 per cent of the 2.9 million violent crimes of rape and sexual assault, robbery, and aggravated assault. Further, 670,500 crime victims reported facing an assailant with a gun.

A national registry has not been established to accurately compile data on the incidence of non-fatal gun-violence injuries. Based on what is known, statisticians estimate a higher rate of non-fatal gun-violence injury in the US than has been reported to date (Zawitz 1997).

Gun violence and trauma

The pervasiveness of traumatic responses caused by gun violence is impossible to capture statistically. Secondary victims or, as gun-violence activists refer to them, "co-victims" are the parents, children, siblings, spouses, and loved ones who have lost a family member or friend to gun violence or who have witnessed gun violence. Co-victims, in the aftermath of an injury or death by gun violence, must cope with working with the police, the press, the court system, the medical examiner, crime scene clean up, and often need to arrange for a sudden funeral.

Family members and friends, fortunate enough to access mental health treatment, may work through the trauma caused by gun violence and the sudden injury or loss of a loved one. Individuals, families, and communities that don't have access to crisis intervention and ongoing mental health treatment are often forced to cope with traumatic reactions on their own and

are at higher risk of developing chronic posttraumatic stress disorder (PTSD).

One in two people will be exposed to a life-threatening, traumatic event in their lifetime. Epidemiological studies indicate that about ten per cent of Americans have had or will have PTSD at some point in their lives, and that about 5 per cent cope with PTSD at any given time. Women are twice as likely as men to develop PTSD.

Every person, young or old, regardless of race, creed, or color, who is exposed to gun violence is at risk of developing PTSD. A huge body of research on the rate of PTSD among survivors of gun violence focuses upon children and youth due to the high rate of exposure to gun violence among these age groups. Studies of urban youth show a high correlation between exposure to violence and depression and PTSD. Elementary school-age children are also frequent witnesses to gun violence and often display symptoms of PTSD and other trauma-related disorders (Schwab-Stone *et al.* 1995).

Contributing factors that may have an impact on the severity of PTSD symptoms in children and youth include the type of wound, the proximity to the shooter, the relationship to the shooter, and whether the shooting took place in a context generally considered safe. Child witnesses who have been raised in a subculture of violence in the home may have additional risk factors for long-term psychosocial consequences (Richters and Martinez 1993).

Community trauma

Traumatic reactions spread well beyond the families and friends of gun-violence survivors and victims. Entire communities can become co-victims as well. According to a report from the US Department of Housing and Urban Development (2000), public housing residents are more than twice as likely as other members of the population to suffer from firearm victimization, one in five residents reports feeling unsafe in his or her neighborhood, and children show symptoms of PTSD similar to those seen in children exposed to war or major disasters. Likewise, James Garbarino and Kathleen Kostelny, in their chapter "What Do We Need to Know to Understand Children in War and Community Violence?" (1996), report that children in war zones and those living in the inner cities of the US often exhibit the same cluster of symptoms associated with PTSD. Such children tend to live in a constant state of alarm.

Lenore Terr, in her book *Too Scared to Cry* (1990), explores how the psychic numbing that often occurs as result of a traumatic event may have an impact not only on the individual trauma survivor but also on the community as a whole:

> Psychic numbing may be a culturally accepted personality trait in geographical areas where dehumanizing events routinely take place. Recurrent flooding, famine, and mass death probably serve to create benumbed characteristics in an entire populace. (p.95)

Stories from the front: War and inner-city survivors

Working as an art therapist with survivors of war and torture, I witnessed on a daily basis the emotional and physical injuries caused by gun violence. In my later work with inner-city youth, I continued to witness the severe symptoms of chronic exposure to gun violence. Certain stories that emerge during therapy sessions are destined to remain embedded in a therapist's psyche. These stories challenge our ideals, change how we think about the world, and eventually drive us to take action.

As an art therapy student and later as a postgraduate volunteer, I provided long-term art therapy to a young war survivor. Anya, a 9-year-old Bosnian girl and war survivor, was forced to flee Sarajevo and relocate with her family in a drug-ridden, violent neighborhood in Chicago. In Sarajevo, Anya and her family lived under siege surrounded by snipers in the hills encircling the city. In Chicago, they continued to live under siege surrounded by gun violence.

While playing in the front yard of her home in Sarajevo at age six, Anya stepped on a landmine and her left leg was blown off up to her hip. After that, she experienced vivid nightmares at night and vivid flashbacks by day. Three years later, she was referred to art therapy for treatment of chronic PTSD when her parents sought help for her from a refugee mental health agency. During a family session one day, her mother tearfully said:

> Anya runs from the apartment to the car. She runs from the park to the apartment. She runs from one building to another and always tries to look every which way. She can't stop running. It is not good for her because it is very hard with the prosthetic leg.

Anya responded to her mother's story in a quiet, yet matter of fact voice:

> I have to run because if I don't I will be shot in the head. You know they aim for people's heads.

I later worked at a children's hospital with a team of clinicians providing crisis intervention within 24 hours of admission to children and youth brought to the hospital with gunshot injuries. Again, I became a witness to the physical and mental injuries caused by gun violence.

I was called to the bedside of a four-year-old child shot in the stomach during a drive-by shooting in front of his house. He did not speak; he did not make eye contact. He looked straight ahead and sat as still as possible in his hospital bed. His mother and grandmother sat teary- and wide-eyed beside him. He chose a red marker and created scribble after scribble for 20 minutes. Then, in a soft unsteady voice, he began to tell his story: "I was playing and little bombs were all around me and then something went into my stomach. Now it's out, but I have a hole in me and my guts may come out."

The role of countertranference

Sustaining empathy when working with survivors with PTSD and other trauma-related reactions is both necessary and often difficult to maintain. Countertransference reactions are partly related to the conscious and sub-conscious role-playing that occurs within the therapeutic relationship. In therapy, when a client is reliving or retelling traumatic experiences, the therapist may feel as if she or he has entered into the traumatic experience through role enactments. Wilson and Lindy (1994) describe common role enactments related to countertransference reactions:

> Countertransference positions (role enactments) range from positive "The therapist becomes a fellow survivor or helpful supporter, rescuer, or comforter near the trauma" to negative "The therapist becomes a turncoat collaborator or hostile judge." (p.9)

Yael Danieli, in her article entitled "Who Takes Care of the Caretakers?" (1996), states:

> Countertransference reactions are integral to and expected in our work, which call on us to confront, with our patients and within ourselves, extraordinary human experiences. This confrontation is profoundly humbling in that at all times it tries our view of the world and challenges the limits of our humanity. (p.196)

When confronted with the inhumane life conditions and traumatic aftermath that people are left to cope with throughout their lives,

countertransference reactions may inspire the art therapist to practice art therapy as social action.

Gun-violence prevention and community intervention: Art therapy as social action

The art therapist can affect change beyond the traditional art therapy session. Practicing art therapy as social action, the art therapist provides a visual process for the child, family, and community at large to cope with and process traumatic experiences while collaborating to taking action. Clinical evidence supports the therapeutic value of victims working as change agents in grassroots or church activities, informal support groups, and anti-crime organizations (Temple 1997). Art therapy as social action may serve as either an adjunct or primary change-agent intervention.

When approaching gun violence or any identified social ill as a public health issue, art therapists practicing social action can work to develop interventions at three primary levels within communities. These primary levels of intervention, according to public health practice, are traditionally characterized as "primary" approaches, which aim to prevent violence before it occurs; "secondary prevention" approaches, which focus on a more immediate response to violence; and "tertiary prevention" approaches, which focus on long-term care in the wake of violence (Krug *et al.* 2002).

To envision and develop a clinically appropriate and socially relevant art therapy as social action project, the art therapist brainstorms an idea, conducts research, collaborates with allied professionals and organizations, develops project materials, identifies funding, markets and launches the project, and develops an interactive exhibition of the project. The history of the Paper People Project (PPP), an international arts installation against gun violence that I initiated, illuminates this process and, at the same time, explores the project results.

Transforming ideas into action: The PPP

The concept behind the PPP is simple: to invite people from countries around the world (including Australia, Bosnia, Canada, England, France, Israel, Japan, Korea, Morocco, Somalia, and Vietnam) to create artwork in response to their ideas, feelings, and experiences related to gun violence. People are asked to use the same human-form outline for their art expres-

sions, and all these are linked together to create an installation against gun violence.

Extending one's work as an art therapist beyond the walls of the therapy session requires much thought and planning before transforming an idea into action. In order to create and launch an effective art therapy as social action project, research and development must take place during the initial planning phase of the project. Art therapists, possessing a wide breadth of experiential knowledge gained from clinical work with various populations, need to conduct academic research to strengthen project goals and project implementation.

Collaboration and relationship building with local, national, and inter-national organizations are vital to all stages of the development and launch of an art therapy as social action project. During the initial planning phase of the PPP, there was collaboration with the Million Mom March, the Trauma Foundation, the Bell Campaign (a national organization aimed at preventing gun death and injury), the Illinois Art Therapy Association, and Ceasefire.

Collaboration leads to concrete goal setting based on community needs in the area of violence prevention, intervention, and social activism. The PPP goals include providing an arts-based intervention to people of all ages impacted by gun violence, increasing awareness regarding the issue of gun violence worldwide, creating thousands of Paper People artworks for exhibitions across the US and online, establishing an interactive exhibition process, and training health professionals and youth leaders to use the PPP as an intervention tool with diverse populations of children, youth, and adults.

Creating the PPP materials

As with most social action projects, one of the main goals is to empower individuals, groups, and communities to take action. Art therapists must work towards this goal while developing project materials and ensuring that all materials are clinically appropriate. My collaboration with the Illinois Art Therapy Association (IATA) board members proved to be invaluable during the initial development of the PPP materials. IATA board members were committed to the practice of art therapy as social action and contributed to the development and funding of the PPP.

The art materials and written materials for any art therapy as social action project must be accessible to diverse age groups and easy to distribute, clearly state the goals and purpose of the project, and provide education on

how to use the project responsibly. The PPP packet of materials consists of one gender-neutral outline of a person, a one-page project description, a one-page project directive, two release forms (one for people under 18 and one for people 18 or older), and a five-page project curriculum. The simple outline of the Paper People person provides participants with a safe, contained space to visually express their ideas and feelings about gun violence.

The written information that accompanies the person outline includes release forms because they are required in order to display and publish the PPP artwork. To create a long-lasting and effective social action project, the art therapist must accept that non-art therapists are capable of implementing the project. The curriculum is essential in order to ensure that allied health professionals and youth leaders are able to responsibly use the project to promote change in their communities.

Marketing: How do people find out about the project?

Some may consider a discussion regarding marketing and distribution awkward to include in a chapter about art therapy as social action. Marketing is an essential skill that all art therapists and social activists must develop to carry out their community work. To successfully market and distribute the PPP worldwide, a website was developed that included all project materials for downloading, an online gallery featuring Paper People artworks, information on gun violence, links to other sites, and project updates. Networking, sending out press releases, conducting interviews for newspapers, radio, and television are all effective ways to market a project to the public. The PPP has been featured on local news, in newspapers, and on the radio over the past four years.

Distribution of project materials might consist of mailings, driving around to drop off materials to schools, agencies, and community centers, and initiating collaboration with agencies, non-profit organizations, artists, art therapists, and social activists around the world. Sending project materials free to anyone requesting materials can also be done. Most Paper People packets have cost between US $1–5 including postage, with participants asked to pay for return postage.

Launching the PPP

Following six months of project development, the PPP was launched to the public at the Million Mom March in Chicago, Illinois, on Mother's Day

2000. The event drew survivors of gun violence, families of victims of gun violence, activists, and everyone in between including pro-gun advocates. Mothers carried framed pictures of their children killed by guns. Brothers and sisters wore buttons featuring pictures of a loved one lost through gun violence. Behind the chain link fences surrounding the event, pro-gun advocates held posters bearing such legends as "My President is Charlton Heston," "University of Smith and Wesson," and "Gun control means using both hands."

Over 500 children and their mothers and fathers waited up to 20 minutes to create Paper People artworks. We were not prepared for the overwhelming desire to participate in the project. People used the art process to create memorials, visual statements against gun violence, and images calling for peace. Teachers, social workers, therapists and youth leaders collected Paper People packets to take back to their communities to spread the project across Illinois. Parents, sisters, brothers, and cousins took packets to bring to friends, family members, and their local community centers. At the end of the day, the PPP had grown beyond the IATA's and my wildest dreams.

By 2001, hundreds of art therapists, social workers, therapists, educators, youth leaders, and activists introduced the PPP to schools, colleges, universities, community centers, treatment centers, youth conferences, community events, and a federal women's prison.

Paper People artwork

Universal visual responses to gun violence have emerged in the Paper People artworks as thousands have been compiled over the years since the launch of the project. The universal responses can be divided into the following categories: graphic depictions of gunshot wounds, the heart as a central visual element, messages of peace, death imagery, warrior images, and memorials.

Vivid memories of direct exposure to gun violence, media-generated images of gun violence, or witnessing gun violence may contribute to the creation of numerous Paper People artworks that depict graphic imagery of gunshot wounds. These artworks may offer the viewer a glimpse into the memories of survivors of gun violence or a glimpse into how differently people process their fear of gun violence. Some of the graphic images may also reflect how people choose to make a visual statement against gun violence. It is impossible to determine why so many people choose to depict graphic gunshot wounds, yet the evidence of this universal visual response to gun violence is evident in the PPP collection.

Most people sustaining a gun injury to their heart do not survive. Perhaps this universally known fact influences the large grouping of Paper People artworks with the heart as a central visual element. In many of these artworks, the heart is depicted in bright red dripping blood. Perhaps the heart represents the emotional pain people have experienced as a result of gun violence or the emotional pain that emerges as they imagine the consequences of gun violence. Again, each artist holds the key to the meaning of their own artwork, yet it is quite remarkable that so many people emphasize the image of a heart in their Paper People artwork (see Figure 9.1).

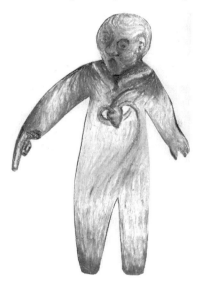

Figure 9.1: Paper Person showing heart

Many Paper People artworks include peace symbols and written words calling for the end of gun violence and for peace. People may turn to powerful words to accompany their artworks in order to feel assured that their voices are heard. War is closely associated with gun violence. The Paper People artworks containing calls for peace may be influenced by this close association and by a natural human tendency to globalize the issue of gun violence. Many people struggling to cope with chronic exposure to gun violence may symbolize, through the use of peace imagery, their recognition that they live in American war zones.

Death imagery in the visual form of skeletons, body bags, and "Xs" over the eye regions seems to reflect the universal recognition of the fatalities

caused by gun violence. These images also serve as warnings to the public regarding the future deaths that will occur as a result of gun violence. Warrior imagery seems to stand at the opposite end of the spectrum when examining the Paper People artworks. The warrior images depict superhero-type figures with swords, shields, capes, and words of power. Many of these images appear to be created by children and may reflect a belief that they are invincible or that they will be saved from gun violence by someone with magical powers (see Figure 9.2).

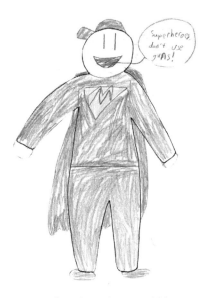

Figure 9.2: Paper Person as superhero by eight-year-old boy

The need to memorialize is evident across cultures. Captured in many of the Paper People artworks is this universal desire to memorialize loved ones who have passed away (see Figure 9.3). Families and friends of victims of gun violence must cope with the trauma in the wake of a sudden death and discover ways to memorialize their loved ones. Judging by the numerous Paper People created to symbolize loved ones killed by gun violence, the art process seems to provide a safe way for people to create visual memorials. The need to ensure that a loved one has not died in vain as a result of gun violence is also partly fulfilled when people knowingly create visual memorials for inclusion with thousands of other Paper People to stand together against gun violence.

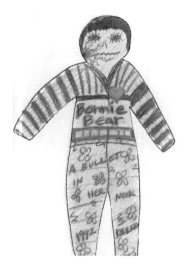

Figure 9.3: Paper Person as memorial

The interaction exhibition: The growing chain of Paper People

The first small exhibition of the Paper People took place at the Open Studio Project in Evanston, Illinois, in 2001. The first exhibition of the entire project installation took place in Peoria, Illinois, at the performing arts center at Illinois Central College later that same year. When visitors enter the Paper People exhibition space, they are confronted by hundreds and, in larger exhibitions, thousands of Paper People artworks hung alongside one another, attached by paperclips to lines of twine. On some of the Paper People are poems, stories, and gun-violence statistics placed inside the Paper People outlines. Visitors may wonder why there is an area with twine and no Paper People. Not until they delve further into the exhibition do they realize that the space is waiting for their Paper People.

The traditional associations and meaning of "artist," "audience," "art therapist," "client," and "exhibition" are transformed by the interactive exhibition. There is no such thing as a "non-artist" to an art therapist. Artists working to launch community arts projects may experience frustration working with non-artists. Art therapists know that everyone possesses the ability to create art and thus may be more readily able to create interactive exhibitions than artists. The interactive exhibition places visitors in an active rather than a passive role. It creates an opportunity for everyone visiting the exhibition to immediately respond visually or verbally to the artwork

displayed, and to include these responses within the exhibition. Paper People art exhibitions always include a space for visitors to create their own Paper People, which they can immediately include in the exhibition. They are provided with art materials, the project directive, and paperclips, and they are encouraged to hang their artwork alongside the existing artwork.

Visitors become artists and participants, and find themselves immediately abandoning outdated concepts about the experience of visiting an art exhibition. The interactive exhibition is necessary to the growth and expansion of art therapy as social action. The very nature of the PPP is to encourage people to make their contribution through creating artwork and writing about gun violence. The interaction exhibition is the only way to further this project goal.

Art therapists know that viewing artwork and creating artwork may raise clinical issues. In order to establish the interactive exhibition as a safe environment, a trained art therapist or allied professional must be present to ensure the safety of the art-making process for everyone. This person checks in with people and makes sure that people get the support they need to process the interactive exhibition experience. In no way does this mean that the art therapist or allied professional is providing therapy at the interactive exhibition; it means that they are prepared to contain emotions and maintain the safety of the environment.

Containment for the art therapist

As mentioned above, countertransference reactions may inspire the art therapist to practice art therapy as social action. The art therapist may also experience countertransference reactions to the social action project at any stage of the development, implementation, launch, and exhibition of the artwork. Each time I received a Paper Person memorial artwork, I experienced intense feelings of sadness and hopelessness when faced with more evidence of the human toll resulting from gun violence. Supervision, long conversations with family, friends, and colleagues and creating artwork all proved to be invaluable ways to cope with and process these countertransference reactions. Just as many life experiences seem to work in cyclical patterns, the countertransference reactions fueled ongoing work promoting and expanding the PPP.

There is no conclusion: The PPP transformed

No one predicted that the PPP would take on a life of its own. Transforming the PPP to meet the concerns and needs of art therapists interested in addressing diverse social issues has taken place over the past few years. I received an email from an art therapist concerned about global warming, who asked me for permission to use the PPP idea to launch a social action project for that issue. We exchanged emails and in those emails I explained that the idea of ownership of the project did not seem to honor my intentions for the PPP. Since then, art therapists have transformed the PPP to address issues of sexual abuse, teenage pregnancy, eating disorders, domestic abuse, and homelessness.

I also faced a need to transform the PPP to protest against the war in Iraq. In 2003, Paper People images depicting gunshot wounds were enlarged to life size and used to fill the downtown public square in Portland, Oregon, for the first US "die-in." People of all different ages and backgrounds gathered in the square to "die" on top of the Paper People images (see Figure 9.4). The powerful nature of the visual statement against war attracted hundreds of witnesses including the news media such as National Public Radio, local television stations in Portland, Oregon, and the Oregonian.

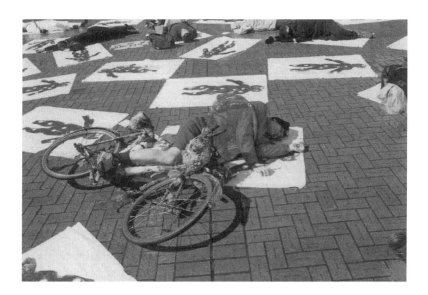

Figure 9.4: Die-in, Portland, Oregon

Perhaps the lesson of the history of the PPP is that, once you practice art therapy as social action, it becomes integral to the way you respond to issues throughout your life.

References

Bey, J.M. (undated) "Life of a gun." Unpublished poem.

Bonderman, J. (2001) *Working with Victims of Gun Violence.* Retrieved 15 May 2004 from www.ojp.usdoj.gov/ovc/publications/bulletins/gun_7_2001/welcome.html

Brady Campaign (undated) *Assault Weapons Threaten Public Safety.* Retrieved 14 March 2004 from www.bradycampaign.org/facts/issues/?page=aw_renew

Danieli, Y. (1996) "Who Takes Care of the Caretakers?" In R.J. Apfel and B. Simon (eds) *Minefields in Their Hearts: The Mental Health of Children in War and Communal Violence.* New Haven, CT: Yale University Press.

Garbarino, J. and Kostelny, K. (1996) "What Do We Need to Know to Understand Children in War and Community Violence?" In R.J. Apfel and B. Simon (eds) *Minefields in Their Hearts: The Mental Health of Children in War and Communal Violence.* New Haven, CT: Yale University Press.

Kellermann, A.L. and Mercy, J.A. (1992) "Men, women, and murder: Gender-specific differences in rates of fatal violence and victimization." *The Journal of Trauma 33*, 1–5.

Krug, E.G., Dahlberg, L.L., Mercy, J.A., Zwi, A.B. and Lazano, R. (eds) (2002) *World Report on Violence and Health.* World Health Organization. Retrieved 20 April 2004, from www.who.int/violence_injury_prevention/violence/world_report/en/index.html

National Center for Injury Prevention and Control (undated) *Youth Violence: Fact Sheet.* Retrieved 12 April 2004 from www.cdc.gov/ncipc/factsheets/yvfacts.htm

National Education Association Health Information Network (undated) *Statistics: Gun Violence in Our Communities.* Retrieved 28 May 2004 from www.neahin.org/programs/schoolsafety/gunsafety/statistics.htm

Rennison, C.M. (1999) *Criminal Victimization 1998: Changes 1997–98 with Trends 1993–98.* US Department of Justice: Bureau of Justice and Statistics: National Crime Victimization Survey. Retrieved from www.ojp.usdoj.gov/bjs/pub/pdf/cv98.pdf

Richters, J.E. and Martinez, P. (1993) "The NIMH Community Violence Project: I. Children as victims of and witnesses to violence." *Psychiatry 56*, 7–21.

Schwab-Stone, M.E., Ayers, T., Kasprow, W., Voyce, C., Barone, C., Shriver, T. and Weissberg, R. (1995) "No safe haven: A study of violence exposure in an urban community." *Journal of the American Academy of Child and Adolescent Psychiatry 34*, 10, 1343–1352.

Temple, S. (1997) "Treating inner-city families of homicide victims: A contextually oriented approach." *Family Process 36*, 2, 133–149.

Terr, L. (1990) *Too Scared to Cry: How Trauma Affects Children…and Ultimately Us All.* New York: Basic Books.

US Department of Housing and Urban Development (2000) *In the Crossfire: The Impact of Gun Violence on Public Housing Communities.* Washington, DC: US Department of Housing and Urban Development.

Wilson, J.P. and Lindy, J.D. (eds) (1994) *Countertransference in the Treatment of PTSD.* New York: Guilford Press.

Zawitz, M. (1997) *Firearm Injury from Crime.* Washington, DC: US Department of Justice, Bureau of Justice Statistics.

PART V

Healing Trauma

Some Personal and Clinical Thoughts about Trauma, Art, and World Events

Annette Shore

Introduction: Attempting the impossible

In writing this chapter, I am attempting what feels like the impossible. My topic explores a personal experience of trauma as well as bigger questions, some of which are clinical and some of which focus on the impact of world events. The terrorist attacks of 2001, the "war on terror," and the war in Iraq have created a backdrop of trauma. I will explore some of the effects of these events from both a personal and a clinical perspective. The material consists of a muddle of questions for which I cannot provide any clear answers. There may not be explanations for much of what I have to say. The experience of trauma produces a kind of nameless dread. To what degree can expression help to name the dread? To what degree can naming the dread help to tame it?

A personal disclosure

In revealing a personal experience of trauma, I am uncomfortably exposing myself. I hope to use this exposure as a tool for illuminating some clinical questions. This is part of an effort to shed light on the experience of trauma and on the question of how it might be resolved through the use of art. I will also address some questions about the role of the therapist in treating clients who live with trauma, whether this is the constant suggestion of trauma that is generated by world events or a discrete experience of trauma. Although

these questions are beyond the scope of my understanding, I shall attempt to approach them in a limited and somewhat subjective fashion.

Using my own experience as an example creates a sense of personal vulnerability. It is my hope that this vulnerability will provide an inroad to understanding the effects of trauma, as opposed to my fear that I will simply reveal the muddle that characterizes its impact. The reason I mention this is to emphasize that shame and self-deprecation are insidious and pervasive sequelae of trauma (Bromberg 1998). The feeling of "fog" that I will refer to is a protective function; but it also limits one's ability to live fully. The experience of trauma can render one unintelligible. So I must fight the pull to remain in a silent fog. I must try to overlay some coherent organization onto my experience; this is a daunting task because on a neurobiological level the nature of a traumatic response is that it impedes coherent thought (Bromberg 2003; Van der Kolk 2003).

Revealing a traumatic experience inevitably induces feelings of shame. So, in a sense, it goes against my better instincts to write this chapter. I feel that I should be exiled and keep my experience unexposed; but this would only further feed the shame. According to Bromberg (2003), a traumatic reaction is constituted by a kind of global ambivalence. A threat to self-survival is inherent in the retelling of the traumatic experience. At the same time, it may not be possible to rebuild the damaged sense of Self unless some way of retelling the experience can be navigated.

Psychological and societal health

Although this exploration includes a study of some effects of political events, I do not bring a political agenda to my clinical work or to this writing. The agenda that I bring is that of fostering improvement in the level of maturity and strength of each individual. This type of growth relates to personal struggle that would not be served by the presence of a political agenda on my part. I work with individuals who fit within a wide spectrum of political and personal beliefs. Although this chapter deals with some political themes, I am not espousing a specific political doctrine. Rather, I am attempting to anecdotally explore, on both a personal and clinical level, the impact of trauma that was generated by some recent current events.

My position emphasizes the belief that promoting psychological health is a form of social action because psychologically healthy individuals improve the quality of society. Individuals and society are mutually and dynamically stimulated and affected by each other (Erikson 1963). I realize

that, as a clinician, my personal growth and limitations affect my clients, that my clients' growth affects me, and that the relative health or pathology of our governmental and economic systems provides a dominant influence on everyone. The strengthening of individuals contributes to the health of society. This is a well-established theoretical position in the field of mental health. Freud (1961) emphasized human beings' reverence for beauty and love as a constructive societal propensity. Erikson (1963) developed a well-known theory of psychosocial development. He maintained that, throughout the lifecycle, individual growth is stimulated by vital interaction with the environment. Resolving the struggle of each developmental stage allows for increasingly reciprocal and mutually satisfying involvement with society.

Vaillant (1993) elaborated on Erikson's (1963) theory, describing the role of defenses and their potential relationship to individual maturation throughout the lifecycle. Mature defenses include altruism, anticipation, sublimation, suppression, and humor. These defenses contribute to the well-being of individuals and to the world at large. Mature defenses contribute to a constructive society.

Both personal and social/cultural/political factors underlie human strengths and pathologies. Fear within a society often generates emotional reactivity. The tone set by a given political leadership influences the personality structure of society as well as the individuals within the society. As Sarra (1998) describes, in reference to both political and clinically oriented systems, scapegoating is a process of defensive disconnection that is based not on reconciliation of differences but rather on disowning or destroying unwanted aspects of the conflicted whole. Rather than having to bear the ambivalence of the conflict, the pain is denied. "These factors contribute to the dynamics of conflict at every level from the personal to the international, for example, propaganda during warfare" (Sarra 1998, p.73).

A personal trauma

In 2003, I experienced a shocking, personal, politically related event. My husband experienced a brutal attack and arrest by the police while standing and silently observing a political protest. This was a traumatic event for him. Although I was an indirect recipient of the attack, it affected me deeply. The experience was temporarily psychologically shattering. I had never before been shattered in this way. I know that every day many people sustain far more devastating experiences (direct combat, abuse, violent assault). I was

very fortunate to have resources necessary to repair much of the damage. I experienced a relatively minor trauma (although it did not feel minor at the time), and I was able largely to recover. Yet, I do not believe that I will ever be fully restored to the level of freedom from fear that I previously experienced.

The trauma begins

On August 21, 2003, I received a phone call from the county jail. It was 6:30 p.m., and I was expecting my husband Mark to come home. When the phone rang, I thought it would be Mark, calling to say that he was running a little late. But it was a mechanical voice, stating that this was a collect call from the county jail. I said, "I accept the charges!" But it was mechanical, so it kept talking and did not listen to me. "This call will cost $2.30," the voice continued. "Press nine to accept." I pressed nine very hard. "I'm in jail," said Mark's voice. Upon hearing this, my state of shock caused me to feel as though my body had split into what it would look like if viewed with double vision. Although I sat still, my internal experience was a violent one. Mark said, "I'll call you when I get out of here in a few hours." I tried to say something, but I could not talk. He sounded extremely frightened. Then he said good-bye, and the phone was silent. I was torn apart.

After hanging up, I thought of what I wished I had asked: "How did you end up in jail?" I had been so stunned that I froze. There were no words. I began to think in tidal waves of fear that overtook me. I had no way to make sense of my husband being in jail. He never does anything wrong, and neither do I. We work hard and are law-abiding citizens. So, beginning with this initial call from jail, I felt ashamed because I viewed incarceration as implying guilt and shame.

I felt alone and frightened. I tried to think. It was hard to think having taken on this doubled version of myself. My thoughts had an echo. My associations to jail were very frightening. They included images of sadistic guards and inmate rapes. Such associations further clouded my ability to think in any rational way. I just sat waiting for the phone to ring, and I was not sure what to do. I did not feel I could call anyone. Was it because I was in a state of speechless shock, or was it because I did not want to tie up the telephone? It got darker and darker outside, but I did not turn any lights on.

After about two hours, the telephone rang again. It was a jail officer. She asked me questions. How long had we lived at our current address? Did we own our home? Did Mark have any mental illness? For the few minutes that I spoke with her, I began to feel calmer because I knew she had just seen Mark.

I had the sensation that an elevator was going up and down inside my body. The woman on the phone said that she was setting up Mark's bail ($650). I said, "I don't know how to post bail. Where do I go? What do I do?" She said, "I'll connect you to the bail officer." Then came silence followed by a recording every few seconds for 20 minutes, "We appreciate your patience. Please hold and the next available attendant will assist you."

Finally, a woman answered the phone. "What's the inmate's name?" she asked. "I haven't processed his bail. Call back in about an hour." I was stunned because I had thought that this person would tell me what I needed to do. After a while, I looked up the county jail number in the telephone book. When I called, I had to listen to the "we appreciate your patience" recording for a very long time. I kept my eyes closed. I felt like a big iron door had slammed in front of me. The person who answered the phone seemed like the same woman I had spoken to previously. She said that the bail was $750. I asked, "What do I do?" She said, "It's too late to post bail tonight." I said, "I don't understand what's happening. Why is he in jail? I can't get in touch with him." She said, "He coulda called you." I tried to picture a phone in his cell. I said, "I don't even know why he's in jail." She said, "The charges are disorderly conduct, resisting arrest, and attempting to assault a police officer." After I hung up, I kept remembering the mean tone in her voice; it seemed as if she was trying to teach me a lesson, as if I was a very low person deserving of hatred. I felt like a helpless victim at the mercy of a seemingly arbitrary and irrational force.

I wanted to cry out, but there was only a soundless dryness in my throat. I felt terribly abandoned – but by whom? Was it by my husband who was supposed to be home? I could not make sense of this. It made no sense that my husband would be in jail and considered a criminal. I had always taken for granted that the law was on my side. If the law was not on our side, would I ever be safe? What would happen to us?

Mark was not released from jail until late the following evening. I spent the entire period of time until then in uncertainty. Upon his release, I got to hear what had happened to him. The period before I reconnected with him was excruciating. As I have described, I felt myself torn apart. It took several weeks to recover from this state.

Mark's arrest explained

Mark told me about his arrest. He believed that he remembered it accurately and completely. He painstakingly sought to describe every detail. However,

there was much that he did not remember. We found this out later because police-watch groups had videotaped the event. Here is what happened.

Mark was standing in a park where several hundred protesters lingered. He was standing on the periphery, watching what looked like the police moving in on some protesters. He was pushed very forcefully from behind by a police officer. As he struggled to regain his equilibrium, three officers jumped on top of him and started beating him on the back. He was so disoriented that he did not know who was on top of him at first. He thought that he was being mugged. "Give me your hand!" said the pile of weight on top of him. Mark was stunned and immobilized by the weight and was thus unable to release his hand. Someone reached under him and yanked out his hand, causing him to scream in pain. He was handcuffed with plastic wires and led to the sidewalk where he was told by a police officer that he was being charged with disorderly conduct, resisting arrest, and attempting to assault an officer.

What followed was a very frightening series of events: enduring handcuffs so tight that wrist circulation was impeded; undergoing interrogation; being strip-searched and then incarcerated for 30 hours; and, finally, being released without identification, keys, money, belt, or eyeglasses. (These items were stored in another building, open only during limited weekday hours, and Mark was released on Friday at 10 p.m.)

A maze of confusion

We spent the following weeks in a state of shock. Facing serious criminal charges was extremely frightening. Our lawyer told us that, for these charges, the sentence could be up to 18 months in prison. Being brutally attacked by the police, whom we had thought of as our protectors, produced an additional state of bewilderment and betrayal. Further, in order to fight criminal charges and possible incarceration, very expensive legal representation was a necessity. We had terrible nightmares. I dreamt of watching prisoners being bound and tortured. It is hard to say whether the dreams or the reality were more frightening.

We spent the entire fall in a frightening and confusing Kafka-esque legal battle that cost over $10,000. Finally, after five months, the criminal charges were dismissed. The videotapes taken by the police-watch groups were instrumental in proving Mark's innocence. They show a chaotic scene that includes a lot of yelling and masses of police in full riot gear. Mark, who is standing near the curb, is pushed with extreme force by a police officer. He

careens, gains momentum, and staggers and runs out of control. As he staggers, he is tackled by three police officers. They bear their weight on him, compressing him into the ground. One of them brutally delivers forceful blows to his back. As they lead him to the sidewalk and handcuff him, he looks like a captured animal.

Reality: How directly should we face it?

The brutal reality of the videotape made it possible to prove Mark's innocence. It allowed Mark to validate why he was so frightened. It provided a document of an incident about which he had almost no memory. This documentation was helpful in many ways. However, it is also important to note that everyone who viewed it was horrified. It was like entering into a nightmare. The word often used was "unbelievable." Not being able to believe a brutal reality helps to maintain stability, underscoring the value of denial and dissociation for facilitating trauma survival.

Because Mark remembered very little of the incident portrayed on the videotape, he could not explain his injuries. In essence, this footage tampered with his protective capacity to dissociate himself from the physical and psychological pain that was inflicted. Bromberg (2003) states:

> Dissociation, in human beings, is fundamentally not a defense but a normal hypnoid capacity of the mind that works in the service of creative adaptation. It is a normal *process* that can become a mental *structure*. As a process, it can become enlisted as a defense against trauma, by disconnecting the mind from its capacity to perceive what is too much for selfhood and sometimes sanity to bear. (p.561)

Essentially, this mechanism serves as an "early warning system" that preserves the individual's selfhood. Although dissociation is protective, it is also frightening because it holds the threat of loss of self. We came to fear the videotape. We did not allow ourselves to watch it – unless we had to during meetings with attorneys. We would leave those meetings in a state of fog (a kind of dissociation).

It was as though watching the videotape could cast an evil spell over us. We developed a means of protection that involved limiting stimuli. This state of shielding ourselves was irrational because the danger was supposed but no longer real. However, the danger of losing control of cognitive functioning is terribly frightening. In a sense, limiting exposure to traumatically

evocative material is a form of conscious or planned dissociation that allows for the preservation of selfhood.

Means of expression and degrees of control

Contrary to what I referred to as the brutal nature of viewing the videotape, I found that writing about my perceptions and experiences allowed me to manipulate and take control of previously overwhelming and unformed emotions. It allowed me to make sense out of very chaotic internal and external conditions. The words felt like tears – relieving, soothing, painful, and sometimes pressured. But they offered more than relief in that they provided an opportunity to reformulate overwhelming emotional reactivity into a semblance of ordered thought.

VISUAL ART: NAMING THE DREAD

A central theme of this chapter relates to the question of what kind of psychological protection or self-expression can most adequately help to restore self-stability. The impact of engaging in visual art expression was very different from writing. While in a high stress state, I was not able to do very much visual art. The associative nature of such processes felt too unsafe. I did one drawing (Figure 10.1) about four weeks after viewing the videotape. The sketch portrays my memory of the video footage as well as the nightmares that disturbed my sleep. This was the only visual artwork I did that directly depicted my perception of the police brutality. The graphic depiction of brutality passionately surged out. To share this image, I felt, would be a kind of abuse. As I write this now, the fact that I felt so alone with my fear saddens me. However, this may have been an inevitable response to the shame induced by a traumatic experience.

To a degree, doing this drawing helped to deflate some of the torment that I experienced. At the same time, it had the reverse effect because it made the horror visible. In order to depict a scene of abuse, one must identify with the aggression and also acknowledge a potentially unbearable and unacceptable level of reality. I felt a mixture of shame and relief when I looked at the drawing: shame at the fact that I was so fixated on horror, and relief that I could state this with some visual clarity. "Shame" is the appropriate term "to describe the affective flooding created by trauma – the horrifyingly unanticipated sense of exposure of oneself to oneself" (Bromberg 2003, p.567). I felt a sense of danger and had difficulty believing that my internal experience could be tolerated. At the same time, my desire to depict this material

Figure 10.1: Pencil drawing of a brutal scence

was driven by the belief that there must be a way to express and reformulate frightening perceptions. The devil of it is that expressing horrifying perceptions can never feel safe. One can only hope for a relative degree of safety so that the belief in self-survival can be sustained.

I spontaneously followed the drawing of police abuse by completing a sketch of Mark resting safely on the living-room sofa. The attack, arrest, and incarceration had shattered some of my beliefs about safety. These beliefs were formerly taken for granted. I see now that an image of present reality – a safe one – was beginning to replace the nightmarish one. Figure 10.2 shows my husband appearing rather crumbled but still intact. It was an attempt at restoration. Although my former naiveté had been shattered and could not be reclaimed, I attempted to rebuild a sense of solidness through depicting a reassuring image of the present.

These two artworks illustrate how is it possible to tolerate two very different realities at the same time. They also illustrate the importance of establishing a semblance of control in the wake of chaos. At any moment I felt that I could fall into confusion and despair. I felt that I was on the edge. I attempted to gain a sense of equilibrium through experiences that elicited a sense of control. At first I did only pencil sketches (as opposed to using less controllable media). This was not a conscious choice. I only became aware of it as I looked back.

Figure 10.2: Restorative pencil drawing

Figure 10.3: Oil painting of two owls in the darkness

After several months, I worked on a painting of two owls in the forest (Figure 10.3). My intent in beginning this painting was to portray the image of two majestic birds at dusk. However, the mood of the painting became increas-

ingly dark, frightening, and mysterious. I kept adding layers of dark hues to the scene, and a black shroud seemed to take over the image.

These are some of the thoughts I had after I completed the painting: the owls brought to mind Mark and I gazing somberly at a chaotic and unpredictable world. On one hand, it painfully reminds me of my experience of waiting in the darkness to find out how to get Mark out of jail. On the other hand, it reminds me of the soothing shroud that fog provided in protecting Mark and me from the clarity of a reality too painful to bear. I later thought that perhaps the image of these predatory birds symbolized my own shrouded feelings of aggression in response to the traumatic event.

The question that I have touched on regarding my own creative process relates to the perceived danger of depicting the graphic realities of a traumatic experience. The need for control in the face of chaos was easily threatened when graphically depicting violence. Expression of anger and feelings of identification with the aggressor were part of this process. There was no easy way out of confusion or overwhelming affect. I struggled to find control, to express complex layers of emotion and perception, to protect myself, and to find ways to meaningfully connect with self and others. Artistic expression was part of the struggle to offset feeling shattered and alone.

In the following section, I progress from subjective experience to a clinical exploration of related issues. The focus shifts to artwork by a boy whose indirect trauma relates to his understanding of current events. Much of his fear has the quality of nameless dread that characterizes the experience of trauma and the struggle to make this experience tolerable.

CASE VIGNETTE: A BOY AT WAR

This client is an artistically talented 11-year-old boy who meets with me weekly. He is a keen visual observer who is deeply affected by current events as well as most other happenings. Due to an auditory processing disorder, he sometimes has difficulties conceptualizing verbal descriptions, which can be extremely frustrating for him. His father is a veteran who has imparted to him an understanding of both the tragedy and heroism of war. His father was in Washington, DC, on September 11, 2001, and was delayed in returning home. This was very frightening to him. It seemed to arouse many already existing fears – fears based on knowledge of his father's war experiences, on current events, and on the anxiety that most boys are subject to as they try to

prove themselves and be accepted amid peer rivalries and other interpersonal challenges.

In working with this client, I had the sense that he was stunned by the terrorist attacks of September 11. His auditory processing disorder probably contributed to this reaction; in a sense, he strikingly embodies the experience of speechless terror that we humans are faced with in contemplating massive aggression and destruction. This boy's capacity to convey such strong feelings through visual art provides some relief as well as a sense of control. At the same time, the depiction of battle scenes is disturbing to him. He is depicting his perception of a disturbing reality that may be too painful to bear. However, to try to find a way to tolerate it through art may provide the only kind of victory that one can realistically hope for – that is, through art, battles with fears and aggression might be resolved with some sense of internal harmony (Kramer 1979).

His pencil drawing entitled "The World" (Figure 10.4) portrays a strong and detached soldier in the foreground; he is shooting amid a scene filled with orange blasts of fiery explosion. A shape, which could be a skull, a world-globe, or a piece of artillery, blasts through the air. The scene depicts a terribly frightening (perhaps apocalyptic) environment. The drawing was

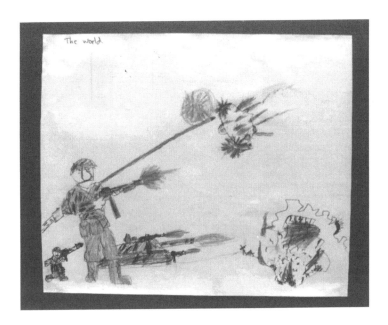

Figure 10.4: "The World," colored pencil drawing

done with a mixture of excitement, fear, and anger. The client's verbal descriptions included anger at the enemy and anger about war and the state of the world. We discussed the terror of war and how frightening this is. Underlying our discussion was the inherent dilemma of how much to face these realities and fears.

"The World" was one of many drawings expressing similar themes. The art process allowed for the naming of significant dread. For months, drawings such as this were completed. They were interspersed with pastoral scenes and battle scenes involving imaginary creatures. These more soothing themes offered a balance and a reminder of the strength and beauty in the world.

A drawing described as "ancient warriors" (Figure 10.5) was completed several months later. The content (of this drawing and many subsequent artworks) has shifted to a mythical theme. The graphic style is detailed and soft and lacks the pressure of the war scenes. The warriors are not engaged in battle. They "may be heading towards combat." Whereas doing the drawing was engaging, talking about it brought up feelings of distress. The boy said that the thought of such a battle was very upsetting to him and that it made him angry to think about it. He appeared overwhelmed and put his head in his hands. He said that he was unable to talk about this further.

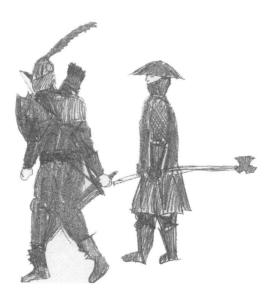

Figure 10.5: Two warriors, colored pencil drawing

This boy's art process expresses his struggles to understand the impact of personal feelings, some of which are related to confusing and disturbing world events. But this material is inherently overwhelming and difficult to tolerate. His attempt to make sense of war-related happenings is a very meaningful endeavor. On the other hand, there is no way to triumph in this internal battle because there really is no way to understand war. As Robert McNamara (Morris 2004) stated when explaining the term "Fog of War" in the motion picture by the same name:

> War is so complex; it's beyond the ability of the human mind to comprehend all the variables. Our judgment and our understanding are inadequate and we kill people unnecessarily... Reason has limits.

Conclusion

In offering concluding remarks, I wish I could tie things up neatly and offer clear guidelines. But this is not possible. I would like to offer the reader a formula because it is difficult to tolerate the ambiguity of this topic. But there is no way to make sense of the personal impact of world events. "Reason has limits," and, in reference to his strategic role in the Vietnam War, McNamara added, "Belief and seeing are both often wrong" (Morris 2004). It is not possible to grasp the enormity of the personal experiences and responses that relate to traumatic world events.

I would like to conclude decisively that creative expression can heal the effects of trauma. And of course, it often can – but sometimes in the process it also makes it feel worse. What seems terribly important is to maintain the belief that self-expression and interpersonal connection within the creative and therapeutic process can offer a means of strengthening the Self. In the face of any trauma, to find a way to make one's understanding of reality tolerable is a complex and uncertain process.

There is no way to undo the impact of a frightening experience. Natalia Ginzberg (2002) wrote of the lasting effects of having lived through the Fascist Regime and World War II in Italy. She stated:

> The experience of evil is never forgotten. For us, the insistent blare of the doorbell in the middle of the night can mean only one word, "police." And there's no use telling ourselves over and over that nowadays, the word "police" may mean friendly faces we can call on for protection and help. For us, this word will always trigger suspicion and fright. (p 57)

Throughout this personal and clinical exploration, I have explored how horrible events (even when experienced indirectly) can attack and infect the self. This can inflict a state of feeling frozen in dread and disconnection. Expression and interpersonal connection can provide the context for struggling with this material. My conclusion is almost ridiculously simple and obvious. It seems that the most important learning that has been reinforced for me is this: engaging in some kind of dynamic struggle will probably lead somewhere. To tolerate the truth to the best of one's ability and not to be alone in this process is a means of strengthening and renewing one's sense of meaning.

The shame and fear that arises in the face of experiencing horrors can seriously threaten the possibility for interpersonal connection and struggle. To find a way to clearly and safely express such experiences may not always be so simple or possible. Accepting a horrible reality involves tremendous struggle and pain. A person can only engage in such struggle in accordance with the level of internal strength and external support available. To be meaningfully engaged in this type of struggle involves tolerating ambiguity, as well as fear and confusion.

In the work mentioned above, Ginzberg (2002) also stated:

> Some things are incurable and, though years go by, we never recover, even if we have lamps on the tables again, and vases of flowers, and portraits of our loved ones, we have no more faith in such things, not since we had to abandon them. (p.57)

She goes on to describe that it is not possible to pretend that the world is a safe place, implying the necessity of struggling honestly with the personal impact of atrocities. She concludes on this note, "We are not defenseless against our fear. We have a toughness and restraint that those who came before us have never known" (p. 58). To strive for and foster this kind of "toughness" of Self, in both personal development and clinical work, is a form of social action.

References

Bromberg, P. (1998) *Standing in the Spaces: Essays on Clinical Process, Trauma and Dissociation.* Hillsdale, NJ: The Analytic Press.

Bromberg, P. (2003) "Something wicked this way comes. Trauma, dissociation and conflict: The space where psychoanalysis, cognitive science and neuroscience overlap." *Psychoanalytic Psychology 20*, 558–574.

Erikson, E. (1963) *Childhood and Society.* New York: W.W. Norton.

Freud, S. (1961) *Civilization and its Discontents.* New York: W.W. Norton.

Ginzberg, N. (2002) *A Place to Live and Other Selected Essays of Natalia Ginzberg.* New York: Seven Stories Press.

Kramer, E. (1979) *Childhood and Art Therapy.* New York: Shocken.

Morris, E. (Director) (2004) *Fog of War* [Motion picture] Culver City, CA: Sony Pictures.

Sarra, N. (1998) "Connection and Disconnection in the Art Therapy Group: Working with Forensic Patients in Acute States on a Locked Ward." In F. Skaife and V. Huet (eds) *Art Psychotherapy Groups: Between Pictures and Words.* London: Routledge.

Van der Kolk, B. (2003) "Posttraumatic Stress Disorder and the Nature of Trauma." In M. Solomon and D. Siegal (eds) *Healing Trauma: Attachment, Mind Body and Brain.* New York: W.W. Norton.

Vaillant, G. (1993) *Wisdom of the Ego.* Cambridge, MA: Harvard University Press.

Art Making as a Response to Terrorism

Rachel Lev-Wiesel and Nancy Slater

Introduction

Our project examined and compared responses of graduate students at Ben-Gurion University of the Negev in Israel to acts of terrorism in their homeland and to the September 11 attacks in the US. In early 2002, students from two graduate classes in the Department of Social Work participated in a three-step project that included drawing activities, writing a narrative, and group discussion. Twenty-seven students were placed into two groups. Students in one group were asked to give responses to the terrorist attacks in the US on September 11, 2001; students in the second group were asked to give responses to the ongoing acts of terrorism in Israel. The participants in both groups demonstrated powerful reactions to all forms of terrorism and to their first-hand experience of ongoing terrorism in Israel. The participants showed their strong sense of connection to the US both before and after the September 11 terrorist attack. We (the researchers) identified categories of visual and narrative responses. Comparisons of the frequencies of these responses are presented in the following report. Finally, our separate reflections show the differing cultural backgrounds that influenced our perceptions of the students' responses and our own experiences of terrorism in Israel.

Facing the threat of terrorist attacks is an aspect of everyday life in Israel. This has been so since Israel became a country. Each generation and influx of new immigrants needs to learn to cope with this reality. Everyone always needs to be ready for an attack to happen, yet they need to live life as normal – family, school, work, play go on as though everything will be all right even

though reality shows a different picture. It is within this context that our project was done.

In this one-session project, art expressions along with written narratives provided views on the events of September 11 in New York City and Washington, DC, by graduate social work students at Ben-Gurion University of the Negev. This project also showed the reactions and effects of ongoing terrorism in Israel that the project participants had witnessed and experienced. In addition, the graphic and narrative responses offered perspectives on the effects of political terrorism that have relevance for all global citizens. Qualitative research was used to gather and analyze the data. This included both descriptive and comparative analysis to examine the depth and breadth of the responses given.

Literature on art therapy and violent conflict

At this time there is a developing body of literature on art therapy in response to massive terrorism and war. The events of September 11, 2001, and its aftermath have resulted in a focus on art therapy interventions that are effective for attending to the short- and long-term effects of terrorism in all its forms (Henley 2001).

During the past 20 years, many art therapists have addressed treating the effects of interpersonal violence and posttraumatic stress disorder. A pioneer in the creative arts therapies, David Read Johnson (1987) discussed in his earlier work the use of the creative arts therapies for treating psychological trauma. In this paper and a later one (1999), he offered explanations of the use of the creative arts therapies for addressing trauma; these were based on his many years of working with American veterans of the war in Vietnam and victims of interpersonal violence. Johnson (1987) specifically described the role of art therapy:

> Art therapy has a special role in gaining access to traumatic images and memories. Because the encoding of traumatic memories may be via a "photographic" visual process, a visual media may offer a unique means by which these may come to consciousness. (p.10)

In recent years, the multicultural art therapy literature in the US and the UK has documented examples of art therapy interventions in the aftermath of war, terrorism, and political torture (Byers 1996, 1998; Golub 1989; Heusch, 1998; Kalmanowitz and Lloyd 1999, 2002; Schaverien 1998; Wertheim-Cahn 1998). However, it is the art therapy intervention by John

Goff Jones (1997) following the 1993 bombing in Oklahoma City that stands out as *the* written account for using art therapy in treating victims immediately after a massive terrorist attack. And, more recently, reports in the journal *Art Therapy* (Anderson 2001; Gerity 2002) on art therapy responses to September 11 are additional evidence of the effective use of art therapy as crisis intervention following extensive terrorism.

Jones' (1997) article provides a set of guidelines as well as support for art therapists who attend to the effects of massive violence and terrorist attacks. Jones stated:

> The art therapy process gave the patients permission to deal with the intensity of the feelings they were experiencing, including anger, guilt, sadness, helplessness, and being completely overwhelmed by the expansiveness of the tragedy. (p.91)

His account informed the approach that was taken in developing our project in Israel. Although one goal of our project was to gather and compare information, providing the therapeutic effects of art making with narrative accounts was the second goal. Art expressions externalize memories and painful experiences. Art making can help to describe the indescribable and to bring hidden memories to consciousness (Johnson, 1999; Schaverien, 1998).

The project participants had lived for many years in stressful circumstances and would most likely continue to do so for some time to come. Several reported their concerns about expressing responses to terrorism because they did not want to think about it. A number of project participants were only one generation away from the Holocaust and were children of refugees or immigrants. Their personal histories influenced their reactions and responses to the graphic and narrative expressions of the other participants. As Schaverien (1998) discusses in her chapter on art psychotherapy workshops with adult children of Holocaust survivors:

> The reaction to the trauma of an experience which was both unthinkable and unspeakable took the form of repression on both a personal and collective scale... Common amongst the coping mechanisms, passed through the generations, are denial and forgetting. (p.157)

Several participants identified and expressed their awareness of using several coping mechanisms of the kind just mentioned. The graphic and narrative examples presented in this project demonstrate some of these methods of coping with the stress of living with violence as well as carrying family

histories of surviving extreme and massive terrorism. Our project exemplifies another significant observation by Schaverien (1998): "In making visible that which is usually unseen [such as memories and psychological effects of terrorism], art validates experience which defies articulation" (p.168).

History of terrorism in Israel

Israel endured ongoing terrorism and threats of terrorism even before its inception as a recognized state in the Middle East. The history of terrorism in Israel, a country not even 1/20th the size of the continental US, is significantly more extensive than that of terrorism in the US. The students who participated in this one-session project had witnessed and experienced terrorism all of their lives. This context, which includes the prior violent history of Jews in the Diaspora, influenced the impact and results of this project.

Since ancient times, from medieval Europe to the present, the history of the Jewish people is filled with extreme loss, ostracism, and suffering. Several examples can highlight this history (Arad 1991; Makovsky 1995):

1. During the medieval era in Europe, such as in England during 1144, Jews were subjected to blood accusations – that is, charges of kidnapping and killing non-Jews for ritual purposes. These accusations led to riots and to massacres of Jews.

2. Jews have often been expelled from their homelands, as they were in Spain between the years 1481 and 1492. Jews were forced to convert to Christianity, and many, who were thought not to have converted, were tortured and slaughtered.

3. The 1600s were horrific times for Jews in Central and Eastern Europe. They were persecuted and slaughtered by both the sides that fought during the Thirty Years War (1618–1648) and in the Chmielnicki Massacres (1648–1649).

4. The Holocaust, in Hebrew called *ha-sho'ah*, was the systematic slaughter by Nazis of almost all European Jews. The Holocaust officially began in 1933 when Hitler and the Nazi Party came to political power in Germany. *Ha-sho'ah* lasted through to 1945 when the allies defeated Germany. During those years, the Nazis committed atrocities unique in world history. Six million Jews including men, women, and children were murdered. And many thousands of others were included in the systematic degradation, torture, and murder by the Nazis. Other targeted groups included

homosexuals, Romanies (commonly called "Gypsies"), and those who had mental illness or were physically handicapped. Although such violent events took place primarily in Europe, atrocities against Jews continued after Israel became a homeland for the Jews of the Diaspora.

5. Only one day after the United Nations vote in 1948 declared Israel a state, seven Middle Eastern countries attacked it. At that time, the Jewish population of Israel was 600,000. In contrast, the Arab nations, which declared their wish to eliminate this new state of Israel, had a combined population of 30 million.

6. Between 1956 and 1982, Israel was forced into four additional wars with her Arab neighbors.

7. In 1964, the Palestinian Liberation Organization (PLO) was established at an Arab summit meeting. Its primary purpose was to create a Palestinian state by destroying Israel through terrorism. One of the PLO groups, Al Fatah, was founded in 1965 and led by Yasser Arafat. Since then, there have been thousands of acts of terrorism against Israeli citizens. These acts of terrorism have included the hijacking of a Sabena airplane in May 1972, and the slaughter of 11 Israeli athletes at the Olympic Games in Munich, September 1972.

8. The Palestinian uprising of the 1980s, the first Intifada, led to the Oslo Peace Agreement in 1993. The winds of hope for peace in the Middle East were spreading. But, in September 2000, Arafat refused to accept the agreement with Israel after days of discussions at the Camp David meetings initiated by US President Bill Clinton. The second Intifada started then and continues today.

The historical context of US terrorism

The historical context of terrorism in the US is significantly less extensive than that in Israel. Prior to the September 11, 2001, terrorist attacks on the World Trade Center in New York City and on the Pentagon in Alexandria, Virginia, the US experienced few acts of either terrorism or war. This level of politically generated death and destruction within US borders has infre-quently existed since the American Civil War between 1862 and 1865. Other significant attacks in the US that occurred in the 20th century were the military attack on Pearl Harbor in Hawaii on December 7, 1941 (Gilbert 1989), the bombing in the World Trade Center on February 26, 1993

(Caram 2001), and the bombing of the Murrah Federal Building in Oklahoma City on April 19, 1995 (the latter perpetrated by American citizens) (Jones 1997).

After World War II, US citizens lived through the nuclear weapons threats of the Cold War and through the long military involvement in Vietnam that cost many lives. Yet with its isolationist stance, the US has provided most Americans with a sense of security from outside attacks. In addition, whereas before September 11 many Americans were aware of threats or acts of individual violence within the country, most Americans maintained a belief that terrorism happened "over there." Americans have been taught to believe in the superiority of the US as a nation and as a military power. Also, since World War II, those in many other countries have viewed the US as a sought-after place to live because of the safety that it offers along with economic advantages. And countries such as Israel have come to rely on the US for many kinds of support. From news accounts and as evidenced by this project, the vision of security in the US changed greatly as a result of the tragic events of September 11, 2001 (Richardson and Evans 2001).

Psychological context for project participants

Living with frequent terrorist attacks is likely to heighten individuals' anxieties, fears, and cautiousness. Direct or indirect subjection to ongoing terrorism is also likely to bring about traumatic stress reactions that can develop into posttraumatic stress disorder (PTSD). The risk of PTSD becoming chronic is presumably dependent on exposure to continual traumatic events such as war and terrorism (Friedman, Schnurr and McDonagh 1994). However, there is a general consensus that traumatic experience and its specific components can both contribute to the risk of developing PTSD and have salutary effects on personality and overall functioning (Bowman 1997).

Even though the intention of this project was not mental health assessment, it is important to acknowledge that all the project participants have lived most of their lives under continual threats and actual events of terrorism and war. Living in this threatening environment necessitates that individuals develop defenses to cope with these realistic threats. Ongoing threats and fear of terrorism affect psychological and emotional reactions, as may be seen in the responses in the project participants.

Development of the project

The concept for this project came out of the second author's (NS) reactions to discussions at the November 2001 American Art Therapy Association Conference that offered reflections on the horrendous events of September 11 just two months earlier. In addition, observations of Israeli students during art-therapy class activities suggested that the ongoing terrorism in their country had affected them. We (both authors) then discussed (a) the usefulness of gathering information that could add to the understanding of the emotional effects of massive terrorism and (b) the therapeutic potential of a project that could serve as a model for future therapeutic interventions.

Kalmanowitz and Lloyd (2002) described their art therapy interventions with teachers in Kosovo and reported that directed drawings assisted the teachers in learning to use art making to *express* and *reflect* their own pain and loss. And although Mayo's (1996) use of group art therapy was specific to palliative care, her process of "symbol, metaphor and story" also influenced the method developed for this project. Mayo (1996) eloquently pointed out that a work of art could include both ugliness and beauty. This characteristic of art is essential to the identification and expression of reactions to massive terrorism.

Twenty-seven graduate social work students (25 women and 2 men) at Ben-Gurion University participated in this one-session graphic and narrative inquiry. Participants were advised that the project was set up to gather information about the use of drawing, narrative writing, and group discussion to influence and reflect responses to violent events. They were also informed that this project would be a learning experience, which we hoped would be useful for all participants.

Each participant was assigned to a group for one two-hour session. Participants in Group 1 were asked to give responses to the terrorist attacks in the US on September 11. Participants in Group 2 were asked to give responses to acts of terrorism in Israel. Each two-hour session utilized a three-step process that included (a) directed drawing activities, (b) written narratives in response to drawings about terrorism, and (c) a group discussion on the specific topic assigned to each group. Second author NS conducted the group on reactions to 9/11 (Group 1, $n = 19$), and first author RLW conducted the group on terrorism in Israel (Group 2, $n = 8$).

All participants completed drawings in response to the directive, "Draw whatever you want. This is a free drawing to make whatever picture comes to mind." They were given ten minutes to do this initial drawing. Our intention

for this drawing was to familiarize participants with the drawing materials and with our approach. For the second drawing, Group 1 participants were instructed, "Draw a picture that represents your response to the terrorist attacks on September 11, 2001, in New York City and in Washington, DC"; Group 2 participants were instructed, "Draw a picture that represents your reaction to the bombings, shootings, and other terrorist attacks that have occurred here in Israel in recent times." Participants in both groups were given 20 minutes for this drawing. Upon completion of the second drawing, participants were asked to "write a story about your drawing" and given 15 minutes to complete this final directive.

Following the completion of each group, the two of us met to discuss our reactions to the group experiences. This discussion focused on observations of individual and group participation and our reactions to the process and to student responses. At a later time, we reviewed the drawings, the narratives in response to the terrorism drawings, and the notes we had taken during the group discussions.

Participants' responses

Group 1

Included here are examples that are representative of Group 1 participants' second drawings and narrative responses.

G'S RESPONSES

G's drawing was titled "Total Destruction" (Figure 11.1); G wrote:

> The drawing is dealing with a big fire that was caused by the crash and people jumping from the windows to escape. For me these are the most difficult memories to see… The US and these buildings were the safest and most protected place that people can be…[I have] fears that a war of total destruction and death will begin. I focused on the fire and people falling off the buildings because I constantly see it in my mind. It is so difficult.

Z'S RESPONSES

Z's drawing was titled "Them and Us" (Figure 11.2); Z wrote:

> It happened almost on my mother's birthday. The myth of America was broken. My own small country is actually stronger than they are. We are used to this kind of terror. They remained helpless… They bleed, and we are continually bleeding.

Figure 11.1: G's drawing: "Total Destruction"

Figure 11.2: Z's drawing: "Them and Us"

Y'S RESPONSES

Y's drawing was titled "The Crash (Figure 11.3)"; Y wrote:

> Being crushed is what I felt. I went out with my children to have a
> pizza. A nice, warm family time. The people there began to whisper,
> then turned on the TV. This was awful. I couldn't believe it. The big
> America, even there, terrorism reached them. My children began to ask
> questions. It was difficult to explain – difficult to explain insecurity...
> How to explain that it is one of the Free World's symbols and it crashes
> like a tower of cards... I felt frozen, helpless, crushed. When I was
> asked to draw, I found myself back to that day, that hour, those difficult
> feelings broadcasting over and over again on the TV those awful scenes.
> Fear for existence. Even though it happened thousands of kilometers
> from here, I feel now heavy and sad.

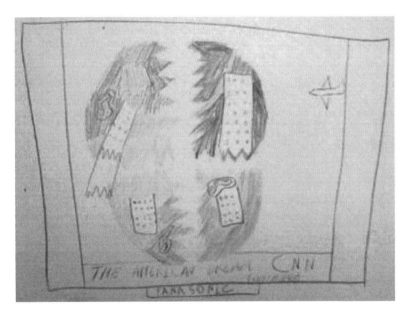

Figure 11.3: Y's drawing: "The Crash"

Group 2

Included here are examples that are representative of participants' drawings
and their narrative responses to them.

R'S RESPONSES

R's drawing was titled "Hurt" (Figure 11.4); R wrote:

I painted a hand of something in blood. In all the darkness of this terrorism, I chose to paint this picture because it symbolizes for me an attempt to take out the hand from the blackness, the blackness of explosion, the darkness of fear, alarm and lack of understanding. For me, the hand is the hand of the victim. He tries to reach out although he got hurt asking for help, asking for life. When I drew, I tried not to think... I drew without control. I identified with everyone there although I was not actually there. I am glad that I was not. I felt as if it was my own hand – which I actually used to draw.

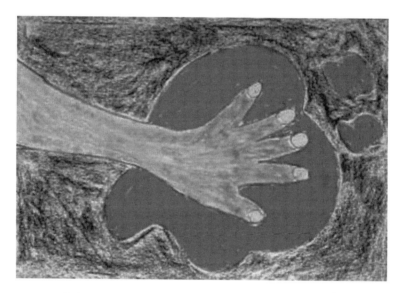

Figure 11.4: R's drawing: "Hurt"

L'S RESPONSES

L's drawing was titled "Indifference: Why or Until When?" (Figure 11.5); L wrote:

I must say that it was very hard for me to connect emotionally to this subject which reflects how I cope with terrorism. The drawing is an eye with question marks and exclamation points – with a dove of peace and the peace symbol...the drawing expresses my reaction today. Indifference, routine, avoidance?! Through the drawing I tried to examine myself...it helps me not to sink into huge pain or to over-identify with the victims' families. Not to relive over and over every day, not to mess with politics with such an obsession as I did before. Maybe it is a kind

of survival… I ask myself, does the indifference result from the reality today or is it a kind of escaping and being overwhelmed?

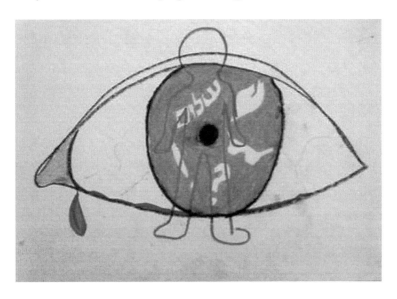

Figure 11.5: L's drawing: "Indifference: Why or Until When?"

C'S RESPONSES

C's drawing was titled "Helplessness" (Figure 11.6); C wrote:

The drawing tells about a group of people who decided to go out and enjoy themselves in their city street… They thought that they were going to have a nice time when suddenly a catastrophe fell upon them – totally unpredicted, destroying, destructive… There is no god that instructs people to destroy what he built. It can't be… The world is committing suicide. And, we have no one to defend us. We can't even rely on the soldier who guards us against this murderous urge… It reminds me of the Holocaust. They kill us and we cannot do anything. So, there goes a group of people in the street in Jerusalem, and suddenly they were not there… The feelings are helplessness, anger, aggressiveness, will to revenge, feeling that you shout in a vacuum, in a place where the sound of your voice isn't heard… My deep feeling is a big wrong against us – unjust to us. Usually I feel these feelings when I hear about another terrorist attack or when I watch it on TV. Somehow after that, I manage to get back to my routine. On second thought, drawing it arouses difficult feelings more than those I feel when watching TV.

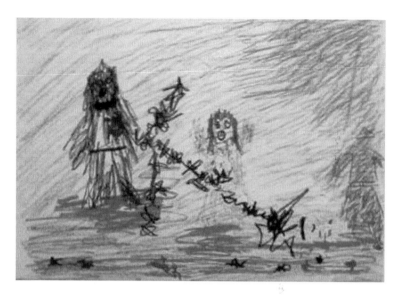

Figure 11.6: C's drawing: "Helplessness"

Comparing the drawings of Group 1 and Group 2

As seen in Table 11.1, categories of content, form, style, and color were used to examine the art expressions of both groups. Within each category, elements were identified that were most frequently used, and the percentage use for each group was calculated. Although numerous observations can be made, a few appear of particular significance – for example, note that participants in Group 2 used circles filled in with black and/or blue more than twice as much as those in Group 1. On the other hand, nearly twice as many Group 1 participants depicted a terrorist attack compared with Group 2 participants. Regarding predominant colors, note that all in each group used black in their drawings and that nearly the same percentage in each group used red. However, almost twice as many in Group 1 as in Group 2 used yellow and/or orange.

We researchers surmised that each type of image represented strong responses to the separate events – for example, "black holes" in drawings about terrorist attacks in Israel suggest feelings of *emptiness* or of being in a *vacuum* as a result of ongoing terrorism. These feelings seemed less strongly connected to the one-time terrorist attack in the US, a place further from daily experience.

Table 11.1: Incidence of specific art elements across groups

Art element	Group 1: 9/11 drawings, n = 19 (% use)	Group 2: Israeli terrorism drawings, n = 8 (% use)
Content		
Circle filled with black and/or blue	26.3	62.5
Segments of human body	42.1	50.0
Faces or facial profiles	26.3	50.0
Full human figures	21.0	37.5
Scene of terrorist attack	42.1	25.0
Blood or drops of blood	15.8	50.0
Tears	10.5	37.5
Form		
Space filled	63.2	50.0
White space 25% or more	36.8	25.0
Border or encapsulation	26.3	25.0
Style		
Realistic	10.5	0.0
Abstract	42.1	25.0
Mixed realistic and abstract	46.8	50.0
Predominant colors		
Black	100.0	100.0
Red	68.0	75.0
Yellow and/or orange	68.0	37.5
Blue	42.1	67.5

Comparing the narratives of Group 1 and Group 2

Table 11.2 shows comparisons of the narratives written in response to the drawings on terrorism. Table 11.3 shows comparison in percentages of the major themes in these narratives. An intention of this activity was to offer participants a means to put into words their responses to the terrorist attacks before participating in group discussion. Here, too, there are several between-group differences in frequency of specific responses. As shown in the tables, more than twice as many participants in Group 1 used metaphors

Table 11.2: Examples of narrative themes across groups

Theme	Group 1: 9/11 narratives, n = 19	Group 2: Israeli terrorism narratives, n = 8
Related to event(s)	Connected to the terrorism in Israel (Black September,* Yom Kippur war,** now people in US will understand us)	Living under terrorism is routine
Beliefs and perceptions	Difficult to absorb these events; shared fate	Personal best interest versus society's best interest; terrorism is a continuation of Jewish history – e.g. Holocaust, bombing Israel's northern border***
Psychological reactions	PTSD, anxiety, intrusive thoughts, avoidance, somatization	Depression, anxiety
Emotions	Helplessness, sorrow, sadness, horror, indifference, disappointment, frustration, anger, and disgust	Helplessness, hopelessness, sadness, pain, apathy, inability to intolerate
Coping styles	Dissociation, suppression, minimization	Incubation (isolation), dissociation, minimization
Metaphors	Darkness, end of the world, world committing suicide, World War III, chaos, raining tears	Holocaust, ruined and smashed bodies, tragedy, tears pouring with sun shining, a black day

* Black September. The PLO, formerly a group of terrorists, acted during the mid-1970s. They carried out many terrorist attacks such as hijacking planes, kidnapping schoolchildren and tourists in hotels in Tel-Aviv, hijacking buses, etc. They performed their attacks from Jordan, Lebanon, and Tunis (after being expelled by Hussein, King of Jordan).

** Yom Kippur War: In 1973, Egypt and Syria attacked Israel by surprise. As a result, Israel withdrew from part of Sinai.

*** Bombing Israel's Northern border: Between 1950 and 1967, Israeli villages and kibbutzim situated below the Golan Heights were frequently bombed by the Syrian army.

Table 11.3: Incidence of narrative responses across groups

Response types	Group 1: 9/11 responses, n = 19 (% use)	Group 2: Israeli terrorism responses, n = 8 (% use)
Personal, family	63.2	50.0
The state or other institutions	84.2	87.5
Emotions	100.0	87.5
Metaphors	79.0	37.5
Coping styles	42.1	75.0
Past terrorism	63.2	62.0
Psychological reactions	21.0	25.0
Loss of beliefs, sense of security	84.2	0.0

when talking about terrorist attacks. And, most significantly, a majority of Group 1 participants – yet no-one in Group 2 – expressed loss of beliefs, loss of a sense of security. Here we surmised that it was easier or "safer" for our Israeli participants to express such strong reactions to an event far away and not in their homeland.

Researcher reflections

RLW

I am second generation to Holocaust survivors. I was born and raised in Israel almost since it became an independent state. I have experienced wars and frequent terrorist activities and have worried constantly about my husband and three sons serving in the army. During the last year and a half of the Intifada, I have become a witness to horrible scenes of ruined bodies and the killing of innocent people who were walking, driving, shopping, or dancing in the streets, malls, clubs, and coffee shops. All of this makes me think of the meaning of life, the meaning of a state, what is human, what is not – not on a cognitive level but on an emotional level – accompanied by feelings of helplessness, hopelessness, deep sorrow, and deep disillusionment regarding the human race and their moral codes.

Yet, I am a professional who is supposed to assist others in distress, to supervise other professionals so that they can cope with people who have

been injured physically and psychologically by this situation. My profes-
sional activities help me to dissociate from my own feelings. During the data
gathering for this project with our students, I empathized with their grief,
fears, and anxieties. I was glad to hear that the process was good for them, as
some said. Indeed, a few said that it was actually the first time they could
really express their feelings. Later, analyzing the data shocked me. The
students' responses were a powerful reflection of my own feelings and
despair.

At the time of the September 11 events, I perceived it to be the end of the
world, the end of Israel, for I consider the US to be Israel's only friend.
Nowadays, after several bloody, horrifying months when several hundred
Israelis were killed and thousands were injured, I am afraid to drive home,
afraid for my children traveling back and forth to school. I avoid doing
casual things like shopping, going to a movie, meeting friends for coffee at a
restaurant. It seems that for each day that is better, the next day is worse. In a
way it resembles the Holocaust: Jewish people, as well as the rest of the
world, knew or could have known what was going to happen yet preferred
not to see.

NS

From October 2001 to August 2003, I lived in Israel, where I was teaching
art therapy. As an American living in this Middle Eastern country, I experi-
enced a huge cultural shift, and I was continually in a learning mode just
about daily living. Residing almost all my life in the US, I believed that I was
safe from outside terrorist attacks. On September 11, 2001, I was in Australia
watching the events that happened in the US on television. As so many at
that time, I stayed "glued" to the television for days, filled with disbelief at
what had happened in my country. In Israel, I gained valuable awareness of
what it is like to live with ongoing violence and the threat of violence, and to
go about daily life almost as though nothing bad would happen.

This project provided me with an opportunity to see more clearly the
influence and reactions of Israeli students as they cope with daily life – as
they have for all their lives. I have been in awe of their ability as social
workers to help others who suffer and need assistance of all kinds when their
own lives and the lives of their families are continually under threat. I have
been in awe of these students' ability to be flexible: for example, volunteer-
ing for this project when they wanted to get home to their families after
having classes all day, and staying with it when the room was too noisy

because another group was also using the room. They adjusted and partici-
pated in less than ideal circumstances just as they live with the threats of
continued violence.

The art expressions, narratives, and group discussions moved me pro-
foundly. I was saddened by several of the responses. Many of these students
are so young and also have very young children who have lived through such
horror. My anxiety rose as I saw their responses to the September 11 attacks
and how they displayed strong, longstanding connections to the US. I saw
most expressing such hopelessness about the future that I, too, felt their
despair about "What is the future?"

As I watched the participants involved in responding to terrorism, I saw,
in different circumstances than I have experienced before, the value of art
making and the usefulness of this way of expressing emotional pain and
difficult thoughts and memories. Later, as we reviewed the drawings, narra-
tives, and notes on the group discussions, I was overwhelmed by the depth
and breadth of expression by the participants in a one-session project.

Conclusion

The words and pictures by project participants offer a vision of the impact of
massive terrorism and the usefulness of engaging in art expression accompa-
nied by written narrative and group interaction as a response. In our opinion,
this technique, with some changes, would be a valuable intervention for
other individuals in Israel, where everyone is affected by the present
situation – as well as in other places where violence is threatened or has
occurred.

Limitations of the project

Limitations included difficulties for some participants in the larger group
that was facilitated by the English-only group leader (NS). The first language
for most of the participants in this group was Hebrew. This may have influ-
enced reactions to project directions although all stories were written in
Hebrew, as requested by the group facilitation. As noted previously, the
room utilized for this part of the project was also used by another group
during the last half of the data gathering, which might have caused distrac-
tions. Further, these Group 1 participants were a combination of the partici-
pants in two successive sessions. Due to misunderstanding, a second group
was organized by NS, but not by RLW. Although we decided to include this

additional data, this might have influenced what was found, as well as the analysis of the artwork and narratives.

Summary

This chapter has reviewed selected graphic and narrative responses of graduate students at Ben-Gurion University of the Negev to terrorism in Israel and to the September 11, 2001, attacks in the US. The 27 student participants were divided into two groups: Group 1 gave graphic and narrative responses to the terrorist attacks in the US on September 11, and Group 2 gave responses to the ongoing acts of terrorism in Israel. The responses from participants in both groups suggested that all forms of terrorism, along with their first-hand experience of terrorism in Israel, have had a significant impact on them and their views of the world. In addition, the participants' strong sense of connection to the US both before and after the September 11 terrorist attacks is reflected in the graphic and narrative responses. Our reflections as researchers were included because our differing cultural backgrounds influenced our own responses to terrorism even though we were both affected by the ongoing terrorism in Israel.

References

Anderson, F.E. (ed.) (2001) "Art therapists in their own words: Responses to events of September 11, 2001 (special section)." *Art Therapy: Journal of the American Art Therapy Association 18*, 4, 179–189.

Arad, Y. (ed.) (1991) *The Pictorial History of the Holocaust.* New York: Macmillan.

Bowman, M.L. (1997) *Individual Differences in Posttraumatic Response: Problems with the Adversity-distress Connection.* Mahwah, NJ: Lawrence Eribaum.

Byers, J.G. (1996) "Children of the stones: Art therapy interventions in the West Bank." *Art Therapy: Journal of the American Art Therapy Association 13*, 4, 238–243.

Byers, J.G. (1998) "Hidden Borders, Open Borders: A Therapist's Journey in a Foreign Land." In A.R. Hiscox and A.C. Calisch (eds) *Tapestry of Cultural Issues in Art Therapy.* London: Jessica Kingsley Publishers.

Caram, P. (2001) *The 1993 World Trade Center Bombing: Foresight and Warning.* New York: Janus.

Friedman, M.J., Schnurr, P.P. and McDonagh, C.A. (1994) "Posttraumatic stress disorder in military veterans." *Psychiatric Clinics of North America 17*, 2, 265–277.

Gerity, L.A. (ed.) (2002) "Special Issue on 9/11." *Art Therapy: Journal of the American Art Therapy Association 19*, 3, 98–129.

Gilbert, M. (1989) *The Second World War: A Complete History.* New York: Holt.

Golub, D. (1989) "Cross-cultural Dimensions of Art Psychotherapy: Cambodian Survivors of War Trauma." In H. Wadeson, J. Durkin, and D. Perach (eds) *Advances in Art Therapy.* New York: Wiley.

Henley, D. (2001) "Responses to the events of September, 2001: Several blocks from Ground Zero." *Art Therapy: Journal of the American Art Therapy Association 18*, 4, 179–184.

Heusch, N. (1998) "Art Therapist's Countertransference: Working with Refugees Who Have Survived Organized Violence." In A.R. Hiscox and A.C. Calisch (eds) *Tapestry of Cultural Issues in Art Therapy.* London: Jessica Kingsley Publishers.

Johnson, D.R. (1987) "The role of the creative arts therapies in the diagnosis and treatment of psychological trauma." *The Arts in Psychotherapy 14*, 7–13.

Johnson, D.R. (1999) *Essays on the Creative Arts Therapies: Imaging the Birth of a Profession.* Springfield, IL: Charles C Thomas.

Jones, J.G. (1997) "Art therapy with a community of survivors." *Art Therapy: Journal of the American Art Therapy Association 14*, 2, 89–94.

Kalmanowitz, D. and Lloyd, B. (1999) "Fragments of art at work: Art therapy in the former Yugoslavia." *The Arts in Psychotherapy 26*, 1, 15–25.

Kalmanowitz, D. and Lloyd, B. (2002) "Inhabiting the uninhabitable: The use of art-making with teachers in Southwest Kosovo." *The Arts in Psychotherapy 29*, 41–52.

Makovsky, D. (1995) *Making Peace with the PLO: The Rabin's Government Road to the Oslo Accord.* New York: Westview Press.

Mayo, S. (1996) "Symbol, metaphor and story: The function of group art therapy in palliative care." *Palliative Medicine 10*, 209–216.

Richardson, J. and Evans, M.L. (2001) *Terrorism and US Policy: National Security Archive Electronic Briefing Book 55.* Retrieved from www.gwu.edu/~nsarchiv/NSAEBB/NSAEBB55/index1.html

Schaverien, J. (1998) "Inheritance: Jewish Identity, Art Psychotherapy Workshops and the Legacy of the Holocaust." In D. Dokter (ed.) *Arts, Therapists, Refugees and Migrants: Reaching Across the Borders.* London: Jessica Kingsley Publishers.

Wertheim-Cahn, T. (1998) "Art therapy with Asylum Seekers: Humanitarian Relief." In D. Dokter (ed.) *Arts Therapists, Refugees and Migrants: Reaching Across the Borders.* London: Jessica Kingsley Publishers.

PART VI

Building Community

Unity in Diversity

Communal Pluralism in the Art Studio and the Classroom

*Michael Franklin, Merryl E. Rothaus,
and Kendra Schpok*

Introduction

As a means of training the socially engaged art therapist, the role of the art studio (Moon 2002) in transpersonal graduate education (Franklin *et al.* 2000) is explored in this chapter. A comprehensive investigation of this training approach will, we hope, inspire ongoing dialogue among studio-based art therapists (Allen 1992, 1995a, 1995b; Cane 1983, first published 1951; Farrelly-Hanson 2001; McMahan 1989; Seftel 1987; Timm-Bottos 1995). Following a general discussion of these topics, we describe the complex journey currently under way at Naropa University in Boulder, Colorado, where we have created an art studio to serve specific educational purposes and community needs. A flexible, pluralistic model of education is presented that incorporates the challenges of integrating clinical and art-based elements into the self-structure of the emerging art therapist. Social engagement through the arts and service as a spiritual practice are addressed as a way to cultivate the socially engaged art therapist. Overall, this project has added a needed non-clinical dimension to our training program. Our aim is to share what we have learned up to this point as a way to stimulate similar projects in other art therapy training programs.

One week after 9/11, the graduate art therapy program at Naropa University launched a community-based art studio project to explore the role of the socially engaged art therapist. As the towers fell and the world atmosphere remained charged with the widest range of human grief, we were

quietly forging a project that was to become our collective response to a changed planet. Grounded in the spirit of service as a spiritual practice, the Naropa Community Art Studio (NCAS) was to achieve several mandates. In essence, the guiding vision was to provide a safe place for marginalized members of the Boulder community to gather and create art together. Specifically, our mission was to promote unity in diversity, confirm the birthright of every individual to pursue creative expression in community, and activate the capacity of visual art to contain and communicate the full range of human experiences.

Given the complex social and cultural challenges facing our global and local communities, the competently trained art therapist is best served by creating a flexible professional identity that integrates clinical skill with social engagement. Our hybrid profession asks that we seek a balance, a middle path that truly embraces all sides of the artist within the therapist (Franklin 1996). Building an integrative three-year training program that sculpts a flexible, clinically savvy, socially engaged, professional identity has consistently been our departmental goal.

Keeping the fire of artistic identity and remaining socially engaged while pursuing the exhaustive challenges of graduate training is a difficult task for both faculty and students. Graduate training is an intensive period of professional self-development that often precludes full engagement in other areas of life. Further, remaining in contact with the public world as an artist often gets ignored during the extensive theoretical segments of training (Allen 1992). The NCAS has offered our students and faculty a chance to interface with larger social concerns beyond the traditional classroom experience. Participation in the NCAS has expanded our perception of who the art therapist is and how and where she or he can serve. These topics are now discussed by outlining how our project has evolved from its inception to its current form. Matters of service as a spiritual practice and the role of the art mentor as a social activist are also addressed in detail (Moon 2002).

Art as service and the practice of pluralism

Our overall work in the NCAS has been anchored in firm convictions around social and cultural pluralism. We wanted to practice a form of communal inclusion based on humanistic values such as cultivating a sense of unity within a diverse society. We also wanted to provide equal access to those who would likely not be able to afford entrance into a fully stocked art studio. We have consistently attempted to work from this inclusive point of view,

empathically locating ourselves in the ostracized "other." Early on, we realized that we must take responsibility for the culturally privileged point of view that sees teachers and students as experts. Therefore, we have tried to arrive at the studio as artist peers who are open to the yet-to-be-realized potential awaiting us in the materials and overall studio environment. The environment of the studio itself models a comprehensive setting where all who attend can exist as equals. Diverse works in progress hang next to each other on the walls and from cables suspended from the ceiling. Assorted materials exist side by side silently announcing the possibility of how they might combine and mix together. From the very beginning of the NCAS, we have made an effort to maintain an inclusive, welcoming, and diverse studio environment. (See Figure 12.1).

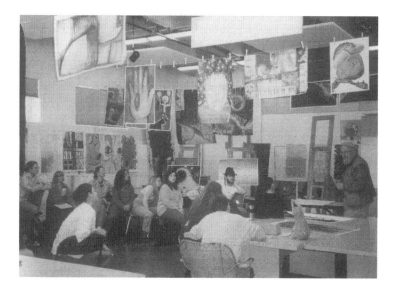

Figure 12.1: Rabbi Zalman Schacter-Shalomi visits the NCAS

In addition to the creation of a pluralistic environment, we have cultivated a service-learning model for our graduate program based on the notion of *seva*, a Sanskrit word for selfless service. When contemplated and practiced by our students and faculty, this idea becomes an astonishing passport for significant forms of self-transformation. Many of the great world traditions teach that, in serving others as selflessly as possible, inner alchemy unfolds, transforming the one who sincerely offers his or her service. The great teachers tell us all actions are, in essence, offerings. It is folly to think or

believe that the outcome of our efforts is primarily to satisfy our own interests or personal gains. Attachment to results or prideful ownership of outcomes is a trap that pulls us away from the orientation of *seva*. This is the spirit of Karma Yoga of which *seva* is a core principle. Swami Chidvilasanada (1997) describes *seva* this way:

> Seva is the most wonderful, the most powerful, and the most profound Alchemy. It is work performed without attachment; duty fulfilled without any desire for personal gain; service without any motive, without any of the objectives that cramp one's actions or contract the heart. Seva means giving one's time and energy without any strings attached and therefore being able to work with total freedom. Seva means doing work for the sake of the highest purpose, doing work while you recognize the worth of another human being, and keeping the value of life in mind. Seva means doing work as a form of worship…an offering for the sake of supreme love. Seva is doing work in such a way that it is Grace in action, devotion in action, knowledge in action. (p.158)

Every day our students, who serve as art mentors, begin their time in the NCAS by pausing and considering how they might align themselves with the principles of *seva*. Everyone is invited to quietly contemplate their personal commitment to be of service to others. This is not an obsessive, self-conscious practice. Rather, we are simply considering how we intend to offer our efforts as artists to the other artists present in the studio.

Ultimately, we all search for different forms of contact. As a transformative environment, the studio confronts the existential overwhelmingness of separateness. Consumerism, a culturally sanctioned practice, creates the illusion of happiness through compulsive behaviors directed toward ownership and wasting. However, people all seem to want access to a greater truth in their lives beyond this sort of existential folly. Therefore, in the studio environment, we practice a kind of sincere availability for each other that is about simple heartfelt connections involving the humanistic values of mutuality, listening, witnessing, and pluralism. Simply put, educating the socially engaged art therapist who is service minded implies a sort of dimensionality that goes beyond the limits of traditional clinical training.

History and context

We could not have attempted to do this work without recognizing those who came before us as guides and mentors. Our work in the NCAS was inspired by art educators Lowenfeld and Brittain (1987) and Henry Schaeffer-Simmern (1961), art critic Herbert Read (1958), and art therapists Florence Cane (1983), Edward Adamson (Seftel 1987), Pat Allen (1992), and Janis Timm-Bottos (1995).

Since its inception, the NCAS project has grown in several significant ways. We have added specific art therapy coursework, conducted research, written and received grants, and also successfully navigated through a complicated approval process with our university. To make this project less theoretical, our students were invited to take an active role in staffing and managing specific aspects of the studio as a way to gain hands-on experience. Simultaneously, a separate art therapy course was created that focused on information about how to set up, manage, and fund a community art studio. The course objective was achieved, in part, by rewriting with each class a collective business plan geared towards creating a hypothetical art studio. Between the opportunity for practical experience and a business-based course to teach management fundamentals, our goal of offering training in community-based work that could be realized and carried out in the world after graduation was firmly in place. To continue realizing our goal, the NCAS needed to become a practicum site for our students. However, before we could fully achieve this, we needed to write up comprehensive policies and procedures to satisfy university concerns that included respectful requirements for our weekly participants.

Developing this sort of articulate, all-inclusive material is a challenging task. This was one of the most difficult obstacles that we faced during the early phases of the project. We showed several colleagues this ever-evolving document and found their critical feedback invaluable. Over time, we hammered out a comprehensive nine-page document that has changed little since then. We began with a mission statement that addressed several significant points – for example, we wrote that the guiding vision behind this long-term project was to provide equal access for marginalized community members. We wanted to advocate for those people who were unlikely to have consistent contact with the humanizing practice of engaging in creative, artistic behavior. Also, we were emphatic in our conviction that this was not to be a restrictive environment. Respect for social, ethnic, gender, and spiritual diversity was stated as a founding principle of the NCAS.

As we clarified our values and completed all our written material, our final hurdle was to clear the project with the university administration. Liability issues were of concern to the various administrators within the upper management of the university. They were rightly concerned because we would be using university classroom space for the project. Therefore, we made sure our policies and procedures were written in a clear, persuasive manner that carefully emphasized that we would be doing *only* studio-based work with our community members and not practicing any form of psychotherapy. Once we convinced the president of the university along with the rest of the upper administration that all the necessary details were in order, we received the green light to proceed.

We currently have four programs in place that function as studio-practicum placements for our students: (a) an after-school program for area teens; (b) a collaboration with the Speech, Language and Hearing Center at the University of Colorado, Boulder; (c) a group for adults with mental illness; and (d) an emerging partnership with the Boulder Shelter for the Homeless. The after-school program serves area high-school students. This program was set up to provide a constructive alternative to unsupervised afternoon time for area teenagers. Approximately 30–40 youth per week participate for ten weeks each semester. We created a position for an "elder-in-residence" to join us during the scheduled studio times for teenagers. Originally a participant in our program through the University of Colorado, this elder serves as an intergenerational bridge, offering the youth her accumulated wisdom and infectious enthusiasm for art and beauty.

Since July, 2002, we have collaborated with the University of Colorado Speech, Language, and Hearing Sciences Center to work with a group of 10–12 post-stroke or head-injured individuals along with their caregivers. Many of the members of this aphasia group have been attending for the entire three years we have been meeting.

In the spring of 2003, we began working with adults who struggle with different forms of mental illness. At the same time, we also began a partnership with the Boulder Shelter for the Homeless to serve their "transitions group" shelter clients. Because the only time to work with the residents is at night, this group has to meet at the shelter for logistic reasons. Aside from this group, all the other programs are held in our studio classroom during weekday hours, usually between 3 and 5 p.m. We are currently serving around 70 people per week in the NCAS during the ten-week periods of the fall and spring semesters (see Figure 12.2).

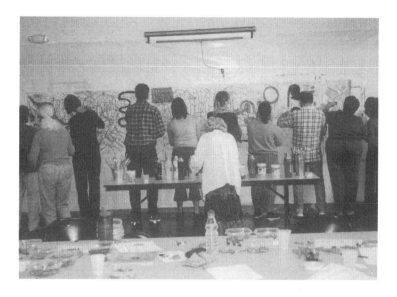

Figure 12.2: Members of the aphasia group working on a mural

Setting up systems

Because the NCAS is a project within an art therapy program that functions within a university, we faced a significant challenge as we developed our own administrative systems. These systems were essential for the project to function well. To these ends, we created budget-tracking strategies, program-evaluation policies, and weekly operational systems.

Our accounting needs were shaped by the existing financial structures within the university and included generating and submitting a budget, setting up a sub-account to allow direct access to our funds, and using the university's payment procedures for equipment and art supply purchases. To date, we have received several grants from local and regional funding agencies. Fortunately, we anticipated the need for accounting systems for donor and grant monies, which allowed us to track expenditures and in-kind donations, and to balance the studio budget at the end of each fiscal year. This type of additional administrative detail has allowed easy retrieval of necessary information for grant proposals as well as demonstrating the fiscal responsibility of the project independent of the university.

Another necessary part of budget administration was the creation of operating systems that interfaced with the ongoing administrative needs of the studio, and allowed students to work within those systems. Due to the additional roles our students now play, the NCAS has enhanced not only the

Boulder community but also our graduate program community. Members of different art therapy classes, faculty, alumni, and friends from other programs meet informally at the studio resulting in more continuity between training and life beyond. During free time in hectic school and work schedules, the studio has become a destination – a place and time to make art for a few hours, nurture each other, and keep up with friends. Students' identities as artists are enhanced because the studio provides space for formal and informal exhibition of artwork, for leading workshops, and for pursuing large-scale or long-term artistic endeavors. NCAS has been essential in turning our art therapy studio into the beating heart of our program – keeping us alive, sustaining our passion, renewing us. This renewal has inspired us to build into our program specific ways to practice art as a form of social action.

Mentorship

Mentorship and social action

How can a group of people making individual art in a studio be a form of social action? Can images created collectively stimulate cultural awareness in order to fuel various forms of social activism? Historically, artists were the visionaries who gave form to ideas and possibilities through images that beckoned viewers to see and feel the extremes of the human condition. Who today does not experience an emotional reaction to Picasso's *Guernica*, an image created in response to the Spanish Civil War in 1937? Meister Eckhart (as cited in Fox 2001), the Christian mystic who lived from 1260 to 1327, discussed the artist as one who has the power to awaken people to the universe and the awe that defines it. Through an artist's image, viewers are offered seemingly endless realities and opportunities for engaging in the collective imagination.

Zinn (2003) writes that artists have the power to transcend immediate social trends as they envision new possibilities and, thus, surpass the conventional wisdom of their current times. Artists' images inherently possess a capacity for significant personal and collective change. Matthew Fox (2001), naming artists as the leaders of social change within any given culture, has suggested that the transformation artists undergo (or do not undergo) has repercussions for whether we move forward as a society or even as a species. Given such a responsibility, it is perhaps not only important but also compulsory that artists bring together groups of people in an inspiring environment that inherently cultivates freedom, possibility, and imagination. To this end,

the participants in the NCAS are modeling a willingness to transcend or ameliorate their life challenges through the act of giving form to their personal stories.

A particular account comes to mind concerning one of the participants in our aphasia group. Jay had had a significant stroke that resulted in global aphasia and a severe reduction of his expressive language skills. Although ambulatory, he shuffled with his cane when walking. In spite of his challenged gait, aphasia, and use of one hand only, Jay courageously entered the art studio each week, ready to dig in and get to work. One day, we were all working on collages. Jay embraced the project, carefully selecting images of animals from a wide assortment of magazines. With the help of a graduate student acting as an auxiliary set of hands, he compiled a small stack of pictures that seemed to enchant him. Eventually he edited his pile down to just monkeys, chimpanzees, and apes.

Over the next hour and a half, Jay maintained his focus with sustained commitment, ultimately manifesting numerous sophisticated ideas, including humor. With the help of his assistant, the pictures were glued in place. Once completed, his engaging composition easily caught the attention of the group. Although his receptive language skills were satisfactory, expressive language was extremely difficult for Jay. However, he was able to say a great deal through the language implicit in his collage. The final piece articulated a specific narrative that was complex in both form and content. All who witnessed his work saw the complexity of his composition.

As he received the numerous compliments that were offered to him, an unforgettable moment occurred. Jay seemed to sense that we knew, through the example of the narrative alive in his collage, that his inner subjective life of thoughts and ideas was intact and working quite well. With no other way to really tell us, in this moment he ceased to be a diagnosis and cluster of disabilities. Instead, Jay was recognized for his thoughtful creative efforts and for his healthy poetic ability to articulate engaging stories rich in metaphors and symbolic communication.

Junge *et al.* (1993) wrote:

> Imagination is the essence of hope – and of the potentialities of the creative process... It is the act of imagination that offers a vision of something different, better, and the resulting hope that can impel us to action. (p.149)

The importance of supporting, nourishing, and giving life to their emerging dreams, feelings, and imaginings through the creative process is crucial for

the NCAS participants. Through creative freedom they learn to embody authentic artistic expression both as individuals and within community. (See Figure 12.3).

As artists creating individual images within a community context, participants are undoubtedly influenced by observing and vicariously experiencing one another's artistic processes. Schaverien (1987) confirms that, when an image exists, it has the power to interact with and affect not only the artist who created it but also others who view it. Being witness to another's artwork may stimulate a process that results in change and new thinking (Lachman-Chapin *et al.* 1998). There can be emotional release and affirmation not only for the artist, who scribbles attentively with black oil sticks and then writes about it or shares the process with the group, but also for another artist who is working on similar themes. The result of these interchanges is the formation of a relationship between artist and viewer based on a more intimate understanding of the artist's life experience. Compassion, empathy, and mutual empowerment are generated among the participants as a result of individual creative processes conjoining in the studio. These humanistic qualities can then be taken into the larger world to generate change in other social systems, such as family, school, work, local, or even global systems. The social role of the artist has become common discourse within the contemporary art world as artists and art critics revisit and re-envision the

Figure 12.3: A beloved member of the Naropa University community visits the NCAS

greater purpose of their identities and the function of their art. As members of society with the capacity to positively affect the world, the artist as social activist can have a significant effect on the wider culture (Flack 1986; Gablik 1991; Grey 2001).

Defining the role of the art mentor

Because the university administration did not want us to engage in therapy in the NCAS, we have been exploring the boundaries between art therapy and art mentoring. Finding where these two practices meet and diverge has stimulated continual dialogue with each successive semester. As we continue to explore the concept of art mentoring, we hope to bring a fresh perspective to the long tradition of mentoring as a vital social activity.

The practice of mentoring can be traced to Ancient Greece. Before Odysseus left for the Trojan War, he entrusted his friend Mentor with the care and education of his son. This historical context still shapes the idea of a mentor as a:

> caring, mature person who forms a one-on-one relationship with someone in need…[and is] one who listens to, cares for, gives advice to, and shares information and life/career experiences with another, especially a young person requiring assistance. (Dondero 1997, p.881)

Bona, Rinehart and Volbrecht (1995) emphasized that mentoring is not limited to talking but is also action oriented. The mentors and mentees are in the same environment, acting within it, allowing the mentee to observe the mentor as a role model. The mentor provides instruction or commentary but performs, presents, and demonstrates the nuances of a given discipline for the mentee as well.

On cursory inspection, art mentoring and art therapist–client relationships share commonalities and differences. Both the mentor and therapist occupy a special place in the life of the receiver, which is different from any other relationship the person may have. Both may be long-term relationships in which there is an inherent power differential based on experience or expertise. The mentee or client receives help from this trusted person in an effort to enrich or change life patterns in specific ways. The art therapist, like the art mentor, listens to, cares for, and extends a basic attitude of respect for and belief in the abilities of the client or artist participant. And in some instances, such as an open studio approach, art therapists and art mentors make art alongside other participants (Allen 1992; Haeseler 1989).

However, when art therapy graduate students begin serving as mentors, we need to stress that art mentoring is not art therapy. Therapeutic codes of ethics caution therapists against entering into dual relationships with clients or engaging in social contact. According to the literature on mentorship, there is no ethical injunction against developing a social relationship outside the proscribed arena (Cannister 1999; Dondero 1997; Gagnepain and Stader 2000; Merriam 1983; Parkay 1988; Royse 1998; Sunoo 2000). In many traditional mentoring programs, the interaction between mentor and mentee is not limited to an academic or activity-oriented sphere but may require regular social activities in addition to the stated area of assistance. Also, unlike therapy, an essential aspect of mentoring is the sharing of the mentor's personal experience and life story. Through this sharing, the mentee's self-image is awakened and his or her ideal Self may come to be embodied by the mentor. The mentee then internalizes selected aspects of the mentor's proffered ego (Kramer 1971; Parkay 1988). Mentoring focuses on skill acquisition and application, and on developing and manifesting the untested self-concept of the mentee, not on psychodynamic functioning or the healing of trauma.

Structuring the role of art mentor within a program that has significant clinical elements has been challenging. Nonetheless, over the years, we have gradually been able to draw the line between art mentoring and clinical art therapy. When discussing art with our mentees, despite occasional psychic or emotional pain in the images, we follow a guideline of consistently returning to the art by framing our comments and interactions around aesthetic concerns. We accomplish this by simply witnessing the creative struggle as it unfolds and supporting people to be who they are and create honest art. Mentors are also free to share their struggles, and do so within customary social boundaries and their own comfort levels. The challenges of when to make personal material public are constantly explored with our pool of mentors throughout each semester.

The policies and procedures that we crafted anticipated several concerns regarding matters of participation ranging from generalized personal disclosure to a personal crisis. We addressed these concerns in several ways. Prior to attending the studio, all participants are asked to sign consent forms that outline rules for attendance, emergency contacts, and general policies and procedures for attending the NCAS. Should a concern for the welfare of a particular participant arise, we follow a protocol that any good citizen would

pursue by bringing our concerns to the attention of the parents or legal guardians listed on the signed consent forms.

Although traditional models of both therapy and mentoring stress the hierarchical nature of these relationships, the creative process has an equalizing effect on the relationships that form in the NCAS. Although mentors may have more artistic knowledge, experience, or technique than the participants who join us, the nature of creativity – its changing images, novel points of view, experimentation, unique forms of expression, and observations that lead to significant discoveries – makes every participant a potential mentor. Expertise is shared rather than used to create hierarchies of difference. In practicing pluralism in the studio, we invite this shifting of roles and seek to be taught as much as to teach, to receive as much as to offer. The creative process makes each of us an expert on our own vision, which can then be taught and shared with others. What we practice in the studio could be more accurately described as "co-mentoring" (Bona et al. 1995, p.116).

Even though mentoring may have a positive effect on the life course and personal development of the individual, the primary function of mentoring is to facilitate and maintain social and cultural cohesion by transmitting wisdom either to an upcoming generation or to another interested group. Mentoring often attempts to provide what is lacking in the community or culture, and at the same time to aid individuals in participating in society. To accomplish this, mentor programs seek to redress social ills by providing a counterweight to the negative impact of societal forces on individual lives. The NCAS – with its emphasis on unity in diversity, creative expression in community, and containment of human experience through art – seeks to redress the social isolation created by privilege, racism, and consumerism (Johnson 2001). In the context of the community art studio, individual creativity and personal development may be fostered, identities as artists may be forged, and people of differing ethnic origins, socioeconomic backgrounds, age groups, and abilities may find belonging with the ultimate goal of cultural healing (see Figure 12.4).

Mentorship in practice

Kramer (1971) has advocated that the art therapist should, at appropriate times, serve as an artist who knows how to teach. To be an art mentor working as an artist-teacher means instructing participants in ways that reference the skill of the "third hand" (Kramer 1986). Technical skills such as how to score clay, to create depth in a painting, or to throw on the potter's

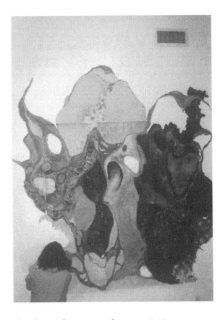

Figure 12.4: Kendra Schpok working on a large painting

wheel constitute potential third-hand exchanges. Therefore, our graduate student mentors offer "teach-ins" where they teach artistic skills. In addition, participants tell us what they would like to learn. Teach-ins on gesture drawing, gold-leaf application, wire-sculpture, doll making, and clay mask making have been offered among other techniques. Additionally, we have invited participants to host teach-ins for us where they introduce us to art forms and techniques of personal interest.

In addition to serving as an art teacher, it is an absolute that our mentors relate to studio participants from their fundamental core as artists. Relating artist to artist, for example, means sharing frustrations, discoveries, inquiries, and desires about the gifts of making art and, therefore, engaging in bi-directional exchanges of the creative process. Here, a participant may ask for artistic guidance or recommendations. There, an adult mentor may solicit the help of a high-school freshman about how to paint more realistic eyes on the sea turtle in her painting. A teenage participant may hang all her work and ask for feedback. Or, there is the delight of multigenerational collaboration as a group of high-school students help our 75-year-old elder-in-residence add volume to the lower lip of her clay portrait.

Near the end of each day at the NCAS, participants are invited and encouraged to write about their images and artistic process through the practice of "witness writing," a practice developed by Allen (2001) and her colleagues at the Open Studio Project in Chicago. Witness writing has been described to the studio participants as a way to foster an intimate relationship with one's artwork. This may be accomplished through writing what the image might say if it had a voice, or through engaging in stream-of-consciousness writing about the image, or even a descriptive examination of the artwork. Once complete, participants are invited to read their writing aloud while the other members receive and resonate with the text without commenting. In essence, according to Allen, witness writing is a practice that illuminates the wisdom of the image. It is also a practice that helps to build community through receptive, resonant listening. After writing, there is a silent walk through of the art created, during which participants view it from a phenomenological approach (Betensky 2001) by suspending judgment and simply inhaling the lines, shapes, colors, and textures of the art made over the past few hours (Franklin and Politsky 1992). Coming together as a group, participants volunteer to share their writings or discoveries or visit with one artist and her or his work. In essence, in a matter of hours, a community of artists has been invited, established, and confirmed.

Conclusion

Mentoring is about moving within the dynamic space of the NCAS as we create art together as an offering to ourselves, one another, and the community beyond the studio environment. To mentor is to embrace the transpersonal view of authentic service that is non-dualistic, selfless, and focused on process as much as outcome (Davis 2000). The role of mentor has been explained to our graduate students as similar to the way of a dolphin. A dolphin sleeps with one eye closed and the other open. The closed eye allows the dolphin to turn inward whereas the open eye is aware of its surroundings. Mentoring is to be engaged in one's own practice of making art while being aware of the others, and being available and accessible to their artistic needs, challenges, and discoveries.

From its earliest origins, this project has intended to cultivate socially engaged art therapists who could carry this way of working into the waiting world. The NCAS is a social and cultural intervention that continues to instruct all who participate in the transformations available when creating in the community. The creative process belongs to no one. It is to be shared and

freely offered to all who are interested. It is this creative freedom that we strive to follow and promote as we look forward to the next opportunities in the NCAS (see Figure 12.5).

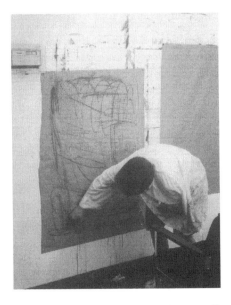

Figure 12.5: NCAS member with partial paralysis enthusiastically working on a large drawing

Acknowledgement

The project on which this chapter is based would not have been possible without the financial support of a generous anonymous donor.

References

Allen, P.B. (1992) "Artist in residence: An alternative to "clinification" for art therapists." *Art Therapy: Journal of the American Art Therapy Association 9*, 1, 22–29.

Allen, P. (1995a) *Art is a Way of Knowing: A Guide to Self-Knowledge and Spiritual Fulfillment through Creativity.* Boston: Shambhala.

Allen, P. (1995b) "Coyote comes in from the cold: The evolution of the open studio concept." *American Journal of Art Therapy 12*, 3, 161–165.

Allen, P.B. (2001) "Art Making as Spiritual Path: The Open Studio Process as a Way to Practice Art Therapy." In J.A. Rubin (ed.) *Approaches to Art Therapy: Theory and Technique* (2nd edn). Philadelphia: Brunner-Routledge.

Betensky, M. (2001) "Phenomenological art therapy." In J.A. Rubin (ed.) *Approaches to Art Therapy: Theory and Technique* (2nd edn). Philadelphia: Brunner-Routledge.

Bona, M.J., Rinehart, J. and Volbrecht, R.M. (1995) "Show me how to do like you do: Co-mentoring as feminist pedagogy." *Feminist Teacher 9*, 116–124.

Cane, F. (1983) *The Artist in Each of Us.* Craftsbury Common, VT: Art Therapy Publications. (Original work published 1951.)

Cannister, M.W. (1999) "Mentoring and the spiritual well being of late adolescents." *Adolescence 34*, 136, 769–779.

Chidvilasanada, S. (1997) *Enthusiasm.* South Fallsburg, NY: SYDA Foundation.

Davis, J. (2000) "We keep asking ourselves, what is transpersonal psychology?" *Guidance and Counseling 15*, 3, 3–8.

Dondero, G.M. (1997) "Mentoring: Beacons of hope." *Adolescence 32*, 881–886.

Farrelly-Hanson, M. (2001) *Spirituality and Art Therapy: Living the Connection.* London: Jessica Kingsley Publishers.

Flack, A. (1986) *Art and Soul.* New York: Penguin.

Fox, M. (2001) "Art Spirituality." Paper presented at Chicago Art Institute, Chicago, IL.

Franklin, M. (1996) "A place to stand: Maori culture-tradition in a contemporary art studio." *Art Therapy: Journal of the American Art Therapy Association 13*, 2, 126–130.

Franklin, M. and Politsky, R. (1992) "The problem of interpretation: Implications and strategies for the field of art therapy." *The Arts in Psychotherapy 9*, 3, 163–175.

Franklin, M., Farrelly-Hansen, M., Marek, B., Swan-Foster, N. and Wallingford, S. (2000) "Transpersonal art therapy education." *Art Therapy: Journal of the American Art Therapy Association 17*, 2, 101–110.

Gablik, S. (1991) *The Reenchantment of Art.* New York: Thames and Hudson.

Gagnepain, F.G. and Stader, D. (2000) "Mentoring: The power of peers." *American Secondary Education 28*, 3, 28–32.

Grey, A. (2001) *The Mission of Art.* Boston, MA: Shambhala.

Haeseler, M.P. (1989) "Should art therapists create art alongside their clients?" *American Journal of Art Therapy 27*, 3, 70–79.

Johnson, A.G. (2001) *Privilege, Power, and Difference.* New York: McGraw-Hill Higher Education.

Junge, M., Alvarez, J., Kellogg, A. and Volker, C. (1993) "The art therapist as social activist: Reflections and visions." *American Journal of Art Therapy 10*, 3, 148–155.

Kramer, E. (1971) *Art as Therapy with Children.* New York: Schocken Books.

Kramer, E. (1986) "The art therapist's third hand: Reflections on art, art therapy, and society at large." *American Journal of Art Therapy 24*, 3, 71–86.

Lachman-Chapin, M., Jones, D., Sweig, T., Cohen, B., Semekoski, S. and Fleming, M. (1998) "Connecting with the art world: Expanding beyond the mental health world." *American Journal of Art Therapy 15*, 4, 233–243.

Lowenfeld, V. and Brittain, W.L. (1987) *Creative and Mental Growth.* New York: Macmillan.

McMahan, J. (1989) "An interview with Edith Kramer." *American Journal of Art Therapy, 27*, 4, 107–114.

Merriam, S. (1983) "Mentors and proteges: A critical review of the literature." *Adult Education Quarterly 33*, 3, 161–173.

Moon, C. (2002) *Studio Art Therapy.* London: Jessica Kingsley Publishers.

Parkay, F.W. (1988) "Reflections of a protege." *Theory Into Practice 27*, 3, 195–200.

Read, H. (1958) *Education Through Art.* New York: Pantheon Books.

Royse, D. (1998) "Mentoring high-risk minority youth: Evaluation of the brothers project." *Adolescence 33*, 129, 145–158.

Schaeffer-Simmern, H. (1961) *The Unfolding of Artistic Activity.* Berkeley, CA: University of California Press.

Schaverien, J. (1987) "The Scapegoat and the Talisman: Transference in Art Therapy." In C. Case, T. Dalley, D. Halliday, P. Nowell-Hall, D. Waller and F. Weir (eds) *Images of Art Therapy: New Developments in Theory and Practice.* New York: Tavistock.

Seftel, L. (1987) "A conversation with Edward Adamson." *American Journal of Art Therapy 26,* 2, 48–51.

Sunoo, B.P. (2000) "HBO programs partnerships for inner-city teens." *Workforce 79,* 7, 66–67.

Timm-Bottos, J. (1995) "Artstreet: Joining community through art." *American Journal of Art Therapy 12,* 3, 184–188.

Zinn, H. (2003) *Artists in Times of War.* New York: Seven Stories Press.

Art and Community Building from the Puppet and Mask Maker's Perspective

Lani Gerity and Edward "Ned"Albert Bear

Everybody needs beauty as well as bread, places to play in and pray in, where nature may heal and give strength to body and soul alike. (John Muir 1912, p.198)

Introduction

A neighbor of mine,[1] a very devout Vietnamese Buddhist monk not given to impassioned speech making, turned to my husband the other day and asked, "Do you worry for the world?" They had been building a little guest house on the monk's land, and they had stopped for tea. The monk had been telling stories of his youth in Vietnam, stories of the sorrow and suffering of his people. He was looking at parallels between his experiences in Vietnam and the experiences of the people of Iraq. My husband replied that, no, he didn't worry so much as he felt deeply sad. As he relayed this story to me, I thought of Edith Kramer's use of the term *Weltschmerz*, or "world pain". Sometimes the sorrows of the world can weigh us down to the point where we begin to wonder what we can do. If the world pain is a call to action, how are we to respond? What can artists and art therapists do about so much suffering? How can we answer the call if we feel overwhelmed by the enormity of sorrows and the relatively meager size of our ability and talent?

This chapter is about the collaborative response of one puppet maker/bart therapist and one mask maker/educator to that call to action. Before Ned and I describe our collaborative efforts in community building, I will

introduce you to a few of the artists and art therapists whom I talked with about this idea of socially relevant activity. Finding my own way to a response to this call to action was a process, an adventure filled with inspiring artists and their stories and ideas. Four of these encounters are presented below: with a group of artists in Quebec called "Boréal Art/ Nature," with Peter Schumann of Bread and Puppet Theater, with art therapist/artist Edith Kramer, and, finally, with artist/educator Ned Bear.

Four encounters

Boréal Art/Nature

Boréal Art/Nature is an artist-run center located in the Laurentian Mountains. These artists came together from various disciplines because they shared an idea of exploring and encouraging links between contemporary art practices and nature. Their research is undertaken with a growing concern about the relationship between nature and culture. Christine Doyle, a friend of this group who is an art therapist, looks for sustainable, collaborative ways to create art and to encourage art making in others. Christine explained to me that we are an extremely dependent culture; it is as if we are looking for the ready-made bouquets in life with a kind of fast-food mindset. We look for things that we can passively and effortlessly buy and consume, things that demand no investment or thought from us. These things don't interest Christine at all because they are not deeply engaging and do not create a sense of inner satisfaction. What interests her is seeds – seeds of art, seeds of ideas, things that create literal and metaphoric gardens, and community art projects. She's interested in art that is egalitarian and deeply satisfying. She and the Boréal artists provide art seeds for individuals in the community, art seeds that can be planted and nurtured in fertile imaginations.

To show me how the Boréal artists-in-residence program works, Christine took me to an "open trail day" during which the public is invited to explore a trail where artists have been working for the period of their residence program. In this case, the artists were a large group of art students from Concordia University in Montreal. They had been brought out of their very busy academic, urban environment and placed in the forest, set free to interact and create with materials from nature. The land became the art room, and a Boréal Art/Nature artist became a benign facilitator, explaining the rules: "Find your own special spot. Use only biodegradable materials or materials provided by the forest. Do no harm to yourself or the forest."

The results were awe inspiring, heart opening, and integrating for the artist and viewer. There were structures of wood and stone and earth and leaves; there were caves in roots; there were expressions of wounding, sorrow, and loss; there were amazing performance pieces such as milkweed-pod boats being kissed and sent down a stream to an uncertain future and freedom. As we walked along viewing their work, almost all the students expressed feeling connected to the environment, reconnected to memories. As they shared their stories, you could see strong connections building between them and the viewers. They talked about the magic of finding their own spot and of the wonder and acceptance of natural life cycles, the passing away of things, the needing to let go and say good-bye. The amazing thing was the way in which this art studio, the forest, could so easily absorb and contain such passionate feeling from these students and reflect something reassuring and quiet back to them. They were so deeply moved and moving, and so gentle with each other and with the forest.

One of the students had recently lost her mother. She took us to various spots in the forest where she had set up wooden frames. We could look through the frames and see what she had seen. At the last frame, she said she had wanted to think "outside the box," to look at all the things outside these frames, but her "industrial mind" just wanted things in boxes – unchanged, safe, and permanent. She had wanted to feel her mother's presence in the forest, but, because her industrial mind wanted to keep her inside a clean box, separated from illness and suffering and death, it also kept her separate from the forest and from her mother's memory. She felt that she was missing so much by looking only at what was safe in the frame, that she was missing reality, authentic expression, and her mother. (We observers found her statement deeply authentic and deeply moving.)

As I listened to her talk about her wishes for more authentic expression and feeling, a question began to form in my mind. Would I need a larger frame, one that could be a kind of doorway or a threshold if I were going to answer this call for greater authenticity? Like the student, I wanted to step outside my own industrial mind, my own art-therapist identity, and my own confining views of what making art was for and where it can be practiced. I wanted the artistic and intellectual freedom that walking through the frame would give me.

Peter Schumann and the Bread and Puppet Theater

I found Peter Schumann and the other members of Bread and Puppet Theater on an old farm in Glover, Vermont. One of the barns of the old farm is a converted puppet museum – two floors filled with huge masks and puppets grouped together in their own story environments (see Figure 13.1). What surprised me was a sense of freshness, a kind of stylistic newness in each of the puppet groupings; each group seemed to be an exploration of a different theme and style. I thought I knew what Bread and Puppet was about. I assumed I understood what these artists were trying to say and that I wouldn't really have to listen. But the actual work was startling and fresh. A guide explained the stories and methods used to create the puppets. Indeed, each group was completely unique and called for a "beginner's mind" from the viewer. There was a sense of a collaborative experience as I looked at the imagery, heard the stories that went with them, and imagined the plays at dusk in the Vermont hills.

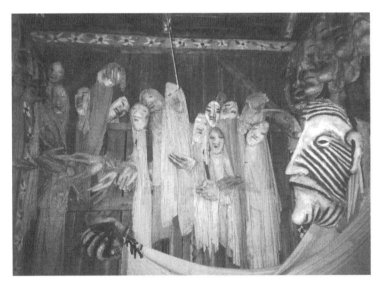

Figure 13.1: A group of puppets in the Bread and Puppet collection

I asked Peter how it was that he could maintain this freshness of art and story. How did he keep his audiences from imagining they knew what was coming next? As artists, how can we call for the beginner's mind from our viewers? Suppose the *Weltschmerz* has us wanting to do something, say something, but

we don't want to be dismissed. We don't want people to pigeonhole us, thinking they know what we are going to say and then not listening.

To this, Peter responded that he's not trying to tell people *what* to think, that he's not interested in propaganda. Although he is interested in creating uncertainty in his viewers' minds, what interests him most is responding to the world and its sorrows and beauty with his art. If this causes people to stop in their tracks for a moment, then that's just fine. But the thing is responding to the world around us with our talents, voices, and generosity.

Peter also said that one of the things he values most is the ability to think. Just as his wonderful sourdough bread needs starter, good art, good stories, and good actions need thought. Good thinking comes from good questions. He suggests that there is much in our culture that discourages thinking, much that entertains us. But "Why shouldn't we think?", he wants to know. Why would anyone *not* want us to think? How do we keep ourselves thinking instead of doing things by rote? How do we keep a beginner's mind, open to possibilities and hope?

So Peter Schumann is most interested in living a thoughtful, artful life, creating puppets and plays about the things he sees in the world: injustice and oppression, and beauty, joy, and hope. He creates stories filled with hope and resurrection, stories in which the viewer feels as though he or she might belong and feel at home.

Edith Kramer

> This is how it looks, my child, the world you were born into… If you do not like this world, then you will have to change it. (Friedl Dicker-Brandeis from an anti-capitalist poster, circa 1930–34, cited in Makarova 2001, pp.20–21)

One of my most heartening conversations on how to live in response to *Weltschmerz* was with Edith Kramer. In describing the years of darkness, the sorrows of World War II, she referred to Austrian artist Friedl Dicker-Brandeis's inspired work. In 1934, before fleeing to Prague, Friedl was arrested, imprisoned, and interrogated because of communist affiliations. When she was released, she confided to Edith that the experience had made her feel very much alive, that she wasn't troubled at all by being confined and, in fact, felt unconstrained. As Edith remembers it, it was because of this experience that Friedl decided psychoanalysis might help her with what she perceived to be masochistic feelings.

Friedl then moved to Czechoslovakia where she began to work with Jewish refugee children fleeing from Nazi persecution. It was here that Edith Kramer joined her and learned so much that was relevant to the field of art therapy: "I am endlessly grateful that she taught me the meaning of art. I was able to build on her foundation. No one else could have given me what she did" (Kramer quoted in Makarova 2001, p.234).

In December of 1942, Friedl was sent to Terezin, the 18th-century fortress turned into a transport camp by the Nazis, where she worked very hard with so very little to teach children to work creatively, to make art under the worst possible circumstances. They used what they had on hand; they created collages, fed their imaginations, and developed their inner lives. Some of the few children who survived credited Friedl with teaching them the importance of survival.

Edith's description of Friedl's story gave me a very real understanding of generosity, of using what you have on hand, whether it is just a few materials or your own flawed human personality. Friedl was able to use her ability to withstand or even feel more alive in confinement to do wonderful things in a time of great suffering. So, for example, if a person is given to making and playing with puppets and dolls, instead of putting that aside and trying to become a serious social activist, that person could look for opportunities to use puppet making and intergenerational play. Friedl's story teaches us to keep our eyes open for possible venues in which to use our gifts. We don't have to try to learn some new way of doing things, and we don't have to wait until we have completed our analysis to be of assistance to someone. We can use what we have on hand.

Ned Bear

I was introduced to Ned Bear and his work through a film, *KWA' NU' TE':* *Micmac and Maliseet Artists,* by Catherine Martin (1991). His sculptures resonated and his words were deeply moving. In this film, Ned talked a bit about growing up "behind a fence" on an urban reserve in north Fredericton, New Brunswick, Canada. He described his work as being in part a way of working through the terrible losses that his culture and his people had experienced. "Forsaken" was the word that he used in terms of these experiences. Ned said that he wished there were more ways to bring the arts into children's lives, that having an outlet for expression sometimes is all it takes to make the difference in a child's life. Something about the work and these words filled my mind with possibilities of bringing puppet making and mask making together. Having been encouraged by Edith Kramer to go out

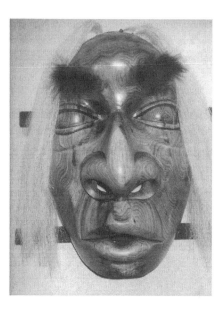

Figure 13.2: "A Warrior Knows," mask by Ned Bear

into the field and talk to artists about what matters most to them, I sought out Ned Bear and made an appointment to see his masks (see Figure 13.2) and to talk to him about his work and his hopes for his community.

Ned talked about modern education's ability to teach children to become "drones," mindlessly accepting extrinsic rewards like grades and short-lived pleasures. He said that, when rewards are extrinsic, then esteem is limited to a few at the cost of the many. But, if education could teach children to think, to find intrinsic rewards in their growing knowledge and creative work, their spirits would expand and the community would be strengthened in this way. I told him a little about my background and my own hopes.

The collaboration

As experienced mask and puppet makers, both Ned and I had a wish to broaden the social applicability of our work, and apply it to the restoration of life in the community. Because of our backgrounds in art therapy and education, we were concerned with what we saw as children's increasing dependence upon virtual environments for their imaginative lives. We were concerned that they were increasingly finding their ego ideals and their role models in the impersonal, uncaring worlds of advertising and the media rather than within the community.

We had observed, however, that, during play or while working in three dimensions with their hands, children seemed to be creating from a place relatively free of the imagery of popular culture and making something of their very own. We had observed parallels in our own artistic expressions: masks tend to be evocative, awakening emotion and thoughts that may otherwise be numbed by the pressures of modern life, and puppets awaken possibilities of wonder, empathy, and story.

We began by running day-long puppet- and story-making workshops in primary and high schools for the native children. We started with sock puppets, progressed to papier mâché hand puppets, and, finally, made full body puppets with large papier mâché masks for heads. Each workshop began with the creation of the puppets, followed by character development (based on the puppet), and ended with group stories created by the students based on their puppets' characters.

Working in a school setting built our confidence in the modality. But we began to realize that we had a longing to add two elements that would require financial assistance: the incorporation of the native community elders and the use of a natural setting away from the distractions of the popular culture for an intense immersion in the creative process. Our thinking was that by creating an art camp in an outdoor setting, away from the imagery and sounds of the dominant culture, with a variety of ages and generations, we would be providing a context that would allow participants to find role models and to develop a sense of pride in their own culture and in working together. Participants would be using the creative process to establish a deeper relationship with the Earth, to awaken and animate their creative selves, and to acquire increased respect and appreciation for Self and others.

We approached the Canada Council for the Arts with our ideas and described our collaborative workshops in the schools. We described our work with Bread and Puppet Theater in Glover, Vermont, how we had approached them with our wish to learn some basics in papier mâché mask making and in the creation of performances. We also discussed what we had learned from Boréal Art/Nature of Quebec. We discussed with the Canada Council for the Arts our long-range goal of creating a protocol for using three-dimensional modalities (puppet and mask making) along with narrative in an outdoor setting that could be applied to various communities.

Specifics

The Canada Council suggested we create a specific plan in a formal grant proposal. So we wrote up a plan for a week-long art camp for approximately 25 intergenerational participants from the St. Mary's First Nation in Fredericton, New Brunswick, and surrounding native communities. Our plan for the camp included an outdoor, holistic, art-making experience combining puppet and mask making with the crafting of a group narrative or story inspired by the artwork. This story would be the participants' own creation, not an imposed narrative.

We wrote that previous collaborations had taught us that this type of experience engages both children and elders in a lively playful way, and yet allows for a certain amount of introspection. It is tactile, three dimensional, and an animated and animating experience. It is visual and yet has a storytelling component. It is completely interactive. Using papier mâché and cloth, and incorporating objects from the environment, participants in previous collaborations had created puppets that mysteriously enchanted both the puppeteer and the viewer. By animating such puppets, the whole world suddenly becomes a new, curious, and exciting place.

Our hope was that this intergenerational art-making, storytelling format would have far-reaching consequences as a result of the exploration and strengthening of the sense of Self to the building of bridges between generations and between artists and their environment. The immediate outcome, presenting a puppetry narrative to the larger community, would serve as a live model for bridge building. Along with creating bridges, our hope was that there would be a reawakening of intrinsic rewards in working creatively, a sense of nourishment that comes with creative effort. This use of mask and puppet making would draw on the strengths that lie within the Maliseet culture, its children, and the wisdom of its elders. It would use art to reawaken self-respect and, we hoped, reanimate respect for the wider world and all its inhabitants.

We also hoped that this experience would be a positive one, encouraging mental health at the broadest level. We looked to Jeannette Armstrong (1995), an Okanagan writer, educator, and poet, for her definition of mental health. Armstrong describes human mental health as a state of being in which the whole Self feels bonded with the community and with the land (perhaps similar to what Freud called the "oceanic" feeling). Within the Okanagan culture, those who have the widest identification (Self, family,

community, land, all beings) are thought to be the healthiest. Without connection to others and to the land, people are not healthy.

The outcome

We were happy to report back to the Canada Council on the outcome of our *K'chi Kuhkiyik* (people/spirits of the woods) Arts Camp project. We were very grateful that they gave us the funding for our arts camp, and the chance to discover that it was indeed possible to broaden the social applicability of our work, applying it to building an exciting, creative community feeling through an intergenerational art camp that included community elders, parents, aunts, uncles, and siblings. For the first two days of the designated week, we were able to use a natural setting for an immersion in the creative process, away from the reserve. Weather forced us back on the reserve, but, even with all the distractions, everyone returned each day until the end of camp. Our objectives – which were to use the creative process to form a deeper relationship with the Earth, an awakening and animation of creative aspects of the Self, a deeper respect for Self and others, and an increase in self-esteem – were apparently all met (see Figure 13.3). The experience concluded with a celebratory presentation of masks to a day care center with

Figure 13.3: A K'chi Kuhkiyik Arts Camp participant with puppet

a parade and hands-on explanation about how the puppets were made, followed by the enactment of three short plays for the community as a whole.

An important feature of the arts camp was the inclusion of Maggie Paul, a community elder and a renowned traditional singer. She was invited to sing and drum for an evening, but became very intrigued by the process. She became an active member of the camp, singing and drumming while creative work was being done. Her presence provided a spiritual grounding to the week and probably influenced the stories that emerged.

The stories

The stories were filled with larger than life characters that were both mythic and mysterious. There were water spirits, forest spirits, and trickster crows (these were characters easily swayed by the temptations of modern fast food) wise chiefs, and wise women. As an example, we include one of the stories here:

> (The story begins with *Bah-tillius*, a kind of cleric, slowly dancing.) The people danced in sorrow. The community is broken. The people's hearts are filled with sadness. And Nature too is forsaken. (Nature enters the scene and begins to dance as well. *Bah-tillius* and Nature do a sad, slow dance together.)
>
> But there are those who come to help. *Med-ow-win* the medicine woman comes with her medicine bag and tries to heal the brokenness of Nature and the sorrow of *Bah-tillius* and the broken hearts of the people. But they don't hear, they don't see. Their hearts are closed.
>
> Then *Geek-nuks* the great turtle comes to heal the hearts of the people and of Nature, but no one sees, no one hears. Their hearts are closed. *Geek-nuks* is very sad. "Why don't you listen? Why don't you see?", *Geek-nuks* asks.
>
> And then at last comes *Gwan-ta-moose*, a strong but independent woman, crying at the edge of the community. *Gwan-ta-moose* wakes the people up with her wailing and they listen.
>
> Gradually the people come to recognize the healing power of *Med-ow-win* the medicine woman, and now they take her medicine. And gradually the people come to remember that *Geek-nuks* is not just a little turtle in the mud but the Sacred Turtle, the people's connection to all things, to our mother the Earth, to community and to Nature, and slowly, slowly the community begins to heal and dance again. (The per-

formance ends with the performers and Maggie Paul weaving their way around the audience and inviting everyone to dance.)

Follow up

As a follow-up project, we took some of the camp participants to the Bread and Puppet Theater in Vermont. Peter Schumann and his staff shared basic puppetry knowledge, stilt-walking skills, wisdom and humor, as well as good homegrown food and homemade bread.

Conclusion

As artists and therapists, we don't have to feel pressured to replicate any specific stories in our search for a response to the sorrows we perceive in the world. As mentioned earlier, we needn't look for the ready-made bouquet: we can look for idea seeds and mix them with our own fertile imaginations and see what happens. We might simply take more time to do the things that nurture our creative inner lives; we might find other artists who are interested in community building or making art in nature with us.

Whatever happens to the seeds of ideas, stories, and art presented here, may they continue to unfold, grow, and spread. Please feel free to contact us, the authors of this chapter (see the References for our website details), when things start to germinate for you. Consider us a part of your community, people to have a conversation with over paint, masks, and puppets. We would enjoy being able to report back to Boréal Art/Nature, Peter Schuman of Bread and Puppet Theater, and Edith Kramer about the spreading of wild and radical acts of hope, art, and compassion.

Note

1 The first author is the narrator throughout this chapter.

References

Armstrong, J. (1995) "Keepers of the Earth." In T. Roszak, M.E. Gomes and A.D. Kanner (eds) *Ecopsychology: Restoring the Earth, Healing the Mind.* San Francisco: Sierra Club Books.

Makarova, E. (2001) *Friedl Dicker-Brandeis, Vienna 1898–Auschwitz 1944: The Artist Who Inspired the Children's Drawings of Terezin.* Los Angeles: Tallfellow/Every Picture Press.

Martin, C. (1991) *KWA'NU'TE': Micmac and Maliseet Artists* [Motion picture]. Canada: The National Film Board of Canada and the Nova Scotia Department of Education.

Muir, J. (1912) *The Yosemite.* New York: The Century Company.

Websites

Boréal Art/Nature: www.artnature.ca

Peter Schumann and the Bread and Puppet Theater:
www.cbc.ca/ideas/features/bread_puppet
www.theaterofmemory.com/art/bread/bread.html

Lani Gerity: www.lanipuppetmaker.com

Ned Bear: www.lib.unb.ca/Texts/QWERTY/Qweb/qwerte/ned_bear/ned.htm

Art Therapy for this Multicultural World

Susan Berkowitz

Introduction

I used to do art therapy with individuals. Now I do art therapy for the world. You are probably thinking, "She needs help herself; no one can have the world as a patient." My present work is educational and borders on clinical, but not in the traditional sense. Unless we diagnose a person as being ill, we don't think of a setting as being clinical. I propose that our society is ill because we are intolerant of the unique differences and unaware of the similarities we all possess. I believe that the multicultural problems we encounter in the US exist in part because of our history. We are not educated to understand and value the myriad beautiful cultures that make up our own country. Instead, we are pitted against one another by politicians for their own gain (Bell 1993), and this affects all of us emotionally. One issue in particular that hampers US art therapists, who are 90 per cent white (Talwar, Iyer and Doby-Copeland 2004), is that most European-Americans are unaware of the benefits of being white and the costs of being a person of color in this society (Brown *et al.* 2003). Unfortunately, our supposedly color-blind society, which blames those who are not making it, goes further and affects the ways in which we interact with the world by perpetuating the "them versus us" rationalizations for war.

In 1999, I was downsized from the job I had held for ten years as an art therapist on a mental health program. Having worked with the adult psychiatric population for over 25 years, I could have obtained a similar job in the field. However, because of corporate takeovers and managed care, my job had become one that involved more paperwork than peoplework. I felt my therapeutic effectiveness had been greatly reduced. It became clear to me

that the corporate managers of mental health programs only cared about the bottom line. This gave me the opportunity to think about what I really wanted to do. I decided to try to affect change on a larger scale by pursuing an old dream of making a family holiday I had originated a wider reality.

A multicultural holiday

I created All People's Day® for my family in 1973. It is a holiday of inclusion instead of exclusion. The motivation for this arose from my own feelings of being excluded and different.

The first way in which I have felt different is that I am Jewish in a Christian society. When I was a child, I felt left out around Christmas time because the holidays of other religious traditions weren't being recognized in schools or in the media. To make myself feel better, I might have told myself that Chanukah was a superior holiday and Christmas was inferior. But I couldn't do that because I had become aware of the atrocities of the Holocaust. I learned about Hitler's inhumane treatment and extermination of Jewish people during World War II. I discovered that many other groups had suffered atrocities. The atrocity that particularly upset me was the enslavement of African people in my country. Once I learned about genocide and other forms of intolerance, I couldn't say that my holiday, Chanukah, was superior and Christmas inferior, because the feeling of superiority of one group creates the justification for the inhumane treatment of others.

The second reason I have felt different is that I am dyslexic. I couldn't read until I was ten years old, and was placed in a class with children who had marginal mental retardation. The school system was unaware of learning differences at that time. They didn't understand that children with learning disabilities are usually very bright and just have different ways of learning. I felt terrible about myself. The school gave me the clear message that I couldn't learn. At that point, I could have easily given up on learning, but someone saved me from that fate. That very special person was my mother. She was told that I was good at art and decided that she would encourage me. Starting when I was 7 years old, she took me to a Saturday art school, even though it was extremely inconvenient for her to do so. When I entered the school and began to draw, paint, and sculpt, an amazing thing happened. I discovered that I was good at something! This gave me the courage to continue trying to read. At that time, I didn't think I would even graduate from high school. However, I graduated not only from high school and

college but also from a master's degree program in art therapy. The combination of my mother's support and my artistic ability had saved me.

Inspired by my feelings of being good at art and accepting my differences, I created All People's Day® – a holiday for all the people in the world that leaves no one out. While developing the traditions for this holiday, I came to see that there are many reasons why people feel left out – including racial, ethnic, age, gender, sexual orientation, religious, physical, and mental differences. Yet, at the same time, I discovered core similarities among people. Because everything starts with art for me, the holiday uses art activities that have diversity issues imbedded in them. These activities help us recognize the beauty in our differences and remind us that we are all human beings who deserve equal rights.

All People's Day® traditions[1]

The following describes the three basic traditions of the holiday, illustrates why I feel they are needed, and presents a few examples of how they can be used in schools and other settings.

Craft-Dough People: Dealing with issues of race

Many white European-Americans are not sure whether racial discrimination is a significant factor in the US today. This is because blatant signs of racism such as "whites only" signs have disappeared since Martin Luther King's time and because white privileges are often taken for granted. The following are some examples of the research on this issue.

In 2003, a Gallup poll was conducted and reported on by Ferguson (2004) concerning racial discrimination in the US. Wade Henderson, Executive Director of the Leadership Conference on Civil Rights, was noted as saying, "The good news is there is a sense of optimism in the respondents to the poll" (paragraph 3). He added, however, "There is a gulf, not only in perception, but in reality" (paragraph 4) in regard to views on discrimination between different racial groups. Ferguson wrote:

> Ninety per cent of whites, 73 per cent of blacks, and 76 per cent of Hispanics surveyed said civil rights had somewhat or greatly improved (paragraph 6)… Still, 49 per cent of blacks said they had experienced some form of discrimination in the month preceding the poll and 62 per cent believe they are treated somewhat or very unfairly. (paragraph 2)

During 2000 and 2001, Dr. Joy Leary (2004), an African-American social scientist, conducted a study on violence prevention. Her study participants were 100 incarcerated and 100 college-bound young black males from the same town. She found that out of the five survey scale variables given, Violence-Victimization Scale, Violence Witnessing Scale, Urban Hassles Scale, Racial Socialization Scale, and Disrespect Scale, violence-victimization and disrespect were rated highest by both groups of participants. Already knowing from previous studies that victims of violence are predicted to commit violence, Leary then asked all 200 participants why they would be disrespected. The large majority responded that they would be disrespected because they were black. She reported being surprised that the responses from both groups were so similar.

Other issues that have impact on people of color today are cited in Brown *et al.*'s book *Whitewashing Race: The Myth of a Color-Blind Society* (2003). Some of these are listed here:

1. Regarding cases of racial discrimination, the US Supreme Court stated, "Plaintiffs must prove specific and conscious bad intentions" (p.38). This kind of proof, which was very difficult to obtain, was not required in cases of age discrimination. (This is the only example in this list that took place before the civil rights movement.)

2. "Blacks and other minorities are denied mortgages far more frequently than whites with comparable income" (p.44).

3. "Similar disparities cut across every aspect of health and health care, and few of these differences can be fully attributed to social class or genetics... Statistics prove that both black males and females are dying at disproportionate rates compared to their white European counterparts" (pp.45–46). These findings are supported by studies such as one in which black actors and white actors reported the same symptoms to doctors; the blacks, but not the whites, were given diagnoses that would have resulted in inadequate treatment.

4. Feagin and Spikes's statement seems all too true: "A black person cannot escape the stigma of being black even while relaxing or shopping" (Cited in Brown *et al.* 2003, p.34).

I have concluded that racism continues, along with the need for the Craft-Dough People project that deals with it – even though this is less

obvious now to many European-Americans than it was when I originated my holiday in 1973.

The Craft-Dough People activity uses white-craft dough that is divided into five equal parts. Food coloring is added to each part to represent the brown, beige, red, gold, and mixed races. The mix is light brown made from combining all the food colorings. Participants are instructed to flatten the pieces into circles. They place plastic eyes on the circles and proceed to complete a relief sculpture of a face on each circle (see Figure 14.1). This activity presents the message that all people are made from the same building blocks (flesh and blood) and, therefore, should be treated with equal respect. For younger children, preschool through fifth grade, the concept of shared similarities is the primary focus. The children make all five faces on their plates and experience the fact that, like real people, they were all made from the same ingredients. They discuss the differences they see in the context of variety being more interesting and beautiful than everyone looking exactly the same. At the All People's Day® celebration later, songs and poems are used as reinforcement for the connections between the races.

For older children and adults, the process is more sophisticated. Participants work in five-person teams with each team member making a different color face. After the faces are completed, definitions of *prejudice* and

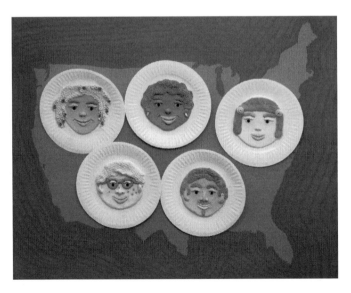

Figure 14.1: The Craft-Dough People by participants aged 11 to adult (photograph by Angelo Quaglia)

prejudice-lies are presented and explored. Using prepared outlines, each team creates a skit about conflict that involves debunking a prejudice-lie and illustrates the need for cooperation to solve a mutual problem. Team members play characters based on their sculptures, which they wear on strings around their necks so the audience can recognize each character's race (see Figure 14.2). The skits are presented at the All People's Day® celebration.

CRAFT-DOUGH PEOPLE PROJECT WITH GROUP HOME RESIDENTS

The Craft-Dough People project was done in a day program for emotionally disturbed and learning disabled boys, ages 12–16, who were living in a group home. The boys were divided into three teams that worked together throughout the day. Each team started by creating their Craft-Dough People. The following is a report on one of these teams.

The boys in this particular team were 13–15 years old and in grades 8 through 10. Student 1, an African-American of medium-dark skin tone, was one of the older boys. He was quite artistic and created his mixed-race, Craft-Dough Person with a mustache and goatee. When we started the skit creation, he was suspicious and slightly resistant at first. (Perhaps he was hiding behind that mustache and goatee?) However, he eventually became the team leader. Student 2, on the other hand, an African-American boy with

Figure 14.2: Teenagers portray the race of their Craft-Dough Person while performing skits that disprove prejudice-lies (photograph by Susan Berkowitz)

the darkest skin in the room, chose to create the beige European-American Craft-Dough Person. I interpreted this as his attempt to align himself with light-skin privileges.

In my five-year experience using these techniques with many groups, the craft-dough color of choice among African-Americans has revealed a decided preference for light skin. Joy Leary (2004) gave an example of this phenomenon. She told about a dark-skinned, African-American mother who said to her equally dark-skinned son, "Don't bring home someone black as you," when referring to a future mate.

Now why would a parent express such apparent self-hate? Dr. Leary has come up with a new diagnosis that she calls "posttraumatic slave syndrome." Reviewing the diagnostic criteria for posttraumatic stress disorder in the *Diagnostic and Statistical Manual of Mental Disorders* by the American Psychiatric Association (1994), she cited every stressor as something most slaves experienced. She then explained that none of the slaves ever received treatment for the trauma they suffered. As a result, there has been a "trans-generational impact" on today's African-Americans. This phenomenon has also been documented by Elaine Pinderhughes (2002), a professor at Boston College and an award-winning author of books on the subject of race.

Further, Dr. Leary (2004) described occurrences of African-American parents unconsciously refraining from using praise. She reasoned that this happens because "we learn from the generation that precedes us." Dr. Leary said that, during slavery, if a parent praised a child and the slave owner overheard, the child might be perceived as more valuable property and most likely taken away to be sold.

Student 2's behavior seemed to support Leary's ideas. When the team members were asked who wanted to create the beige Craft-Dough Person, he jumped out of his seat in his eagerness to raise his hand first. But it turned out that that was the most spirited he was all day. When we began the skits, he asked me if he was required to act in one. I didn't give him a direct answer but encouraged his participation. Acting in a skit requires standing up in front of an audience for everyone to see you. Leary (2004) has provided an illustrative example. She mentioned her trip to Africa and how people there often said to her, "I see you." Upon her return to the US, a dark-skinned child taunted her lighter-skinned son for no apparent reason, shouting, "What you looking at?" She suspected that he was really saying, "I am what I think you think of me" and that he suffered from low self-esteem due to his darker skin

tone. In the skit, dark-skinned Student 2 chose a minor role but did participate.

Student 3 was a European-American who chose to create the brown Craft-Dough Person. He seemed happy to choose the darkest color, perhaps in an attempt to fit in with the rest of the team who were all people of color. Student 4 was an African-American of medium skin tone who chose to create the red Craft-Dough Person. He sought constant attention and acted out in the group; he was eventually taken out of the group by a staff member. Student 5 was a Hispanic-American of light-to-medium skin tone who created the gold Craft-Dough Person. He was shy, compliant, slightly confused, and needed very specific directions.

The problem the team decided to solve was being locked in a car, and the prejudice-lie they chose to debunk was that all African-Americans steal cars and, therefore, know how to pick locks. Student 3, who was white but playing the part of an African-American, was having trouble with his role. Student 1 confronted him, stating that he was not paying attention. It seemed likely that Student 1 was really saying, "White people don't recognize or experience such problems." This went on for a while until Student 3 explained he didn't understand how he could pick the lock from the inside of the car. Once he proved he had been paying attention and appeared to understand this prejudice-lie against African-Americans, the team really started working together. They then came up with the idea that they were locked out of the car with the keys left inside. They debunked the lie by having Student 3 say he had never broken into a car and didn't know how to pick the lock. I reminded the team that they all had to participate in the resolution of the problem. They each took a co-operative part by finding imaginary hangers to feed through the window and so on. I set up a car by arranging four chairs in front of the room, and they acted their skit, giving each other high fives at the end.

CRAFT-DOUGH PEOPLE PROJECT WITH MIDDLE-SCHOOL STUDENTS
In this example, the Craft-Dough People project was used in a mostly European-American middle school with very few students of color. The class assigned to the project was composed of sixth grade students with no reported psychiatric problems. I worked with the class in 45-minute sessions once a month for 3 months in a row. Between each session, I gave the teacher information about mixed-race prejudice, "Jim Crow," and Rosa Parks that she shared with her class. Students started their skits with me and continued to

work on them with their teacher. Two months later I hosted the celebration, which culminated in an assembly. The students who made the Craft-Dough People performed their skits, and performances were done by the two other sixth grade classes with which I had worked on other All People's Day® projects.

In the team I will describe, one student had been inspired the night before our session to write what she thought was a complete skit, and she convinced her team to use it. Thinking they had an advantage over the other teams, the team members completely ignored the written instructions I gave out about choosing a prejudice-lie and a mutual problem. They proceeded to assign parts and practice dialogue for their skit. Their setting was the cafeteria of the school. The skit consisted of the student representing an African-American asking to join a table where the other four students were sitting. Making disparaging remarks, these four refused to allow him to join them for lunch, and there the skit ended.

When a team finishes, I always encourage the other teams to give them recognition by clapping and then ask for constructive criticism. From the feedback, this team became aware that they had only presented a problem; they had not provided a solution. When asked, even the girl who made up the skit could not give a reason for the students' refusal to share a lunch table with the African-American student. This skit seemed to reflect incidents that could have happened in their school and confusion about such incidents. Everyone knew something was wrong, but no one could figure out why. Around the age of middle school, when students start thinking about dating, pressure from their parents, other students, and society encourages them to socialize with their own cultural group. This ambiguous situation is difficult to deal with. By deciding on a mutual problem and a prejudice-lie to disprove, the students were able to clarify the issue.

Choosing the less threatening task first, a team member suggested that they get trapped in a large supply closet. Immediately, I instructed them to act this out. In trying to figure out how the African-American student could be trapped with them, another member of the team came up with the idea that this student might work as an assistant janitor after school and be in that area getting a broom. This suggestion reflected the social status and the expectations of African-Americans in the students' affluent neighborhood. There were many other ideas they could have considered – for example, they might have come up with the idea that the African-American was a computer whiz who was hired by the school to set up their new computers. He could

have been in the computer storage area getting equipment. Alternately, all five students might have been assigned to clean up the closet. I didn't question the team's choice because I felt any criticism at this point could cut off the creativity they were showing. In hindsight, however, I wish I had asked for another suggestion and discussed the implications later.

In the final version of the team's skit, all five students were trapped in a janitor's supply closet because the door had slammed shut and locked. The African-American student, using a key to the closet and leading the others in pushing on the door, eventually freed them. The team then came up with the prejudice-lie that "all African-Americans are unreliable, and you can't depend on them," which they felt their scenario debunked. The skit concluded with the students reconvened in the lunchroom where the others invited the African-American student to join them.

Creating the Symbol of All People's Day®: Dealing with issues of cultural diversity

Art therapists are just beginning to realize that a variety of religious, social, and cultural contexts may have a profound effect on the symbols contained in an immigrant client's artwork. For example, an exercise called "Draw-a-Person-in-the-Rain" (Hammer 1958) is purported to measure how a person deals with environmental stress. The client's defenses against stress are supposed to be depicted by the presence of some form of protection such as an umbrella, coat, or tree. However, clients from many places in the Middle East and in Africa have experienced rain very rarely. Thus, these people tend to view rain neither as a source of stress nor as something from which to be protected. In fact, in the Arabian Peninsula and North Africa, rain is considered a blessing, and people dance in the streets when it rains. A European-American therapist who is unfamiliar with these facts would more than likely misinterpret a Draw-a-Person-in-the-Rain done by a recent immigrant from one of these places – especially if the person in the picture is welcoming the rain, the supposed source of stress. Therefore, initiating the subject of cultural differences with clients makes the topic more accessible and reminds the therapist to ask about circumstances in their clients' countries of origin. In addition, it's important that immigrant clients preserve their ethnic identities. This helps to keep their moral integrity and self-esteem intact, giving them the courage to work on the multifaceted chore of integrating into a new world (Hiscox and Calisch 1998). The All

People's Day® Symbol project can serve as a bridge to the subject of cultural diversity through positive and accepting images.

The symbol I originally created serves as a model for the project. It is a sculpture made of copper-, ebony-, silver-, and gold-colored metals depicting four family groups. Each family represents a different continent, a different race, and a different culture. Within each family are two male and two female figures that represent family members of different ages. The figures hold hands with their arms crossing their hearts to symbolize hope for peace and understanding in the world. The four families are joined in a circle to indicate we are really all one family.

Participants in the symbol project receive photocopies of each of the families in the sculpture. These images are marked red, brown, beige, or gold and are designed in such a way that, when cut out and taped together, they hold hands like the original images in the sculpture. Participants decide on the country where each family's ancestors originated and then color in all four families. Very young children may use a single color for each family (see Figure 14.3). They focus on the simple concept of a world made up of different ethnic groups. Older children and adults can draw the flags and ethnic costumes for each family group, including those of their own cultural background. If participants don't know their family's country of origin, they choose a country from the appropriate continent to adopt and explore. I found that most people were unaware of the costumes of even their own ancestors' cultures.

It was difficult to find pictures of folk costumes either in libraries or on the internet; so I did some extensive research and drew samples of costumes from over 40 countries. The samples were then inserted in plastic sleeves and placed in loose-leaf notebooks to be used as guides. At participants' request, I have also added a representation of a mixed family with two flags. (To honor people with disabilities, a representation of a family with one member in a wheelchair is another option.)

Like the Craft-Dough People project, the Symbol project concludes with presentations at the celebration. Elementary schoolchildren perform ethnic music, dances, and poems or prose about their ancestors. Older children and adults perform skits about the possible misunderstandings among different groups. The prepared scripts are based on participants' own ideas or on examples I provide. Another art option for teams who create the skits is painting one life-size figure clad in a cultural costume. The costumes can be referenced from my notebook and the figures' crossed arms overlap to

Figure 14.3: A young student experiences the beauty of different cultures by drawing one of the four family groups (photograph by Angelo Quaglia)

join hands. Each figure represents a character in one team's skit (see Figure 14.4). These skits are presented at the All People's Day® celebration. In addition, the completed images are taped to the walls creating a huge circle of families surrounding the audience or several life-size figures of different cultural backgrounds can be placed on stage.

Besides fostering the idea of harmony and appreciating the beauty and variety of the features, skin tones, and costumes of the world's peoples, the Symbol project creates interest in one's ancestors' country of origin. Monica McGoldrick's (1998) Multicultural Family Institute encourages people to find out about their families' cultural origins in order to better understand themselves and others. Participants may investigate why their own family or other groups came to the US. Knowing how one's ancestors were treated can help people become more accepting of new immigrants.

EXAMPLES OF SYMBOL PROJECT SKITS
In the mostly white school discussed earlier, a sixth-grade class worked on the Symbol project in teams of four. Drawing ethnic costumes created interest in their own and others' cultural groups. In one team's skit, the only Japanese girl in the class proudly led her group. She informed the other

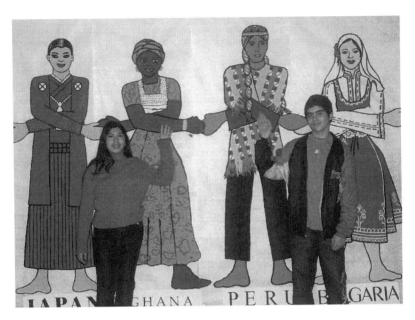

Figure 14.4: Life-size figures created by students serve as a backdrop for their original skits about the possible misunderstandings between people of different cultures (photograph by Angelo Quaglia)

members that the European-American custom of a dinner guest bringing wine as a gift was an insult in Japan. Her team seemed excited to perform their skit with original information, and the Japanese girl's status was elevated as she explained more details of family life in a Japanese family.

Another team used one of my examples that stated, "In some Muslim countries, like Somalia, showing the bottoms of your feet or shoes to another person is an insult." The team set up a situation in which a daughter brought home a new girl friend who came from Somalia. The father in the household, who happened to be facing the friend, put his feet up on a hassock, and the girl became very upset. The family asked why she was shouting, but she was too distressed to answer. During the incident, the student playing the mother made negative comments to her daughter about her new friend's unexplained emotional state. At first, the students wanted to have the friend simply explain the insult to the family, but I pointed out that, in real life, people who feel insulted in such situations usually don't realize that their reactions are due to cultural differences. So the daughter decided to take her new friend into a separate space where they could discuss the

issue calmly. The skit ended with explanations, apologies, and hopes for a deeper friendship. While playing this out, the team said they had learned to look for possible cultural misunderstandings during unusual circumstances with people from a different culture – instead of being quick to judge like the mother in the skit.

Peace Cranes: Dealing with issues of peace

If we care about all the people in the world, we naturally want peace between them. So I chose cranes made by the Japanese art of paper folding as symbols of peace for All People's Day® I picked the cranes because of a poignant story about World War II and the wish for peace by a girl named Sadako. Through the telling of this story, participants learn about the effects of nuclear bombs – weapons that have recently been dubbed "weapons of mass destruction."

A hopeful vision is launched by Sadako's story, which involves an ancient Japanese legend about getting well if 1000 origami cranes are folded. Sadako, who is dying from the long-term effects of radiation released from the atomic bomb dropped on Hiroshima, discovers the legend and tries to fold her 1000 cranes. She is a 12-year-old dying of leukemia, but she also thinks of others. She makes a wish for peace in the world by sending a special crane to the mayor of Hiroshima. She writes "peace" on the crane's wing and says it will fly spreading peace throughout the world.

The human rights abuses suffered by immigrants, 9/11 victims, or the people of war-torn countries like Iraq can be addressed through this project. The cranes become a metaphor for peace issues from a personal to a global perspective. After understanding the deeper meaning behind the craft, participants fold their own Peace Cranes (see Figure 14.5). They hang tags from the cranes displaying the names of people who have come to the aid of others and helped create a more peaceful world. Participants can choose both famous and unknown people. In school settings, students are nominated as peacemakers of their classes, and the winners' names are placed on cranes. Acceptance by others is conveyed symbolically when a participant's choice is added to the group of Peace Cranes.

Many times the individuals who are honored reflect the needs of the people who choose their names. For example, in poor neighborhoods, I have noted that children consistently honor their parents for attending to their basic needs and "taking care of me." Some pre-teens and teens honor their favorite musical groups. They are then asked to examine the message of one

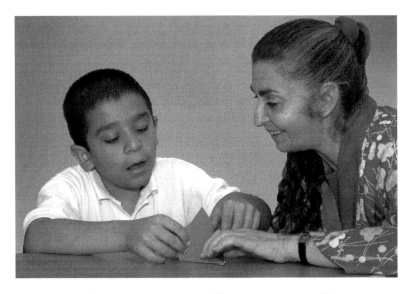

Figure 14.5: Susan helps a student learn to fold a Peace Crane, which is a universal symbol of peace (photograph by Angelo Quaglia)

of the group's songs to show how it helps people. Rebellious messages can be turned into motivation to take positive steps like presenting an issue to a school mediator or arbitrator, signing petitions, e-mailing legislators, or joining peaceful protests on local or global issues.

An original poem, skit, dance, or song about an honored person can be performed at the celebration. Group presentations are made such as reciting syncopated rap songs that emphasize positive acts towards others and spelling out "peace" on large cards and using the letters to begin words that explain ways to promote peace.

About 100 adults attending a Hiroshima Day event learned about the All People's Day® projects and folded Peace Cranes after hearing two Habakusha (survivors of the bomb) tell their personal stories. One person who had attended told me she hung her Peace Crane in her home because it gave her hope in these troubled times.

Conclusion

The visual arts portion of each project sets up a non-verbal experience of connection to the issues of race, culture, and peace. The Craft-Dough People project illustrates that we are all made from the same materials. The Symbol

project visually demonstrates that the people of the world are all one family. The Peace Cranes send a message that war can destroy the world, and peace can be its savior. In preparation for the culminating celebration, participants expand upon their initial artistic expression in another modality. This enables them to explore in greater depth the multicultural issues in society and their daily lives.

The Craft-Dough People Project

After doing the art portion of the project, children from preschool to Grade 5 are exposed to songs and poems that reinforce connections between the races. For middle-school to adult populations, skits reveal people's cultural concerns and help them work out a complex societal illness in a positive manner. For example, the African-American students in my first example chose to create scenarios that disproved prejudice-lies about their own racial group.

Reporting on her trip to South Africa, Dr. Leary (2004) said:

> I was all over three or four different cities in South Africa, and I didn't feel the level of animosity that entire trip that measured the level that I felt in [a US] airport. So as a social scientist, I have to ask myself what is going on with this phenomena?

Referring to months of testimony on apartheid at widespread public hearings, she said:

> South Africa owned it. They couldn't help but own it. South Africa said, "Yes, we did it. We're so sorry." America's pathology is her denial. It is what keeps us sick about this issue of race. It is denied.

Through the Craft-Dough People project, the African-American students in the first example were given the chance to bring present-day issues out in the open in a manner that I feel is part of the healing process. (I support the black community's work on reparations for slavery for the same reason.) The Craft-Dough People project also served as a vehicle for awareness for the white students in the examples. The European-American student in the first example showed he recognized that prejudice-lies about African-Americans exist, and then had a chance to experience just a taste of that prejudice through his role in the skit. The students in the predominantly white school in the second example struggled with the dominant culture's influence. Forming friendships is the next step after sharing a lunch table at school. It's one thing to say, "Yes, all people should be treated equally," and another to

deal with a parent's reaction when a friend from another culture is brought home to do homework.

The US Census Bureau (2004) projects that Hispanic and Asian populations will triple in the next 50 years and that non-Hispanic whites may constitute only half of the total US population. This means people from different cultures will be interacting more often than ever before. We have a choice. We can continue to turn a blind eye toward people different from ourselves and increase cultural misunderstandings, or we can be open to recognizing and understanding cultural differences to form better connections.

The Symbol Project

This project offers a way to start the process of cultural awareness. First, the subject is introduced through the depiction of people from different countries, which provides a natural opening to explore immigrants' issues or to encourage genogram work for people who have lost touch with roots that affect us all. Second, the skits help participants realize cultural misunderstandings and allow them to play their issues out from a positive perspective. Each celebration culminates with the entire group forming the symbol by crossing their hearts with their arms and holding hands. We then recite a responsive recitation of a global-connective nature such as the following:

Act like the symbol of All People's Day®

Cross your hearts with your arms and hold hands with the people near you.

Repeat after me [the words in bold].

We are all in: _____(insert place)

_____(insert town)

_____(insert State)

the United States

On the Earth

In the Universe.

We can all feel: **Happy**

Sad

Angry

Glad

We are all together: Alone

Special

People

Raise your arms and say: Happy All People's Day!

The Peace Cranes Project

The cranes project teaches about the dangers of our times and honors the wonderful people who have created ways to help and heal. Sadako's inspiring story empowers young and old. Taking positive action on issues instead of feeling helpless and becoming depressed is the American way. Therefore, I have run a peace vigil that has been held at the same time on the same spot every week since 9/11. Many people attend; others stop by to discuss the issues. And we hold special events like the Hiroshima Remembrance Day I spoke about earlier.

In these times of war and terrorism, I feel I have an obligation as an art therapist not only to help with people's fears and obsessions but also to recognize when those fears are caused by real events in a society that is ill. We can improve our society by shifting the focus from blaming the individual for being depressed about world events, coming from an alien culture, or being dark skinned. Society can acknowledge these issues as universal by such celebrations as All People's Day®. We must prepare our youth for the future, and we owe them a country and world of harmony.

At the All People's Day® holiday celebration, a piece attributed to Mohandas Karamchand Gandhi (undated) is performed with hand movements by all. It goes like this:

> I offer you peace [palms up and in front]. I offer you love [hands on heart]. I offer you friendship [hands folded]. I see your beauty [hands point to eyes]. I hear your needs [hands cup ears]. I feel your feelings [hands cross chest]. My wisdom comes from a higher source [left hand on chest, right hand on right temple and up]. I salute that source in you [hands together under chin]. Let us work together for unity and love [hands folded].

To this I have added, "Happy All People's Day [arms up and out]!"

Note

1 Detailed directions on how to create and adapt All People's Day® (copyright 1994, trademark 1996) projects for different populations – those presented here and more – will appear in Susan Berkowitz's forthcoming book.

References

American Psychiatric Association (1994) *Diagnostic and Statistical Manual of Mental Disorders* (4th edn). Washington, DC: American Psychiatric Association.

Bell, D. (1993) *Faces at the Bottom of the Well: The Permanence of Racism.* New York: Basic Books.

Brown, M.K., Carnoy, M., Currie, E., Duster, T., Oppenheimer, D.B., Shultz, M. and Wellman, D. (2003) *Whitewashing Race: The Myth of a Color-Blind Society.* Berkeley and Los Angeles, CA: University of California Press.

Ferguson, C. (2004) "Improvement seen in US race relations: But majority of blacks says unfairness persists" (Electronic version). *The Boston Globe,* 9 April.

Gandhi, M.K. (no date) "I offer you peace." Retrieved 26 February 2006 from www.quoteworld. org/quotes/5235

Hammer, E.F. (1958) *The Clinical Application of Projective Drawings* (5th edn). Springfield, IL: Charles C. Thomas.

Hiscox, A.R. and Calisch, A.C. (eds) (1998) *Tapestry of Cultural Issues in Art Therapy.* London: Jessica Kingsley Publishers.

Leary, J. (2004) "Posttraumatic slave syndrome." Presentation given at the Abyssinian Baptist Church in New York, NY, 15 January.

McGoldrick, M. (1998) *Re-Visioning Family Therapy.* New York: Guilford Press.

Pinderhughes, E. (2002) "The legacies of slavery and racism." Paper presented at the 11th Annual Culture Conference on Truth and Reconciliation, Highland Park, NJ, May.

US Census Bureau (2004) Press release on race, 18 March. Retrieved from www.census.gov/ipc/www/usinterimproj

Talwar, S., Iyer, J. and Doby-Copeland, C. (2004) "The invisible veil: Changing paradigms in the art therapy profession." *Art Therapy: Journal of the American Art Therapy Association 21,* 1, 44–48.

The Contributors

Pat B. Allen has been an artist and art therapist for over 30 years. She is currently developing an online virtual studio at www.studiopardes.com. She is the author of the books *Art is a Way of Knowing* and *Art Is a Spiritual Path*, and has published numerous articles. She attempts to walk the mystical path with practical feet and sometimes succeeds. She is Adjunct Associate Professor at the School of the Art Institute of Chicago and is a frequent presenter on art therapy topics.

Edward "Ned" Albert Bear has been a practicing sculptor of natural media for the past 15 years. He began his career as an artist after graduating with honors from the New Brunswick College of Craft and Design, Fredericton, NB, Canada. He continued his studies in the field of art education, receiving a Bachelor's degree with a major in native art. He is now pursuing studies in a Master's degree program in native art education. He has served as a member of the New Brunswick Arts Board and is currently a member of the New Brunswick Maliseet Advisory Committee on Archeology. He presently holds the position of Director of Education for St. Mary's First Nation. Ned's primary focus in his masks and human-figure sculptured works is on interpretations of historic and traditional spiritual beliefs. His work has been exhibited widely.

Susan Berkowitz has presented her All People's Day® program in more than 50 New Jersey towns in a variety of venues: schools K-12, universities, health care facilities, American Art Therapy Association conferences, houses of worship, and juvenile justice facilities. As a result of her efforts, Atlantic City, New Jersey became the first municipality to proclaim All People's Day® a city holiday. Previously, she practiced art therapy for more than 20 years in day treatment programs and on a psychiatric ward. She has been a board member of the New Jersey Art Therapy Association for 12 years.

Michael Franklin has both practiced and taught art therapy in various academic and clinical settings since 1981. He directed the art therapy program at Bowling Green State University in Ohio from 1986 to 1997. He is currently Director of the Graduate Art Therapy Program at Naropa University in Boulder, Colorado. He has lectured nationally and internationally, offering a wide range of research contributions to the field in the areas of aesthetics, self-esteem, AIDS iconography, interpretive strategies, and community-based art therapy. His current work as an artist and researcher focuses on the relationship between art therapy, yoga philosophy, and meditation. He is also working toward a Ph.D. at Lesley University in Massachusetts.

Lani Gerity is a Nova Scotian puppet maker, author, art therapist, and world traveler. Her passions have led her to search out non-traditional ways to combine her travels with words and images. Puppets and stories are where she is currently focusing her creative skills in her fisherman's cottage by the sea. Aside from puppet making and writing, one of the most satisfying activities that she engages in is teaching in the US and Canada: from intergenerational puppet-making workshops for grandparents and grandchildren to multicultural puppet-making workshops.

David E. Gussak is an assistant professor in the art therapy program at Florida State University in Tallahassee and has a private practice. He has published and presented internationally, nationally, and regionally on the work of the art therapist, on art therapy in forensic settings and with aggressive and violent clients, and on various legislative issues facing the field. He is co-editor and contributing author for the book *Drawing Time: Art Therapy in Prisons and Other Correctional Settings*. A past American Art Therapy Association board member, he is currently on the editorial board for the journal *Art Therapy*.

Dan Hocoy is a licensed clinical psychologist and a member of the core faculty at Pacifica Graduate Institute in Carpinteria, California. He is author of numerous articles and book chapters that interconnect psychology, culture, and community empower-ment. His current work explores the relationship between individual and collective transformation and the role of art and therapy. He has had a longstanding interest in social justice issues and has worked as a consultant to governments and agencies addressing cross-cultural conflict including South Africa's Truth and Reconciliation Commission and Canada's Correctional Services.

Maxine Borowsky Junge is an artist, art psychotherapist, writer, teacher, systems person, organizational development consultant, and social change agent. She is Professor Emerita in the Department of Marital and Family Therapy (Clinical Art Therapy) at Loyola Marymount University in Los Angeles, where she was a founding member of the department and department chair for nine years. She has also taught at Immaculate Heart College, Goddard College, and Antioch University, Seattle. She holds a doctorate in Human and Organizational Sytems and has received the highest award given by the American Art Therapy Association, Honorary Life Member (HLM). She has published numerous articles and is the author of two books, *The History of Art Therapy in the United States* and *Creative Realities: The Search for Meanings*, and has finished a third (with co-author Harriet Wadeson), *Architects of Art Therapy: Memoirs and Life Stories* due out in late 2006. She had a clinical practice for more than 30 years, and her artwork has been exhibited widely.

Frances F. Kaplan has had extensive experience in teaching, practicing, and giving presentations on art therapy, including serving as supervisor of creative arts therapies at Carrier Foundation, New Jersey, and as co-ordinator of the graduate art therapy program at Hofstra University, New York. She also taught for a year at Edith Cowan University, Perth, Western Australia, and has given a course on art and conflict

resolution at Portland State University, Oregon. At present, she teaches graduate art therapy courses at Marylhurst University, Oregon, and has just completed serving for four years as editor of *Art Therapy: Journal of the American Art Therapy Association*. She is author of the book *Art, Science and Art Therapy: Repainting the Picture*.

Rachel Lev-Wiesel is an associate professor in the School of Social Work at the University of Haifa, Israel. She serves as the Chairperson of the Family Violence and Sexual Assault Society in Israel. Until recently, she served as head of the Graduate Art Therapy Program and the Social Work Undergraduate Program at Ben-Gurion University, Beer Sheva, Israel. She has published more than 80 papers and chapters focusing on trauma, the Holocaust, and analysis of drawings – in addition to four books on these subjects.

Marian Liebmann has worked in art therapy with offenders, with women's groups and community groups, and currently at the Inner City Mental Health Service, Bristol, England. She teaches and lectures on art therapy at several universities in the UK and Ireland. She also works in mediation and conflict resolution and has run "Art and Conflict" workshops in many countries. She has written or edited eight books including *Art Therapy with Offenders*, *Arts Approaches to Conflict*, and a second edition (2004) of *Art Therapy for Groups*. She recently won a Longford Prize special merit award for her work in art therapy, restorative justice, and mediation.

Rachel Citron O'Rourke is an art therapist, social activist, and artist based in Portland, Oregon. She has worked with survivors of war and torture from Bosnia, Somalia, Guatemala, Cambodia, Bulgaria, and inner city Chicago. She is the founder of the Paper People Project, an international arts-based installation against gun violence. In addition, she has worked extensively as an art therapist with medically ill children and adolescents. In her free time, she writes, and authored her first book (published in 2005) with friends Susan Beal, Torie Nguyen, and Cathy Pitters entitled *Super Crafty: Over 75 Amazing How-To Projects*.

Merryl E. Rothaus is a graduate of Naropa University's Transpersonal Counseling Psychology/ Art Therapy Department. A registered art therapist and licensed professional couselor, she is both adjunct faculty and staff member at Naropa as well as the onsite co-ordinator of the Naropa Community Art Studio. Her passionate belief in art as social action has resulted in her creating and facilitating "Social Action Art Expression" groups for teenagers. The artwork from these groups is exhibited, and the proceeds from sales benefits socially aware organizations. She has a private art therapy practice where she incorporates transpersonal and gestalt art therapy with her postgraduate studies in the Hakomi method. She has presented at national art therapy conferences on the efficacy of art therapy and social action with teenagers.

Kendra Schpok, an art therapist in private practice, brings experiences from adolescent and adult psychiatric inpatient units, an adolescent residential treatment center, a hospital pediatric ward, and municipal youth services to her current work with

teenagers, families, and adults. She is also a consultant for therapeutic schools, training staff in family art therapy and co-leading a parent support group for families with children in residential treatment. She was the Co-ordinator of the Naropa Community Art Studio from 2004–2005, overseeing administration, grant development and program development for Project Bird Homes, a teenage entrepreneurial project. She is an accomplished artist in many media from traditional crafts to drawing, painting, and graphic design.

Annette Shore is a clinical art therapist and supervisor in private practice in Portland, Oregon, and a member of the part-time faculty for Marylhurst University's Master of Arts in Art Therapy Counseling program, Marylhurst, Oregon. Her approach emphasizes the belief that individuals and society mutually influence each other. The therapeutic process facilitates improving individuals' capacities to struggle effectively with conflict, which contributes to building a healthier society. She is the author of articles that focus on child and adult development within the context of art therapy and on interpersonal aspects of the therapeutic relationship.

Nancy Slater is Director of Art Therapy Programs, Adler School for Professional Psychology, Chicago, Illinois, and former Director of the Graduate Art Therapy Program, Emporia State University, Emporia, Kansas. She is the key networker for the International Networking Group of Art Therapists and has served on the American Art Therapy Association (AATA) Research Committee and as chair of the AATA Ethics Committee. Previously, she taught art therapy in the first art therapy program at Ben-Gurion University, Beer Sheva, Israel, and, before that, in Melbourne, Australia. She has presented at international conferences and in the US. Her main interests are in international art therapy and art therapy research on trauma and interpersonal and political violence.

Anndy Wiselogle is Director of East Metro Mediation (a community mediation center in Gresham, Oregon) and a private mediator specializing in workplace disputes. She is an adjunct professor at Portland State University in Portland, Oregon, and has been exploring art and conflict since 1993 by leading groups on that topic for members of the community and for mediators. She is a member of the Association for Conflict Resolution and of the Oregon Mediation Association.

Subject Index

9/11 terrorist attacks *see* September 11, 2001, terrorist attacks

action research approach 32–3
advocacy 73–4
aggression 92–3
 psychological perspectives 143–4
 redirected through art making 148–54, 186
 and social interaction 146–8, 154–5
 sociological perspectives 144–6
 of trauma victims 185
 see also violence
AIDS-HIV 49, 53
All People's Day®
 origins of 245–6
 traditions 246–58
ancestry, learning about own 254–5
anger management 112–13
 art therapy group 126–40
 see also evaluation, anger management sessions
 see also group work
anti-racism 49–50
anti-semitism 42, 43, 47, 49–50, 194–5, 236, 245
archetypal psychology 22, 26, 73–4
art camp 239–42
art mentoring 223–7
art therapy 23–5
 action research approach 32–3
 community-based 33–4
 goals of 34–5
 racial issues 246–53
 and social action 12–14
 for trauma victims 192–4
 see also therapists
Arts Approaches to Conflict (Liebmann) 91
assertiveness 135–7
authenticity in art 232–3

awareness raising, homelessness 69–71

Bear, Ned 236–7
biological bases of art making 95–6
black children, low self-esteem of 250–1
Boréal Art/Nature 232–3
brainstorming 94–5, 100, 112, 119
Bread and Puppet Theater 234–5

cartoon speech bubbles 113–14
cave paintings 98, 100
children
 creativity of 238
 and gun violence 158–9, 162, 166
 and posttraumatic stress disorder (PTSD) 160
 virtual environment of 237
 working with elders 239
civil rights movement 45
cognitive control, regaining after traumatic events 182–4, 185
collective consciousness 22–3
collective shadow 27, 30–1
communal voices of ideal state 34–5
communication
 art as an extension of language 98–9
 using speech bubbles 113–14
community art projects
 homelessness 59–69
 Naropa Community Art Studio (NCAS) 214–27
 Paper People Project (PPP) 163–71
 role of therapist in 72–3
community feeling 240
community trauma 160–1
Con Safos: Reflections of Life in the Barrio (Chicano magazine) 46
conflict
 evolutionary roots of 92–3

necessary for social change 53–4
conflict resolution 91
 drawing workshops 103–20
 non-violent, origins of 94–5
confrontation, necessary for change 53–4
conscienticization 23
cooperation
 evolutionary roots of 92–3
 in relationships 94
countertransference 162–3, 170
Craft-Dough People project, racial issues 246–53, 259–60
Creating Minds (Gardner) 40
Creative People at Work (Wallace and Gruber) 40
Creative Realities: The Search for Meanings (Junge) 52
creativity
 of children during play 238
 and problem solving 100
 studies of creative people 40
crime
 and anger management 133–4
 gun violence 158–62
Criminal Victimization 1998 (Rennison) 159
cultural diversity, Symbol project 253–7
cultural origins, finding out about 255

delinquency, perpetuated by labeling 145–6
depth psychology 27–8
despair 76–82
Diagnostic and Statistical Manual of Mental Disorders (DSM) 25, 250
Dicker-Brandeis, Friedl 235–6
"die-in", protest against war in Iraq 171
Disasters of War (Goya), painting 44

dissociation, effect of trauma
 181–2
"Drawing Out Conflict"
 workshop 103–8
drawings
 aiding problem-solving
 100
 depicting safety 183–4
 and mediation 108–11
 and the negotiation
 process 99
 of police brutality
 182–3
 representing emotions
 111–12
 resolving conflicts
 through 111–17
 responses to terrorism
 198–203

Emotional Intelligence
 (Goleman) 111
emotions
 anger management
 127–41
 controlled by
 self-expression
 182–7
 dissipated by art making
 97–8
 identifying with conflict
 drawings 111–12
 managing 112–13
 released by creative
 process 222
equality
 in access to art making
 217
 and the ideal state 34–5
 between mentors and
 mentees 225
 for women 46–9
evaluation, anger
 management sessions
 138–40
exhibitions
 Chilian folk art tapestries
 98
 mask-making project
 66–7
 Paper People Project
 (PPP) 169–70

"Facing Homelessness"
 project 59–69, 77,
 78–80, 81, 83–4

Federal Assault Weapons Ban
 158
feminism 46–9
Fog of War (film) 188
folk art, communicating
 Chilian atrocities 97–8
fund-raising projects 59–69

group work
 aggression workshops
 148–51
 anger management
 125–40
 conflict resolution
 103–8
 Craft-Dough People
 project 249–53
 drawing conflicts
 emotions 111–17
 mediation sessions
 119–20
 problem-solving 100
 terrorism study
 191–206
Guernica (Picasso), painting
 44, 220
guided imagery 113, 127,
 131
gun violence 158–9
 Paper People Project
 (PPP) 163–72
 trauma caused by
 159–60

healing effect of images
 22–3
heterocentric society 25, 27,
 34
*History of Art Therapy in the
 United States, A* (Junge)
 52
Holocaust, The 193, 194,
 245
 see also Jewish people,
 persecution of
homelessness 59–69, 80, 83
homophobia 25, 28, 30
homosexuality 25, 27, 28,
 30, 36
hope
 inspiring through art
 75–6
 therapists' belief in 53–4
Horse's Mouth, The (Cary) 44
hostility *see* aggression
hunter-gatherers 93

"I"-Statements, as
 communication
 113–14
iceberg metaphor 115–17
ideal state 34–5
Illinois Art Therapy
 Association (IATA) 164
images
 healing effect of 22–3
 link to social action
 22–3
 power to effect change
 44–5, 222
immigrants, learning to
 accept 253–5
individual and collective
 experiences, reciprocity
 of 27–8
inequality of women 46–9
interests versus positions,
 conflict resolution
 115–17
internalized racism 49, 54
internalized sexism 46–7, 54
Iraq, protest against war in
 171
Israel
 history of terrorism
 194–5
 threat of terrorist attacks
 191–2

Jewish people, persecution of
 42, 194–5, 236, 245
justice, as goal of art therapy
 34

K'chi Kuhkiyik Arts Camp
 project 240–1
Karma Yoga 216
Kramer, Edith 235–6
*KWA' NU' TE': Micmac and
 Maliseet Artists* (film)
 236

labeling, leading to
 aggression 145–6
language development
 through art 98–9
life stories, as therapeutic
 tools 40–1
literature
 on art therapy and
 violent conflict
 192–4
 on social action 52–3

marginalized voices 30–2
marketing the Paper People project 165
mask-making 59–69, 237–8
Mean Genes (Bernham and Phelan) 94
mediation 94
 and drawing out conflict 108–11
 map drawing 119–20
mediators, training of 118
mental health, definition of 239–40
mentorship 220–7
"Mourning, memory and life itself: The AIDS quilt and the Vietnam veterans" (Junge) 49, 53
Multicultural Family Institute 255

Naropa Community Art Studio (NCAS) 214–25, 227–8
narratives in response to terrorism 198–203, 204–6
nature, producing art from 232–3, 240–2
NCAS *see* Naropa Community Art Studio
negotiation 94, 99
New York Times, The 15–16

Open Studio Project (OSP) 76
"Operation Adventure" 45–6

PADS *see* Public Action to Deliver Shelter
Paper People Project (PPP) 163–71
peace
 art therapy goal 34
 calls for end of gun violence 167
 and cooperation 92
 drawings of 132, 136, 137, 202
 encouraged by art making 96
 Peace Cranes project 257–8, 261
permanence of art 99–100
personal trauma 177–80

personhood 33–4
perspectives, drawing other person's 99, 114–15, 117
photographic images showing societal injustice 23
pluralism 214–16
police arrests
 fear of 188
 trauma of 177–85
positions versus interests, conflict resolution 115–17
"posttraumatic slave syndrome" 250
posttraumatic stress disorder (PTSD) 159–62, 192, 196
PPP *see* Paper People Project
prejudice lies, disproving 248–53
prison culture 148
problem-solving 99–100
psychic numbing 161
psychological health 176–7
PTSD *see* posttraumatic stress disorder
Public Action to Deliver Shelter (PADS) 59–69, 81
puppet making, Arts Camp project 238–42
puppetry 234–5

racial discrimination 148–9, 246–7
 Craft-Dough People activity 248–53, 259–60
 internalized racism 49–50, 54
 see also anti-semitism
reciprocity 93, 94
reflection 83–4
relaxation
 at anger management sessions 127, 131
 by drawing a safe place 113
 through art making 96–7
repression, reaction to trauma 193–4
role-taking, leading to aggression 145–6
role enactments 162

role models
 children's 237
 for Junge 51–2
 from television 50

safe places 113, 131
selfless service 215–16
September 11, 2001, terrorist attacks 195–6
 art therapy 193
 boy's reaction to 185–6
 drawing and narrative responses 198–206
 peace vigil 261
 researchers' responses 207–9
 role of the arts 15–16
 study of responses 191–2, 197–8
seva (serving others selflessly) 215–16
sexism, internalized 46–7, 54
shame, induced by traumatic experiences 176, 178, 182, 189
slavery 245, 250
social change
 art therapy as tool for 21–37
 artists as leaders of 220–3
 confrontation necessary for 53–4
social interaction, and aggression 144–5, 146–7
societal health 176–7
societal heterosexism 27
societal structures, and individual suffering 25–7
society
 idealized state of 34–5
 reflected in therapy 28–9
stories, mythical 241–2
story-making workshops 238
stress
 cultural differences in perception of 253
 reduced by art making 96–7
Studio Pardes (community studio) 59–69, 76, 78

Symbol project, cultural
 diversity 253–7,
 260–1
symbolic interactionism
 144–6
systems thinking 41, 53

tapestries depicting regime in
 Chile 97–8
"teach-ins" 226
terrorism
 art therapy as crisis
 intervention 192–3
 in Israel
 drawings and
 narratives of
 200–3
 history of 194–5
 responses to 198–203
 in the US
 drawings and
 narratives of
 198–200
 history of 195–6
Theatre of the Oppressed (Boal)
 22–3, 33
therapeutic relationship
 28–9, 147
therapist-client power balance
 50–1
therapists
 avoidance of conflict
 53–4
 and cultural integration
 50–1
 hidden agendas of 29
 ideal role of 72–3
 "moral obligations"
 36–7
 as social activists 31–2,
 74–6
therapy
 action research approach
 32–3
 a microcosm of society
 28–9
 need for imagery in
 44–5
 through folk art 97–8
thinking, value of 235
Too Scared to Cry (Terr) 161
trauma
 in co-victims of gun
 violence 159–63
 dissociation as adaptation
 to 181–2
 role of art therapy 192

traumatic events
 experiencing 175–6,
 177–82
 visual art depicting
 182–5

unconscious mind
 depth psychology 27–8,
 28–9
 impact of images on
 22–3
utopian state 34–5

violence 91, 132–3
 living with threat of
 207–8
 psychological
 perspectives 143–4
 study of responses to
 197–206
 survey on prevention
 247
 see also aggression
Violent Crime Control and
 Law Enforcement Act
 (1994) 158
vision, neurobiology of
 95–6
visual art
 depicting traumatic
 events 182–5
 facilitating
 communication
 98–9

war
 boy's drawings of
 186–7
 paintings of 44
 protests 171
 survivors, continuing
 stress of 161–2
 understanding 188
 using art to support 97
War Is a Force That Gives Us
 Meaning (Hedges) 97
weapons, ban on gun
 production 158
Weltschmerz (world pain)
 231, 235
Whitewashing Race: The Myth
 of a Color-Blind Society
 (Brown et al) 247
"Who Takes Care of the
 Caretakers?" (Danieli)
 162

"witness writing" 227
women
 equality issues 46–9
 powerlessness of 50
"world pain" 231, 235

Author Index

Adams, D. 72
Agosin, M. 97
Alcoff, L. 26
Alland, A. Jr. 96
Allen, P.B. 76, 77, 213, 214, 217, 223, 227
American Psychiatric Association (APA) 25, 250
Anderson, C.A. 145
Anderson, F.E. 193
Arad, Y. 194
Armstrong, J. 239
Ault, R. 52

Baldoquin, H.G. 112
Bartusch, D.J. 145-6
Bear, N. 236-7
Beck, A.T. 144, 145
Becker, H.S. 145, 147
Bell, D. 244
Bellard, J. 112
Benson, H. 97
Betensky, M. 227
Bey, J.M. 157
Black, L. 126
Blakeslee, S. 95
Blumer, H. 145, 146-7
Boal, A. 22-3, 33
Bona, M.J. 223, 225
Bonderman, J. 158
Bowman, M.L. 196
Brady Campaign 158
Brewster, L.G. 148
Brittain, W.L. 217
Bromberg, P. 176, 181
Brown, B.A. 33
Brown, L.D. 32
Brown, M.K. 244, 247
Burnham, T. 94
Bushman, B.J. 145
Byers, J.G. 192

Calisch, A.C. 253
Cane, F. 213, 217
Cannister, M.W. 224
Caram, P. 196
Cary, J. 44
Cassirer, E. 22
Chidvilasanada, S. 216
Cochran, S. 27
Cooley, C.H. 145
Curry, N.A. 96

Cushman, P. 26

Danieli, Y. 162
Davis, J. 227
de Waal, F. 92
Dissanayake, E. 96, 148
Dondero, G.M. 223, 224
Downs, N. 14

Elkins, D.E. 21, 24
Ellis, J.A. 93
Erikson, E. 14, 40, 176, 177
Eubanks, P.K. 99
Evans, M.L. 196

Farrelly-Hanson, M. 213
Ferguson, C. 246
Finn, J. 32
Fisher, R. 94
Flack, A. 223
Foucault, M. 29, 32
Fox, M. 220
Franklin, K. 25, 36
Franklin, M. 213, 214, 227
Freire, P. 52, 54
Freud, S. 14, 28, 40, 143, 144, 177
Friedman, M.J. 196
Friedman, R.C. 25

Gablik, S. 223
Gagnepain, F.G. 224
Gandhi, M.K. 77, 261
Gardner, H. 40
Gay, P. 143
Gerity, L.A. 193
Gilbert, M. 195
Ginzberg, N. 188, 189
Glantz, K. 93
Goldbard, A. 72
Goldenberg, H. 14, 26
Goldenberg, I. 14, 26
Goleman, D. 111
Golub, D. 192
Greenfield, P.M. 23
Grey, A. 223
Grossman, F.G. 96
Gruber, H. 40
Gussak, D. 147, 148

Haeseler, M.P. 223
Hammer, E.F. 253
Hardy, K.V. 29
Harth, E. 99-100
Hedges, C. 97

Henley, D. 192
Heusch, N. 192
Hillman, J. 24, 26
Hiscox, A.R. 253
Hocoy, D. 21, 23, 26, 32, 33
hooks, b. 26
Horney, K. 143-4, 145

James, W. 145
Johnson, A.G. 225
Johnson, D.R. 192, 193
Jones, J.G. 193, 196
Jung, C. 22, 23, 27, 28, 36
Junge, M.B. 11, 21, 24, 26, 28, 33, 43-4, 47, 48, 49, 52, 53, 221

Kalish-Weiss, B. 23
Kalmanowitz, D. 192, 197
Kaplan, K.K. 11, 23
Kasser, T. 96
Kellermann, A.L. 159
Kernberg, O. 14
Kleinman, A. 26
Klinghardt, G. 93
Koenig, O. 99
Kohut, H. 14
Kornfeld, P. 148
Kosslyn, S.M. 99
Kramer, E. 148, 186, 224, 225, 231, 235-6
Krug, E.G. 158, 163
Kuhns, R. 22

Lachman-Chapin, M. 222
Laing, R.D. 14, 51
Laszloffy, T.A. 29
Leary, J. 247, 250, 259
Lee, W.M.L. 14
Lichtman, R. 27
Liebmann, M. 91, 103
Lindy, J.D. 162
Little, C. 13
Lloyd, B. 192, 197
Lorde, A. 41
Lorenz, H. 25
Lorenz, K. 143
Lowenfeld, V. 217

MacIntosh, P. 52
Macy, J. 75-6, 77, 81-2
Makarova, E. 235
Makovsky, D. 194
Martin, C. 236
Martin-Baro, I. 25

Martinez, P. 160
Matsueda, R.L. 145–6
Mayo, S. 197
Mays, V.M. 27
McGoldrick, M. 255
McMahan, J. 213
Mead, G.H. 145, 151
Mercy, J.A. 159
Merriam, S. 224
Moon, C. 213, 214
Morris, E. 188
Muir, J. 231

National Center for Injury Prevention and Control 159
National Education Association Health Information Network 158
Novaco, R.W. 126

O'Brien, M. 13

Parkay, F.W. 224
Patton, B. 94
Pearce, J. 93
Peasley, W.J. 93
Phelan, J. 94
Phua, K.L. 144
Pinderhughes, E. 250
Pinker, S. 96
Politsky, R. 227
Polkinghorne, D.E. 40
Potter, E. 26
Putnam, R. 82

Ramachandran, V.S. 95
Ramm, M. 126
Rank, O. 148
Rappaport, J. 33
Rauchfleisch, U. 25
Read, H. 217
Rennison, C.M. 159
Rhinehart, J. 223
Richardson, J. 196
Richters, J.E. 160
Ridley, M. 93, 94, 98
Robbins, A. 36
Rockwell, J. 15–16
Royse, D. 224
Rubin, J.A. 21, 29, 32, 33

Sagarin, E. 145
Salgado, S. 23

Sarra, N. 177
Schaeffer-Simmern, H. 217
Schaverien, J. 22, 192, 193, 194, 222
Schumann, P. 232, 234–5, 242
Schwab-Stone, M.E. 160
Seftel, L. 213, 217
Shuchter, S.R. 14
Silver, R.A. 99
Sohng, S.S.L. 32
Stader, D. 224
Stovall, K. 21, 24
Stringer, E.T. 32
Sue, D.W. 49
Sullivan, J.G. 27
Sunoo, B.P. 224
Szasz, T.S. 24, 51

Talwar, S. 244
Taylor, G. 27
Telushkin, J. 84
Temple, S. 163
Terr, L. 161
Timm-Bottos, J. 33, 213, 217
Twomey, D. 25

Ulman, E. 12
Ursprung, W. 148
Ury, W. 94
US Census Bureau 260
US Department of Housing and Urban Development 160

Vaillant, G. 177
Van der Kolk, B. 176
Volbrecht, R.M. 223

Wallace, E. 22
Watkins, M. 25, 27, 73–4, 76, 79
Weishut, D. 27
Wertheim-Cahn, T. 192
Wilford, J.N. 95
Wilson, J.P. 162

Zawitz, M. 159
Zeki, S. 95
Zimbardo, P.G. 146
Zinn, H. 220
Zisook, S. 14
Zwick, J. 90

Made in the USA
San Bernardino, CA
20 August 2014